THE OIL PAINTER'S GUIDE TO PAINTING
SKIES

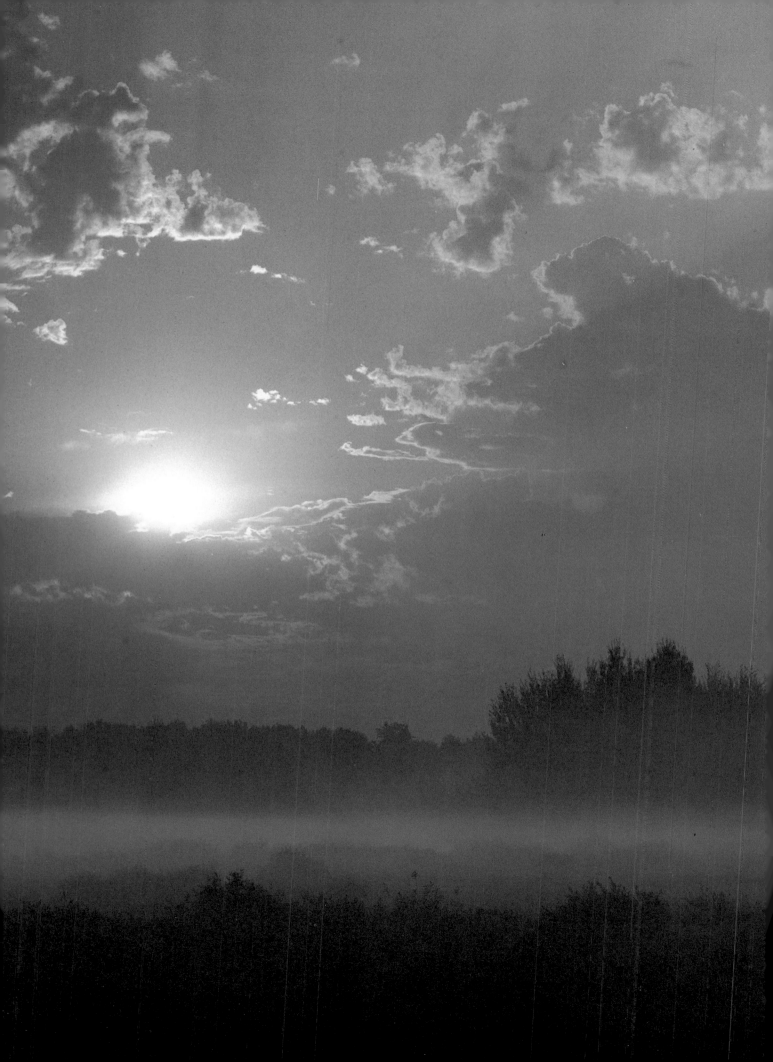

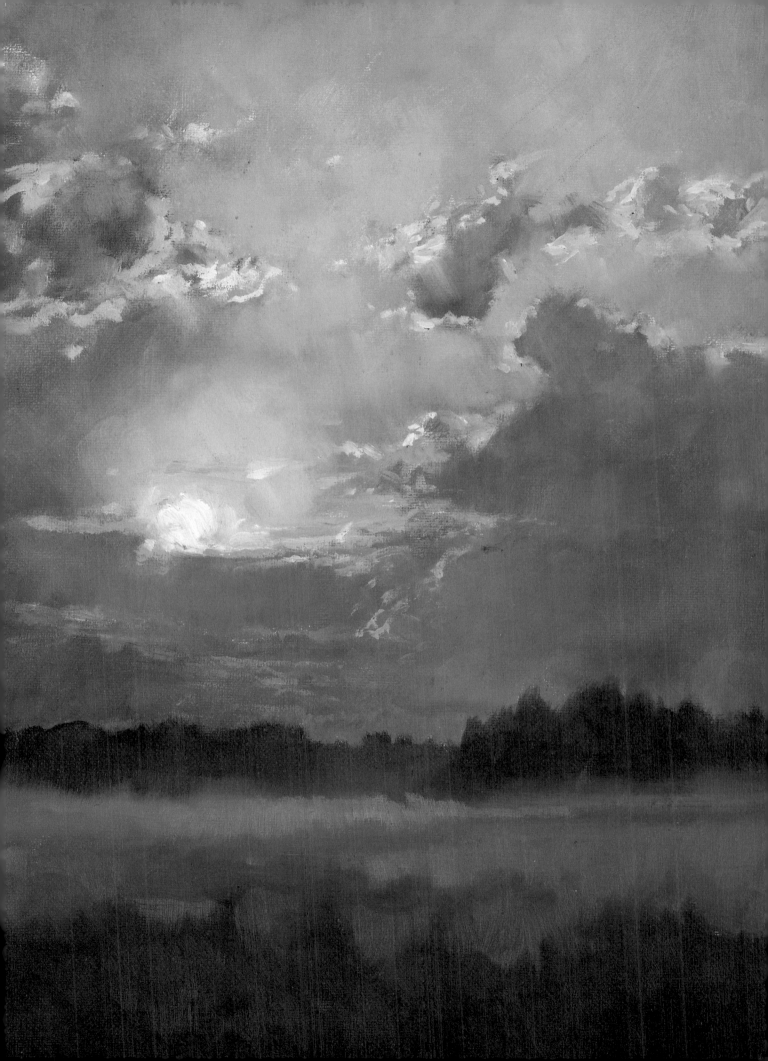

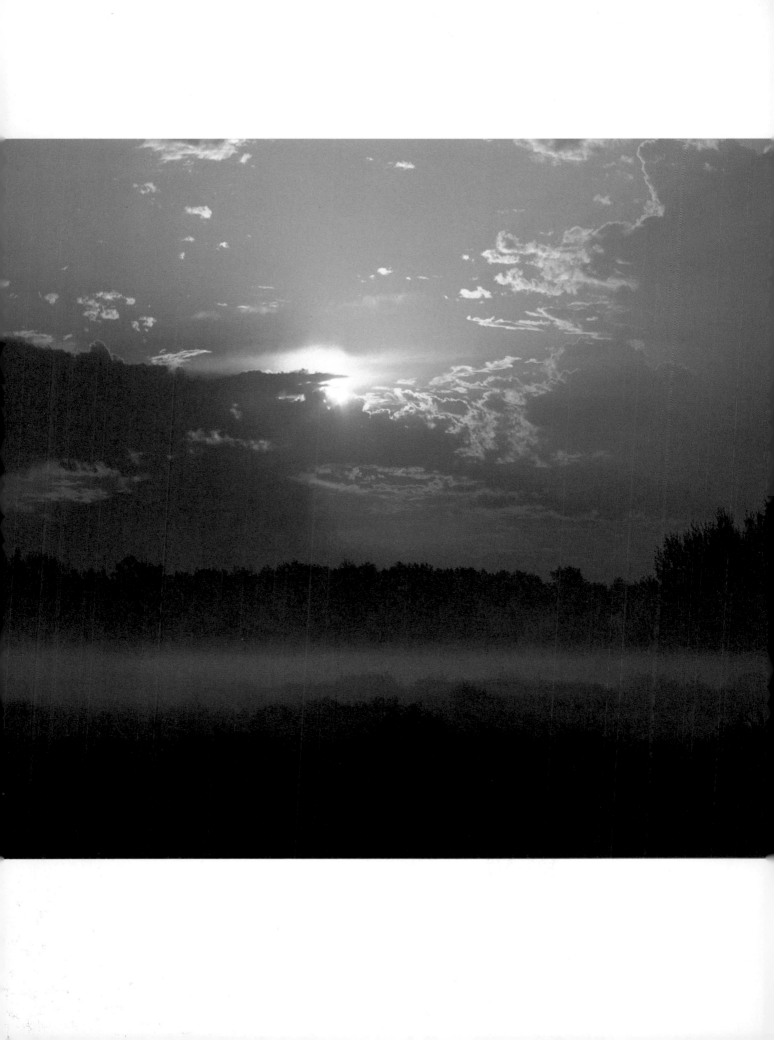

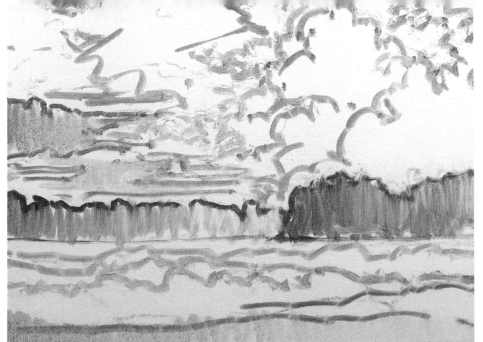

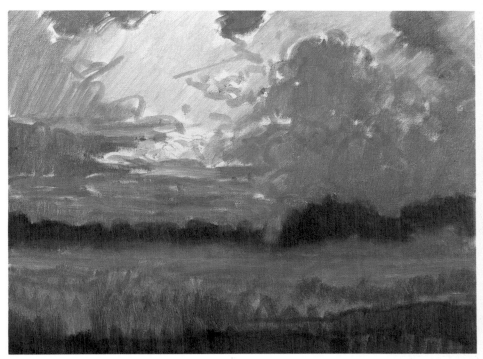

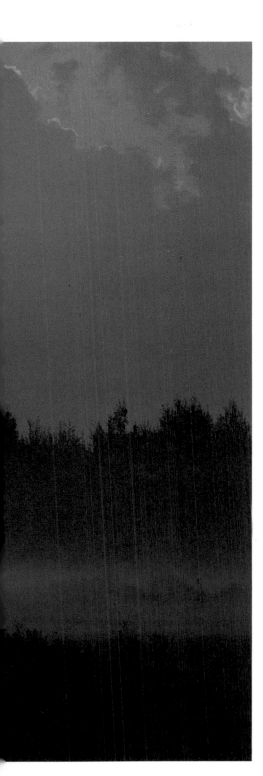

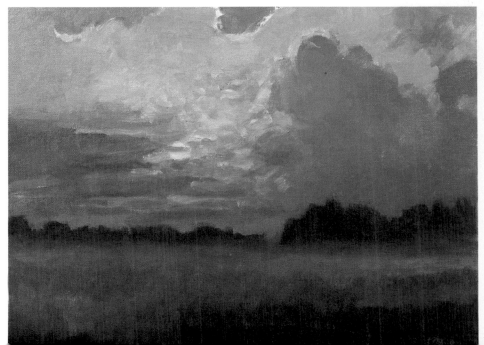

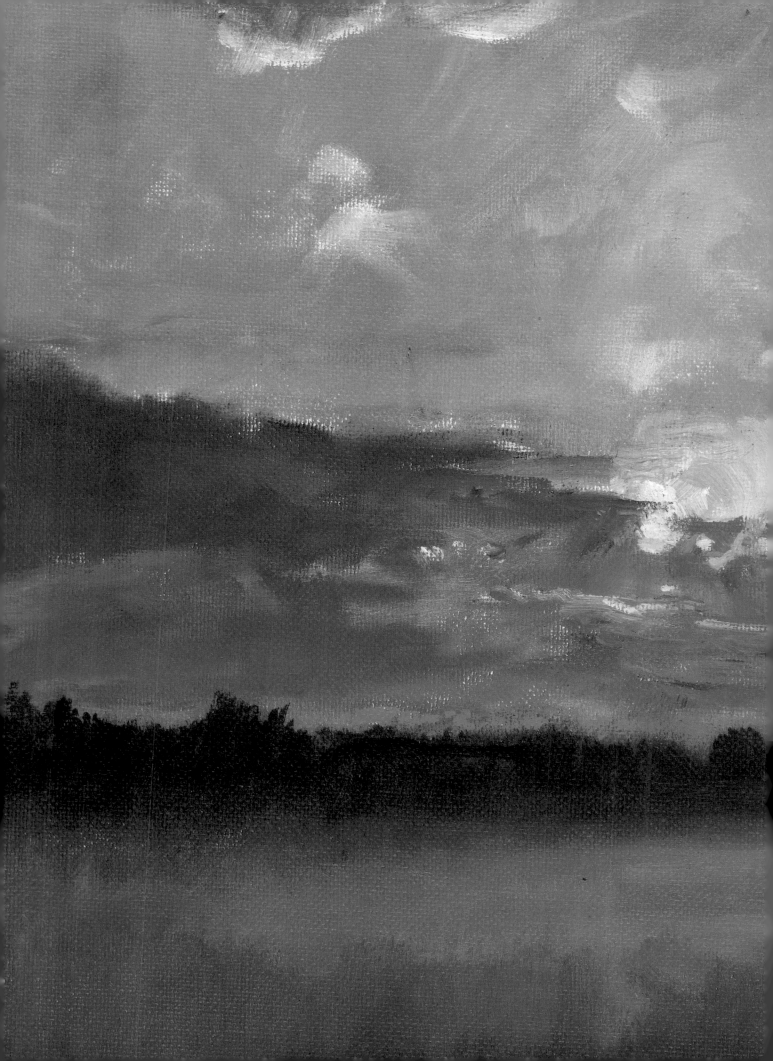

THE OIL PAINTER'S GUIDE TO PAINTING
SKIES

PAINTINGS BY S. ALLYN SCHAEFFER
Photographs by John Shaw

WATSON-GUPTILL PUBLICATIONS/NEW YORK

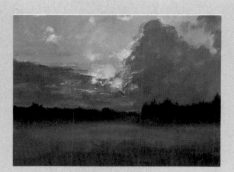

PAGES 2–3

At dawn, the skies are ablaze with brilliant reds, oranges, and gold, while fog settles over the land.

When you approach a scene like this one, try to see its subtle points as well as the dramatic ones. Here, for example, the sky is largely rendered with blue, a tone much cooler than the one that actually exists. The blue not only tones down the bright hues, it gives them additional power because they stand out so clearly against it.

Begin by drawing the scene with soft vine charcoal. Concentrate on the large masses of color that the clouds form. Sketch in the three horizontal bands of color formed by the trees and fog. Reinforce your drawing with thinned colors, using bluish purple and orange, the two colors that dominate the scene. Add turp washes to quickly cover the entire surface. Don't try to capture the exact hues you want—there's plenty of time for that later. Keep your eye on the values, however.

Now start to paint with opaque pigment. First lay in the blue areas of the sky and the cool bluish purples of the ground. Work in the orange strip of fog; then start to build up the clouds. Don't be too fussy as you paint them; use broad gestures to capture their bold feel. Your brightest tones will lie around the rising sun; as you move away from it, your colors will become slightly more subdued. At the very end, add the touches of gold that surround the dark clouds.

PAGES 4–5

The strong colors of a late summer sunrise are softened by the fog.

The brooding quality of the fog-covered land is as important in this scene as the brilliant sunrise. Develop both areas simultaneously and be sure to pay attention to the ground.

Sketch the scene, then reinforce your drawing with thinned color. Emphasize the sweep of the clouds and the silhouettes of the trees along the horizon.

Next, build up your canvas with turp washes. Paint the horizontal bands of color formed by the trees and fog, then establish the large masses of color that make up the clouds. Be sure to keep the area around the sun very light—this contrast in value is important if the darks in the scene are to have any punch.

When you start to work with opaque pigment, refine the colors and shapes that you put down with washes. Because you are working with large shapes, use a good-sized bristle brush. To emphasize the bands of trees and fog, use strong horizontal strokes in painting the clouds on the left.

At the very end, work with a smaller bristle brush. Concentrate on the edges of the clouds and the strong yellows, reds, and oranges that mass together around the sun. Finally, use touches of thick gold paint to increase the strength of the sun. In the finished painting, the blazing colors around the sun stand out clearly, yet they don't dominate.

First published 1985 in New York by Watson-Guptill Publications, a division of Billboard Publications, Inc., 1515 Broadway, New York, N.Y. 10036

Library of Congress Cataloging in Publication Data

Schaeffer, S. Allyn, 1935–
 The oil painter's guide to painting skies.
 Includes index.
 1. Skies in art. 2. Painting—Technique. I. Shaw,
John, 1944- II. Title.
ND1460.S55S3 1985 751.45′436 85-672
ISBN 0-8230-3266-3

Distributed in the United Kingdom by Phaidon Press Ltd., Littlegate House, St. Ebbe's St., Oxford

Manufactured in Japan

1 2 3 4 5 6 7 8 9 10/90 89 88 87 86 85

Contents

Introduction

What happens to the landscape when shifts in light or changes in the weather transform the sky? Everything. Imagine a lush green scene set against a brilliant azure backdrop. Or an ice-covered pond poised beneath a steely gray sky. In both cases it's the sky that sets the mood. The simple truth is that nothing matters more than the sky in determining the final feel of a landscape.

Beginning landscape artists often get lost in the wealth of detail that greets them when they begin to work on a painting. Instead of concentrating on atmospheric conditions or on interesting cloud formations, they tend to focus on concrete things like buildings, trees, or even the ground. Of course these things matter and have to be executed well if a painting is going to work. But no amount of technical expertise can make a painting spring to life if its most important element, the sky, is rendered thoughtlessly. If you paint landscapes and care about how well your paintings work, this book is for you. In it, you can learn to grapple with the most intangible of all landscape elements, the sky.

WHO THIS BOOK IS FOR
This book is aimed at the intermediate artist, one who is familiar with basic oil techniques. But if you are just beginning to experiment with oils, there's something here for you, too. Before you begin to explore the lessons and assignments that this book contains, try your hand at basic oil techniques. Learn how to mix a turp wash, how different brushes handle, which painting medium you prefer, and what support you like the best. Then start to paint.

Don't begin with intricate, cloud-packed landscapes. Instead, try your hand at a scene that is set off by a clear blue sky. Once you are comfortable with the basics, move on to more complex subjects. You'll quickly discover that once you find a logical way to begin a painting, it's easy to complete it with skill.

HOW THIS BOOK IS ORGANIZED
This book contains fifty lessons, each devoted to a problem you are likely to encounter when you begin to paint skies. First, the problem is presented, then a solution is discussed.

In each lesson, the painting procedure is outlined for you. In many cases, clear step-by-step photographs make it easy for you to understand how the paintings actually develop. Fourteen lessons include assignments that have been designed to help you apply what you've learned to your own works. Feel free to start with any lesson and follow any order you like. To learn the most from the assignments, however, read the corresponding lesson first.

THE PHOTOGRAPHS
Every lesson is introduced with a vivid color photograph—the photograph the artist actually worked from as he painted. By studying the photograph and the corresponding paintings, you can discover how the artist analyzed his subject matter. The photographs are also an invaluable aid in learning about composition. Before you start each lesson, take a few minutes and study the scene, analyzing how the photographer approached it. What angle did he shoot from? What lighting conditions did he try to capture? How did he frame his composition? When you move out of doors, use what you've learned to see the world in a new way. As you explore, you'll quickly find out that painting the sky isn't a simple

preoccupation; it's a challenge that can last you a lifetime.

SELECTING COLORS
The paintings in this book were executed with the following twenty-four colors:

- White
- Cadmium yellow light
- Cadmium yellow deep
- Yellow ocher
- Raw sienna
- Cadmium orange
- Cadmium red light
- Cadmium red medium
- Cadmium red deep
- Alizarin crimson
- Light red
- Burnt sienna
- Mars violet
- Burnt umber
- Raw umber
- Thalo (phthalo) blue
- Ultramarine blue
- Cobalt blue
- Cerulean blue
- Thalo (phthalo) green
- Viridian
- Permanent green light
- Thalo (phthalo) yellow-green
- Black

Most of the paintings are built up of just six or seven colors.

You may already have an established palette, one that you have been working with for years. That's fine—there's no need to follow the lessons exactly. However, adding a few new colors to the basics you count on can inject your paintings with new vitality.

If you find that you are relying on the same colors over and over again, it may help to put them aside for a month or two and look for new ways to solve color problems.

Or try this: Every month introduce one or two new, experimental colors to your basic palette.

Some may not work for you, but others may become permanent tools.

If you've never concentrated on the sky before, don't get caught up in preconceived notions about color. The sky isn't just blue, and clouds aren't always white. Both are made up of a wealth of colors. Reds and yellows are particularly important. Reds can warm up a cool blue sky; yellows can reduce the glare of a too-white cloud.

Experiment with a variety of colors as you render the sky; soon you'll discover what colors are best for you.

CHOOSING THE RIGHT BRUSHES

Bristle and sable brushes are both used in these lessons; you'll mostly work with the bristles. Because they are relatively stiff, they are excellent for laying in large areas for color. Not only that, they can produce loose, painterly effects that can turn a plain sky into an exciting one.

Sables have their uses, too. Softer and more pliable than bristles, they are perfect for painting small details. They are useful, too, in applying glazes.

Bristle brushes come in four main shapes: flats, brights (with a rounded tip), filberts (oval shaped), and rounds (with a pointed tip). Fan-shaped bristle brushes are excellent when you want to achieve an unbroken surface. Run over a wet canvas, they smooth away any obvious brushstrokes.

Experiment with the different effects each type of brush produces and discover what sizes are best suited to your needs. Also compare the different effects that result when you work with the whole brush or just its tip.

Sable brushes can be expensive, especially large ones. There are, however, some good synthetic substitutes. In most painting situations, you'll only need the smaller sables. If you choose

them carefully and treat them with respect, they will last for a long time.

MISCELLANEOUS MATERIALS

A sturdy, portable easel is a must if you plan to work outside. Since you'll be carrying your supplies along, you'll need a good-sized paint box. Choose one large enough to accommodate everything you need—paints, brushes, turpentine, rags, and even your palette. Aside from your palette, paints, and brushes, basic supplies include either mineral spirits or turpentine, one or more painting mediums, plus palette and painting knives. Bring along paper towels or rags, too.

What kind of painting medium should you use? Many artists like working with prepared mediums like copal. You can, however, mix your own medium easily and inexpensively. The paintings that appear in this book were all done using a medium made up of one to four or five parts of turpentine to one part damar varnish and one part stand oil. Occasionally you may want to retard drying time or to hasten it; there are prepared mediums perfect for either need.

CHOOSING A SUPPORT

Many artists like to stretch their own canvases. Canvas provides a flexible support, comes in a wide range of textures, and is economical, too. If time is a factor, and if the bulk of stretched canvases is inconvenient for you, consider working on prepared boards.

These canvas boards are relatively light and take up very little space. Most important, they are ready when you are.

Prepared boards have one drawback: They come in a limited variety of sizes. If you want to break away from the standard sizes but don't want to stretch your own supports, consider working on Masonite (hardboard). Masonite comes in large sheets that can be sawed into any conceivable shape. Once you've di-

vided the board, prime it with acrylic gesso before beginning to paint. In addition to flexibility in size, Masonite has another advantage: It's perfect for intricate, delicate subjects, where the weave of canvas might interfere with the effect you are after.

CHOOSING A SUBJECT

When skies are your focus, there is always something there for you to paint. As it changes, the sky provides a plethora of subject matter.

Start with simple subjects. Choose a scene with just a few clouds. Learn how to handle their highlights and shadows, then move on to something more complicated. Gradually you'll be able to render masses of clouds or odd atmospheric effects that occur at sunrise or sunset.

Before you start any painting of a sky—be it simple or complex—understand that you are dealing with a subject made up of abstract shapes. It doesn't pay to be too literal. Instead, play around with what you see, stay loose, and feel free to change your original conception if the sky suddenly changes. Flexibility is vital when you start to paint the most fleeting of landscape elements, the sky.

DEVELOPING YOUR OWN STYLE

As you work through the lessons contained in this book, don't limit yourself to step-by-step copying. Each time you turn to a new lesson, stop and think through the particular problem. No doubt you'll find that your solutions aren't always the same as those presented here. Follow your instincts. If you see a more effective way of dealing with any subject, give it a try. The truth is, there's no simple way to paint the sky. There are hundreds, even thousands, of approaches. This book hopes to awaken you to the challenge that painting the sky presents.

THE OIL PAINTER'S
GUIDE TO PAINTING
SKIES

Choosing a Center of Interest

PROBLEM

This composition is almost perfect; the foreground is visually interesting and forcefully directs the eye backward. But you can't let the foreground overpower the distant tree and clouds.

SOLUTION

Decide what to concentrate on right away; emphasize either the foreground or the tree and sky. If you make all three elements equally strong, your painting will lack power.

☐ Sketch the scene with charcoal, then reinforce the lines of your drawing with thinned color. Next, brush in the dark undersides of the clouds and the patterns that make up the foreground. Treat the tree as a simple silhouette, and let the white of the canvas represent the lights.

Now paint in the blues of the sky with thin washes of color. Start at the top of the canvas with cobalt blue and a touch of alizarin crimson; then, as you approach the horizon, gradually shift to cerulean blue mixed with thalo green. Next add the middle values to the clouds. Now build up the patterns formed by the grass in the foreground.

Working with opaque pigment, repaint the sky. Use a wet-in-wet approach to capture the soft edges of the wind-swept clouds. When you are satisfied with the sky, turn to the tree. Repaint it with thicker paint, then add small touches of blue to depict the breaks in the foliage that allow the sky to show through.

Now comes the step that matters most—painting the foreground. You've already established a powerful sky; to keep it powerful, you'll have to control how you deal with the grass. Lay in thinned yellow ocher overall, then begin to add detail to the immediate foreground. First lay in the grayish rocks, then the grasses that obscure them. Use a small, round brush and let your strokes suggest individual blades of grass. Temper the strength of the yellow ocher with touches of your browns and even greens, and keep your strokes fairly fluid.

In the finished painting, what matters most is the sky. The lines of the composition all sweep toward it, and it is painted with enough vigor to capture the immediate attention of the viewer.

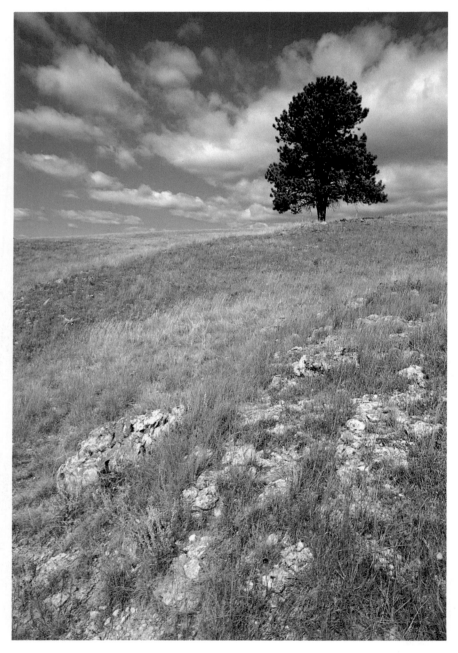

In early autumn, a lone ponderosa pine stands against a cloud-streaked sky.

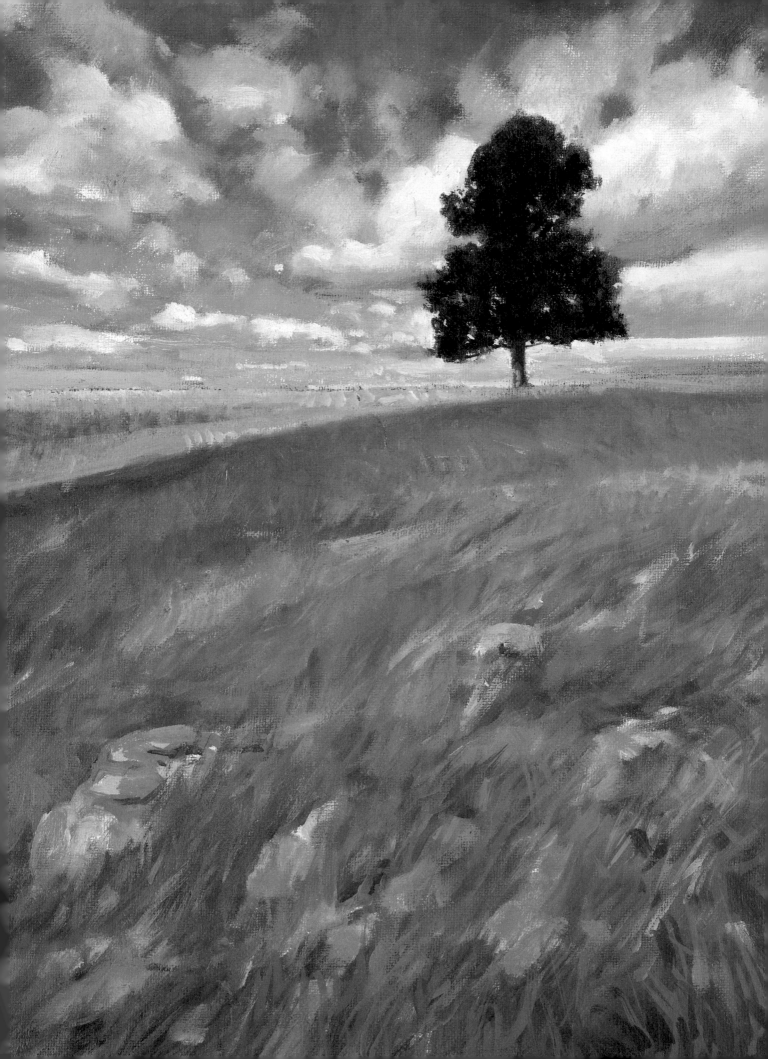

Depicting the Brooding Quality of a Coming Storm

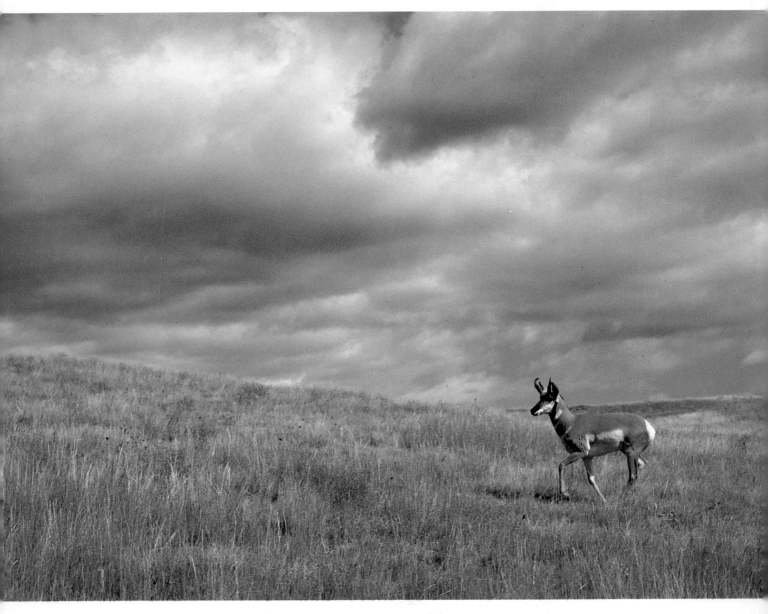

PROBLEM

Even though the animal in the foreground does a lot to establish the scale and mood of this scene, it isn't really the main subject. If you concentrate too heavily on it, you'll lose the power of the dark, threatening sky.

SOLUTION

Until the final stages of the painting, forget about the pronghorn and concentrate instead on the tension between the cloudy sky and the golden prairie. Once the sky and prairie have been established, turn to the animal.

☐ In your drawing loosely establish the motion of the clouds and sketch the pronghorn carefully.

Now brush in the entire canvas with thinned color. Lay in the clouds with washes of gray, raw umber, and cobalt blue. Render the patch of blue sky near the horizon with cerulean blue and use a simple wash of yellow ocher and permanent green light for the prairie.

Now switch to opaque pigment and begin to paint the sky. To capture the soft feel of the

In late October, a pronghorn antelope pauses briefly on a prairie, just before the wind becomes mixed with rain and snow.

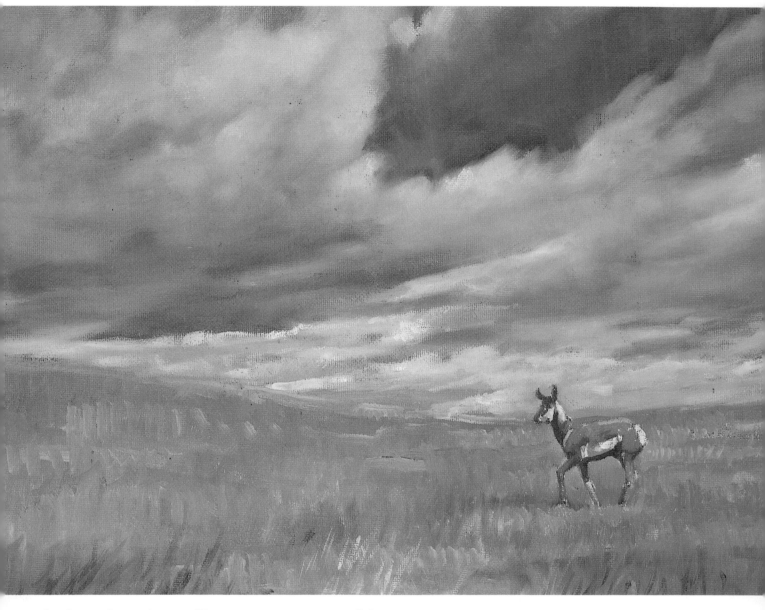

clouds, work wet-in-wet. Here dabs of cadmium red and yellow ocher both warm the clouds and make them more interesting.

Lay in the sliver of bright blue sky near the horizon with cerulean blue mixed with thalo green, then turn to the foreground. To render the grasses, take a small bristle brush and lay down many short, vertical strokes of yellow ocher and cadmium orange. Don't let them become too brilliant; tone them down with touches of burnt umber and per-

manent green light.

Now the scene is set for the antelope. Working with a small sable brush, begin to paint it, searching for the large, simple shapes that make up the anatomy of the animal.

Adding the pronghorn affects the texture of the grass. Some of the short, choppy strokes you used to depict the grass will probably have to be smoothed out in order to make the pronghorn stand out clearly against the field of gold.

ASSIGNMENT
A scene like this one, with an animal paused for a brief second, could only be painted from a photograph. Photographs can not only freeze animals for you, they can also capture the changing conditions of the sky.

Get into the habit of carrying a camera with you when you go outdoors to paint. Back home, keep a file of your photographs and refer to them when you want a particular kind of sky to establish the mood of a painting.

Learning How to Paint Backlit Clouds

PROBLEM

It's the pale, backlit clouds that make this scene interesting. They have to stand out clearly against the silhouetted ground and the dark blue sky.

SOLUTION

To make the clouds stand out, paint the ground and the sky as dark as you possibly can. But don't use plain black for your darks; make them rich with color instead.

☐ After you execute a simple drawing to place the main divisions of the composition, brush in the dark foreground and the heavy sky with thinned color. Since values are so important in this scene, try to capture the correct ones from the very beginning. Next, paint the lighter sky that lies behind the clouds, then turn to the clouds themselves. Establish their shadowy areas with a warm gray; if your gray is

As rain falls over a prairie in South Dakota, clouds press close to the ground.

too cold, you'll lose the backlit feel that you are trying to capture.

Begin to work with heavier pigment now. First, repaint the dark foreground with thalo green and alizarin crimson. Even though this entire area is cast in heavy shadow, try to use a little modeling as you paint. For the time being, forget about the trees that lie along the horizon.

Now, turn to the dark and heavy sky. Try using a mixture of cobalt blue and cadmium red with a little black and white added to it. To paint the lighter sky near the horizon, use a mixture of cerulean blue and white, and work around the clouds. While both the dark and light portions of the sky are still wet, blend them together with sweeping vertical strokes. You don't want an abrupt transition between the two areas.

Once the sky is completed, it's time to paint the clouds. Use a small brush to refine their shapes with white pigment, then build up their shadowy portions with a mixture of white and gray. To suggest the sun that lies behind them, add a little yellow ocher to white and gently accent the clouds. As a final step, paint in the trees that punctuate the foreground.

Handling Two Different Atmospheric Effects

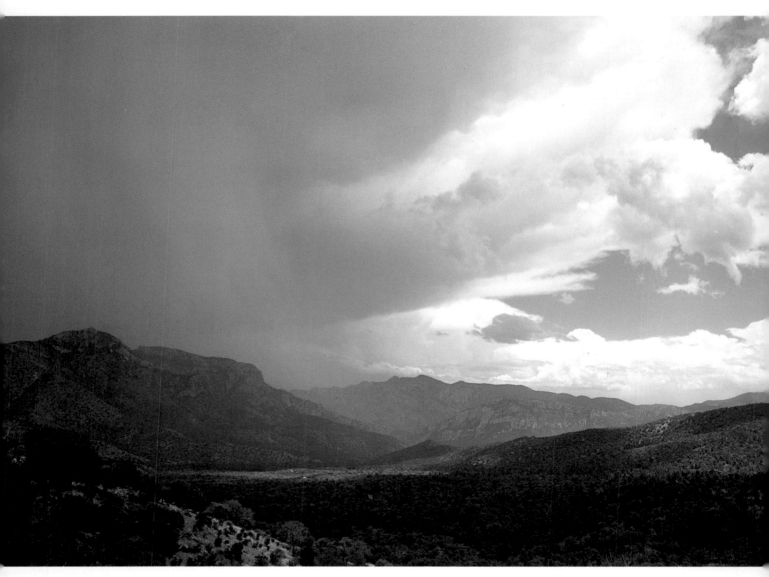

PROBLEM
Two distinct weather conditions appear in this scene—sunshine in the distance and a rainstorm in the foreground. Both must be captured simultaneously.

SOLUTION
Use different techniques to paint each of the two areas. In the foreground, work wet-in-wet to show how the rain softens edges. Paint the sun-filled mountains in the distance using shorter strokes.

In Arizona, sunshine brightens part of the sky while rain sweeps across the mountains.

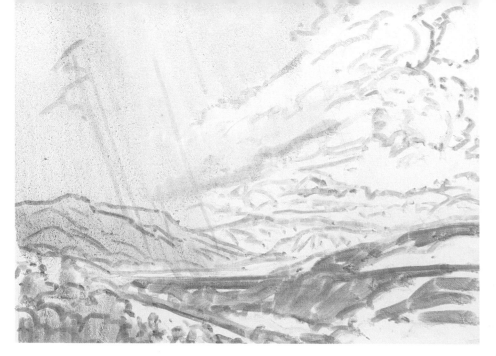

STEP ONE

With soft vine charcoal, sketch the composition, then blow gently on the canvas to remove any loose charcoal dust. Now redraw the main shapes with thinned pigment. Work with the colors that dominate each area of the painting. Here the hills in the foreground are brushed in with green, while the distant mountains and the sky are painted with purples and blues.

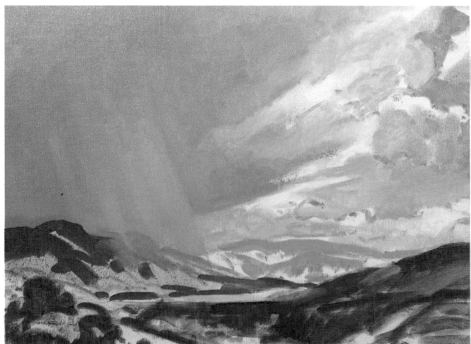

STEP TWO

With thinned pigment, establish the darkest areas of the painting. Once they're done, begin to work with thicker opaque pigment. First lay in the darkest areas— the dark green hills and purplish-brown mountains; then turn to the blue-gray mountains and the sky. While the paint is wet, pull the blue of the sky down over the purplish mountains to suggest how the rain comes sweeping over them.

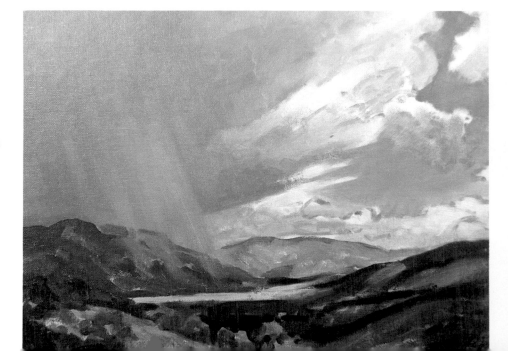

STEP THREE

In step two, you concentrated on the distant landscape. Now develop the foreground to keep the painting progressing evenly. Fill in the green hills that roll across the foreground and paint the sand-colored hills on the left. Then continue to build up the structure of the mountains. As you paint the purple mountains, be careful not to obscure the rainy effect you created earlier.

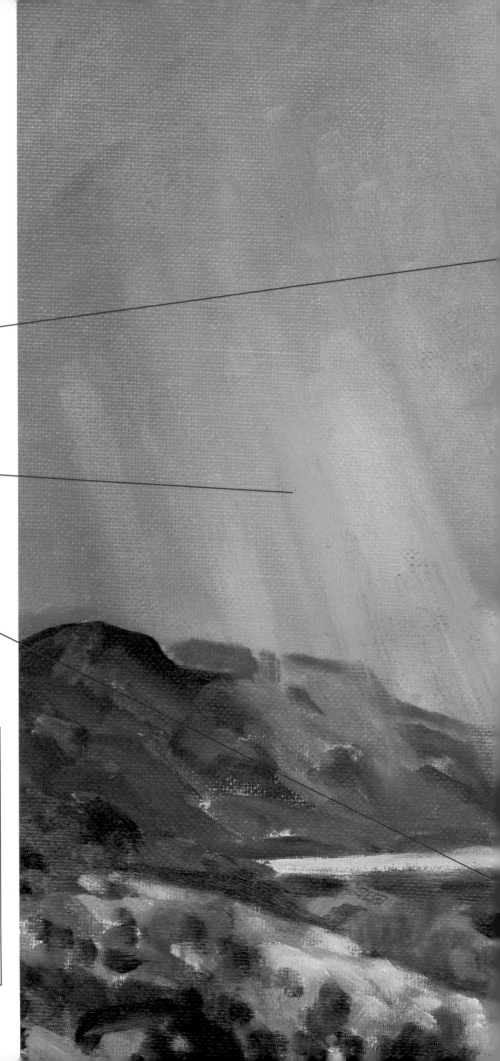

FINISHED PAINTING

To build up the clouds in the distance, take a small bristle brush and load it with white, then dab it against the canvas. The clouds that hover over the horizon are almost pure white; those close to the stormy grayish-blue sky are tinged with gray and yellow ocher. As a final step, look for any areas that still seem undeveloped. Here the immediate foreground was further built up with touches of bright green.

The bright white clouds that lie behind the dark storm front fit into the picture easily because they contain touches of the grayish tone that dominates the sky. A small amount of yellow ocher further tempers their brilliance.

Strong vertical strokes suggest the power of the rain that beats against the mountainside. When you want to create this effect, don't be afraid to use powerful brushstrokes; they are the key to mastering this technique.

To keep it from drawing attention away from the rest of the painting, the immediate foreground is rendered with loose, almost abstract strokes.

ASSIGNMENT

When you go outdoors, go armed with a sketch pad, and whenever you encounter an interesting configuration of clouds, stop and draw it.

Don't belabor your drawings. Work quickly, with loose, expressive strokes. Try to decipher the main shapes that make up the cloud formations. If you work quickly enough, you may even be able to do a series of sketches that traces the movement of a particular group of clouds across the sky.

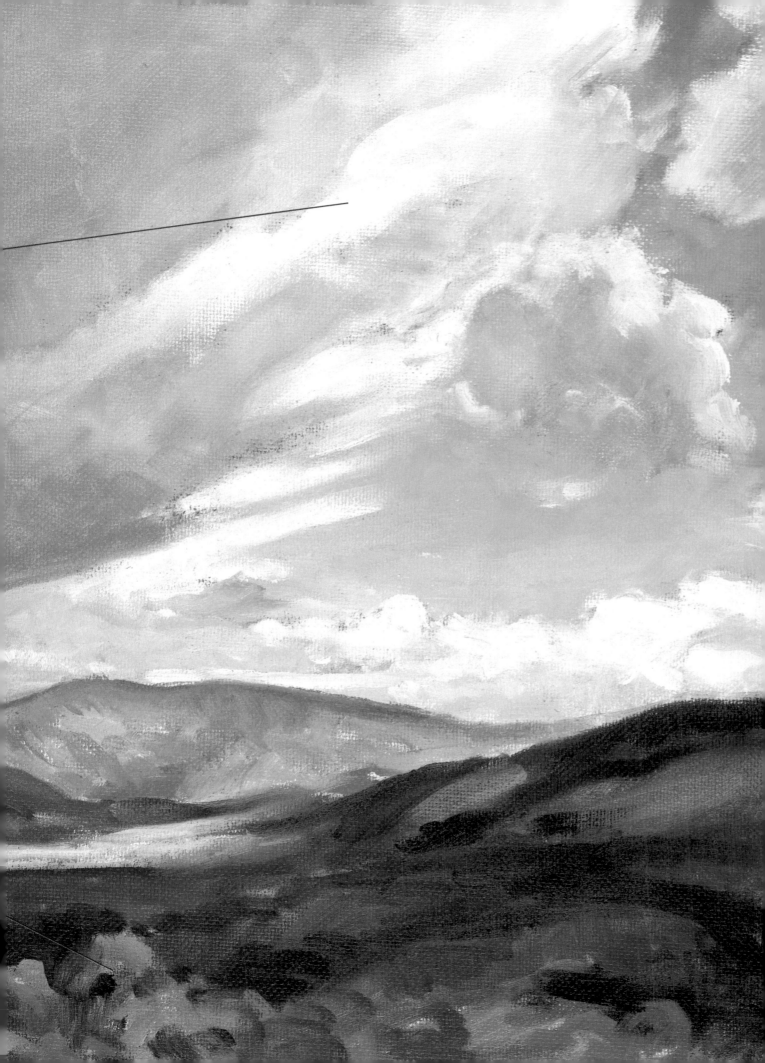

Working with Strong Lights and Darks

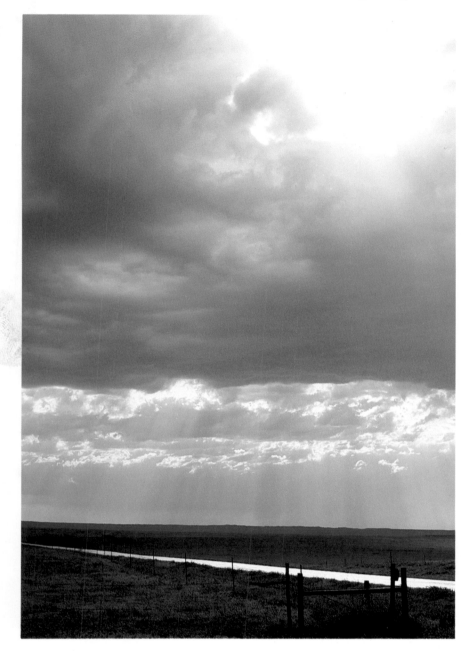

PROBLEM

The strength of this scene lies in the contrast between the dark, shadowy rain clouds and the rays of sunlight that break through them. Capturing these two very different atmospheric effects in one painting is very difficult.

SOLUTION

Play up the contrast between the darks and lights. If the darks are strong enough, they will increase the brilliance of the lights. In the final stages of the painting, infuse the scene with a warm, rosy tone to suggest the feel of sunlight after a storm.

STEP ONE

In your drawing, concentrate on the complicated patterns that the clouds form. Use loose gestures to capture how the clouds move about in the sky. Next, reinforce your drawing with thinned color, let the canvas dry, then lay in the dark areas of the sky and the foreground with a dull bluish-gray wash.

As storm clouds roll away, shafts of light break through and bathe the ground with soft color.

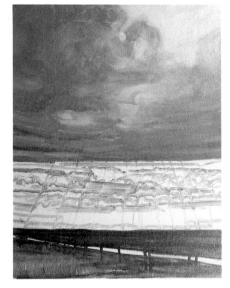

STEP TWO

For the time being, ignore the sun-filled portions of the sky. Instead, concentrate on the dark clouds and the foreground as you begin to work with thicker pigment. Use a big brush and a loose touch as you search for the shapes that the clouds form. Don't get too tight and controlled now; you can add as much detail as you want later on.

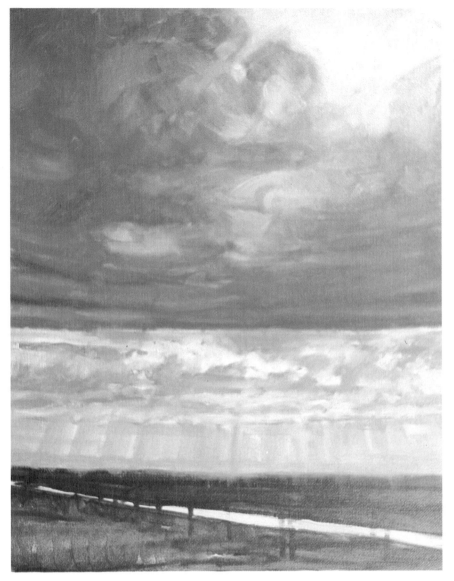

STEP THREE

Barely moisten your largest brush with dark bluish-gray paint, then scrub the color into the darkest areas of the cloud formation. Once the dark areas are clearly defined, add a little warmth to the blue-gray areas by gently scrubbing rose-purple pigment into them; be sure to scrub the dark and light edges together. Now turn to the sunny portion of the sky. With a small brush, lay in strokes of blue, leaving white areas for the clouds; near the horizon, add a strip of pale rose. While the paint is still wet, brush through the pigment to suggest the rays of light.

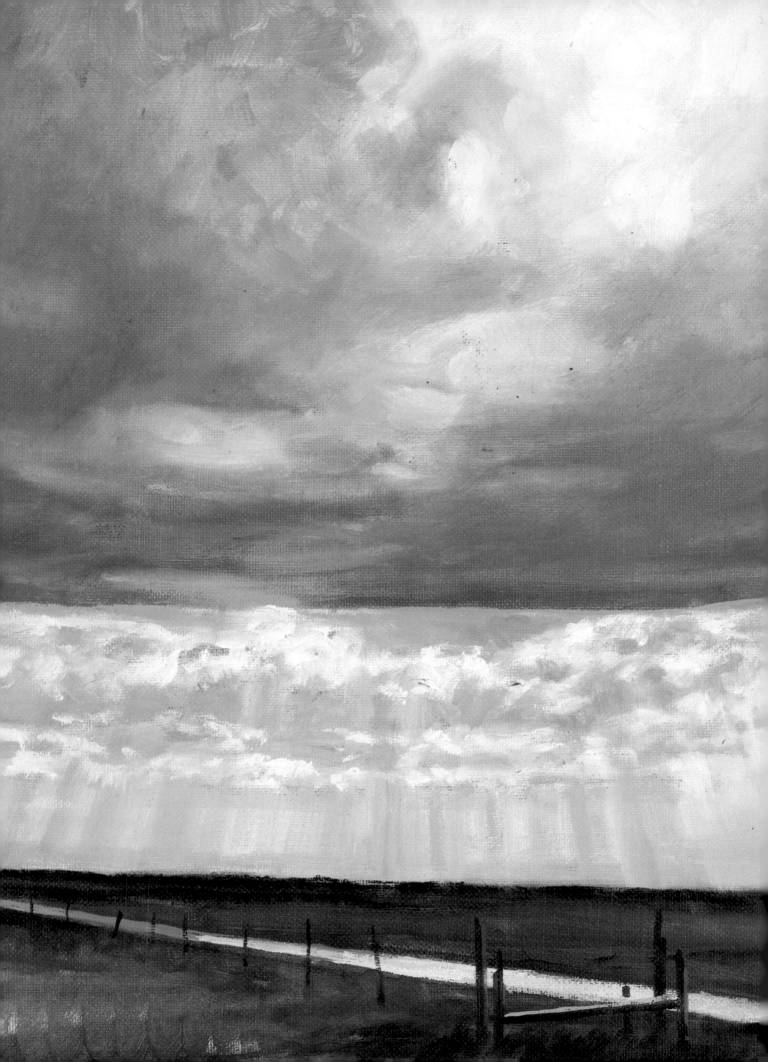

FINISHED PAINTING

Until the very end, the white of the canvas has represented the lightest, brightest areas of the painting. Now develop them. To paint the upper-right corner of the sky, mix together white and yellow ocher, then gently work it onto the canvas. Use the same mixture to lay in the small clouds near the horizon and the small stream that runs behind the fence. Finally, pull dark paint along the horizon line and add the fence posts and details in the foreground.

DETAIL

To capture the effect of light rays breaking through clouds, pull a dry brush through your wet paint. The light, white clouds are added later.

Mastering Unusual Light Effects

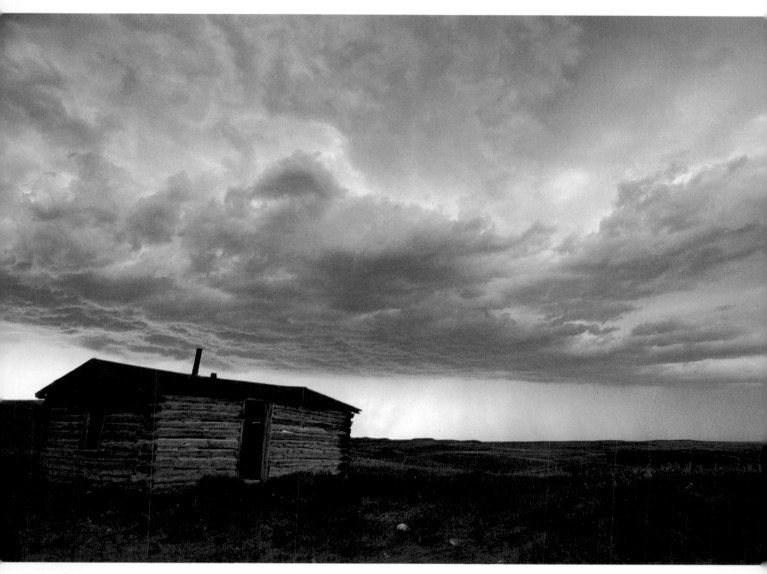

PROBLEM
The eerie light that washes over the ground is highly unusual; it stands in sharp contrast to the heavy storm clouds overhead. If something looks unlikely in nature, it will be doubly difficult to capture in paint.

SOLUTION
Pull the foreground and storm clouds together through the use of related colors. The yellow band of sky that runs between them will seem more likely if the rest of the picture is unified.

A lone cabin crouches against a prairie as dark, brooding storm clouds press toward the ground.

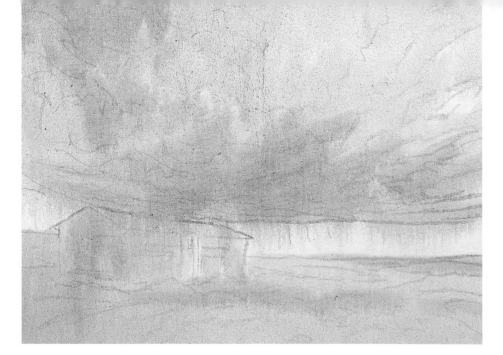

STEP ONE
Sketch the scene with vine charcoal, blow away any surplus charcoal dust, then fix your drawing with a spray preservative. Next, tone the ground and the cloud with a wash of light bluish gray to set the color mood of your painting. While the wash is still wet, pick out the light areas with a dry brush.

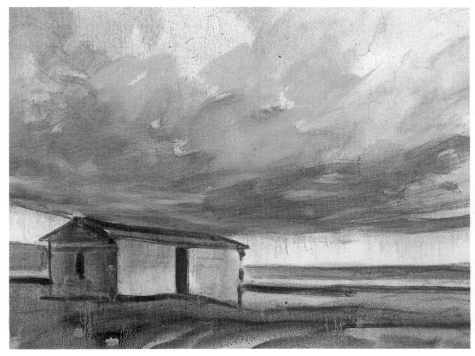

STEP TWO
Redraw the cabin and the patterns that lie in the foreground with a thin wash of burnt umber. Next, lay in the darks of the foreground and cabin with a slightly darker wash of burnt umber. Now turn to the sky. Using washes of cobalt blue and burnt umber, develop the dark undersides of the clouds.

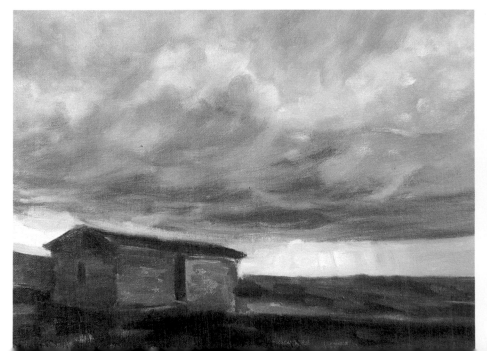

STEP THREE
Since the soft, heavy feel of the clouds is so important in this scene, you don't want to overwork the sky. As you begin to repaint the clouds with opaque pigment, try to get the exact colors and values that you want in your finished painting. Use loose, fluid strokes that follow the thrust of the clouds. Use loose strokes, too, as you complete the foreground. Finally, tinge the sky that lies along the horizon with pale grayish blue.

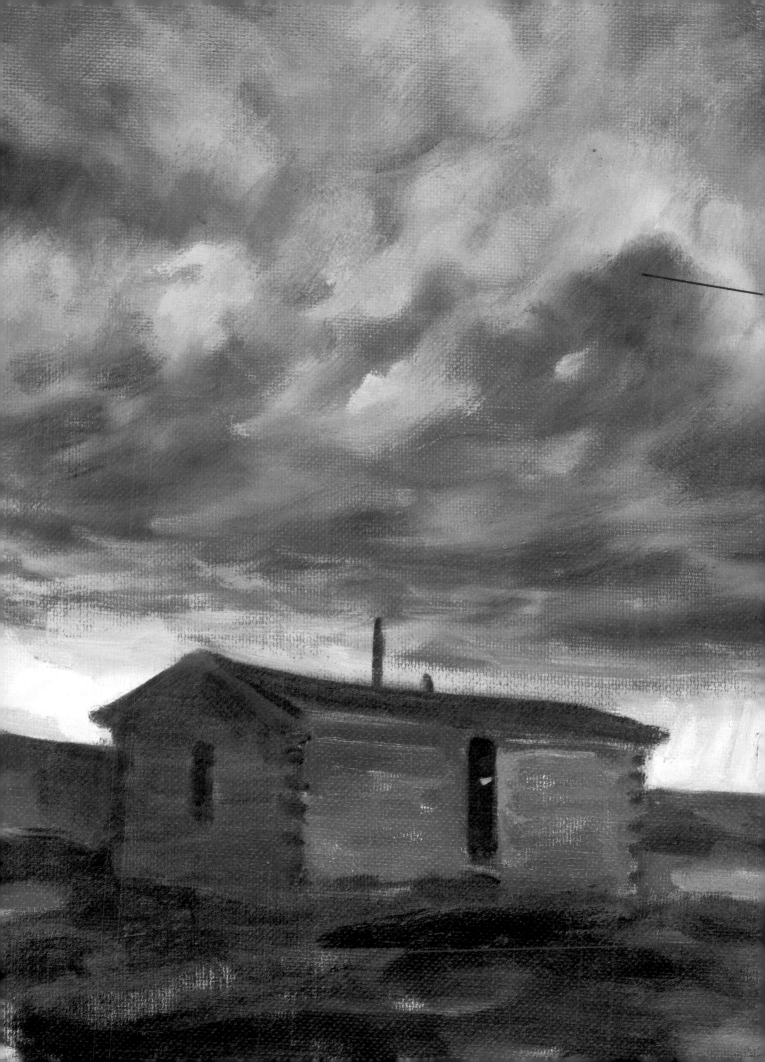

FINISHED PAINTING

Now that the darks are finished, you can easily gauge how strong the lights should be. Add a touch of yellow ocher to your white and gently paint in the remaining band of sky. Short, vertical strokes in the center of the composition get across the feel of the rays that break through the clouds and flood the ground with light.

Painted with loose strokes, the clouds have a soft, wet look—perfect for depicting a stormy sky. Note how overlapping applications of pale gray and dark gray tones are pulled together to avoid harsh transitions.

Not actually present in the scene, these rays of light were added to act as a visual bridge between the storm clouds and the foreground.

Both the foreground and the storm clouds are built up of burnt umber and cobalt blue. Because they are developed with the same colors, they pull the entire composition together.

31

Capturing the Abstract Beauty of Clouds

PROBLEM

The soft, ephemeral patterns that clouds form are tremendously appealing, yet there is really nothing to hang onto—each shape bleeds into the next.

SOLUTION

Follow whatever pattern exists, but don't become too literal. Instead, develop your painting as if you were dealing with an abstract subject.

☐ Work in a very direct manner. Right from the beginning, work with opaque pigment.

Analyze the sky: Are some areas lighter than others? In some places, can you see touches of violet or even yellow? Load your brush with the color that dominates the sky—very pale gray—then sweep the paint over the canvas. Now begin to add touches of lighter and darker pigment. You'll find that Mars violet is perfect for achieving the soft rosy color that washes over portions of the sky and that yellow ocher can warm up your grays. As you add new colors, don't increase or decrease your values radically; you'll find that the slightest change in value will stand out clearly against the soft, undifferentiated ground that you laid in at the start.

In late February, stratus clouds teem together, filling the sky with abstract patterns.

ASSIGNMENT

As you'll discover in this book, skies are rarely pure blue, yet beginning painters tend to render them with just blue and white. Experiment with other colors. Prepare your palette with a range of blues—cobalt, cerulean, and ultramarine—as well as the expected white. Next to these hues, place yellow ocher, alizarin crimson, cadmium red, Mars violet, burnt umber, and thalo green.

For several days in a row, force yourself to use at least two colors other than blue whenever you paint a sky. Don't think that you have to use these unexpected colors full force; experiment with using just touches of them. For example, when you confront a cloudy sky, use Mars violet and burnt umber for the shadowy portions of the clouds. Or, on a sunlit day, warm the sky with a touch of cadmium red. You'll find that while your skies still *look* blue, they have a new excitement to them.

Using a Wet-in-Wet Technique to Depict Backlit Clouds

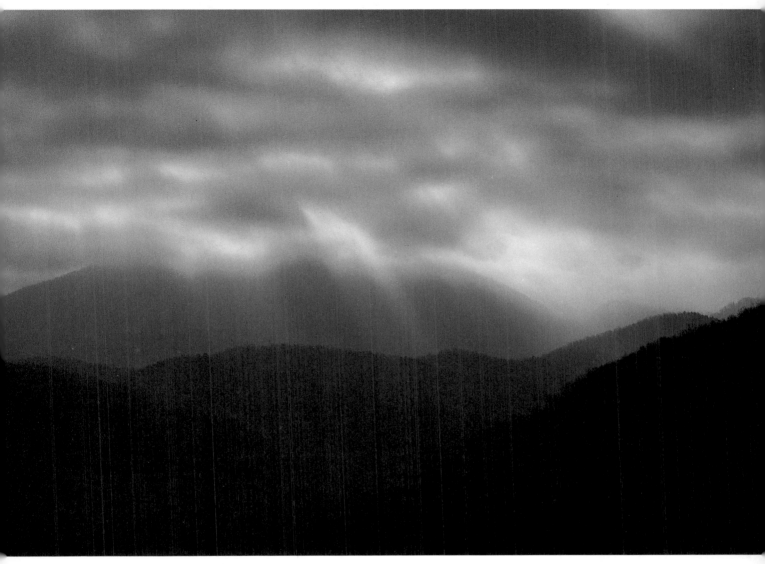

PROBLEM
There's a lot of color to these fog-covered clouds; behind them lies a brilliant sunset. You'll want to capture the effect of the fog but give the clouds a warm, rosy glow as well.

SOLUTION
Paint the sky with overlapping layers of color worked wet-in-wet to maintain a soft, gentle feel. Even in the darkest areas—the hills in the foreground—put plenty of color into your darks.

In late winter at sunset, fog shrouds the gently rolling Smoky Mountains as light breaks through the thickly layered clouds.

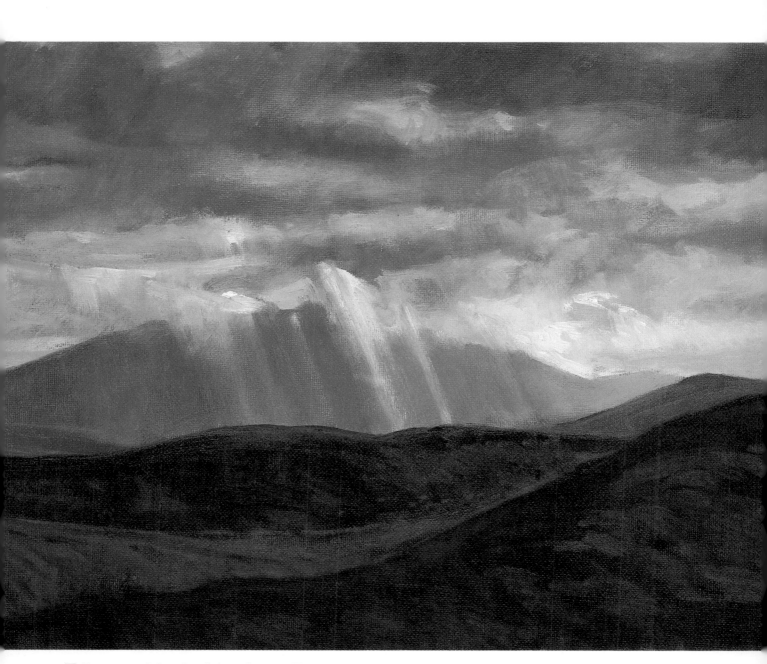

☐ Because of the simplicity of the scene, draw it directly with a brush dipped into thinned paint. Next, working with broad, loose strokes, lay in the darks of the foreground and the sky, again using thin washes of color. At this point your strokes shouldn't be too definite; what you want to capture is the general pattern of the darks.

Once the major darks have been established with turp washes, build up the foreground with opaque pigment. Keep the hills very dark, but make sure they have plenty of color in them.

Here, the use of cobalt blue, alizarin crimson, and violet brightens up the hills and keeps them from becoming too flat. As soon as you've completed the hills in the foreground, paint the distant mountain. Use the same basic mixture of cobalt blue, alizarin, and violet, but lighten it with white and add a touch of thalo green to gray it down.

Now turn to the part of the painting that matters most—the sky. Work from dark to light and wet-in-wet, applying the paint with a big bristle brush. Every time you introduce a new color, carefully work the new tone into

those that surround it. Here, the dark bands that run through the sky are painted with cobalt blue, cadmium red, and white. The light that breaks through the clouds is rendered with cadmium orange and pale yellow ocher.

Once the sky satisfies you, take a fairly dry brush and stroke pale golden paint over the canvas to indicate the shafts of light that fall over the distant mountain. Then, as a final touch, add small strokes of pale gold throughout the sky, and—if necessary—refine the silhouettes of the hills in the foreground.

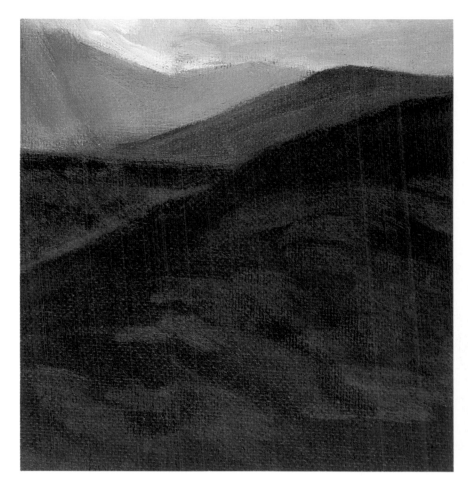

DETAIL
Although they are very dark, these hills are packed with color. Note the rich bluish tinge that runs through the middle hill and the strong red tone that washes across the hill in the immediate foreground.

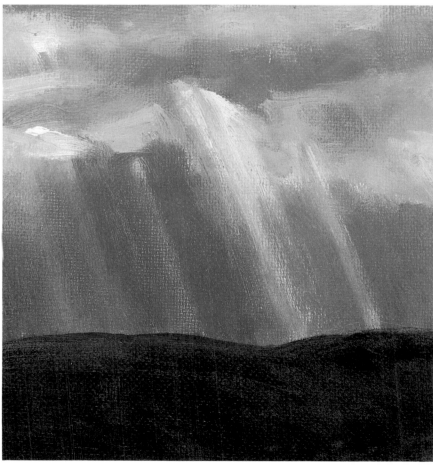

DETAIL
Painted at the very end, these rays of light suggest the brilliance of the setting sun that lies behind the clouds. Touches of pale gold along the horizon achieve a similar effect.

Learning How Light Interacts with Rain

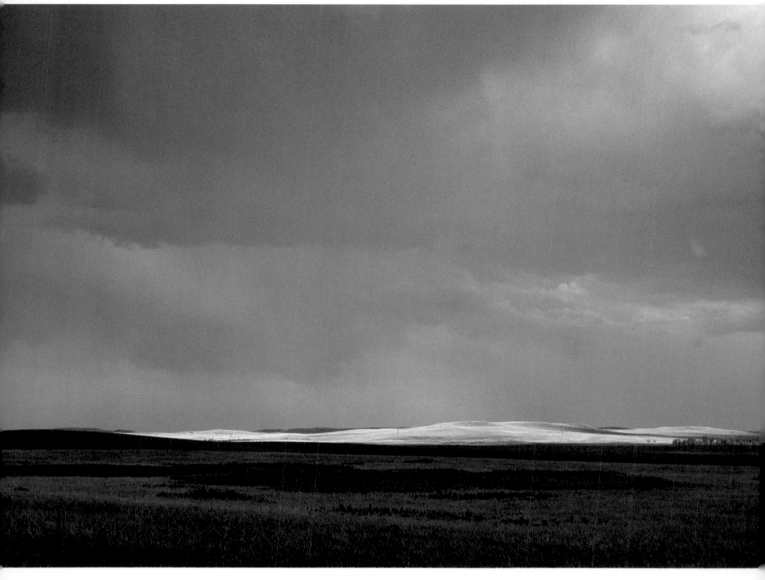

PROBLEM

In summer, the weather can change almost instantly. One moment it may be sunny, then the next moment it may begin to rain. Capturing two weather conditions in one painting is hard.

SOLUTION

When you confront interesting and odd weather conditions, don't be afraid to paint them. Get down the basics of the scene on your sketch pad, adding plenty of color notes; then when you return home, go to work.

☐ There's nothing fancy about this composition; the lighting and the odd atmospheric conditions are what you want to capture, so don't spend too much time on your sketch. Once you've drawn the basic shapes that make up the scene, develop them with thin turp washes. For the time being, the white of the canvas will represent the light-washed hill in the distance.

Next, working from dark to light, repaint the sky with heavier, opaque color. Lay in your pigment rapidly, and soften any

As rain falls gently across a Midwestern prairie,
warm summer sunlight illuminates the distant horizon.

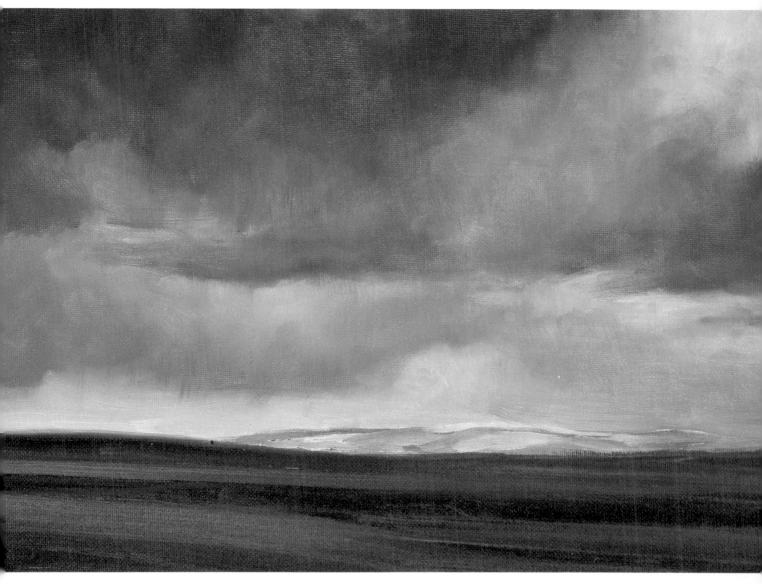

harsh edges carefully. As you brush in the sky, use vertical strokes to suggest how the rain pours down over the prairie. Here the sky is rendered with a rich mixture of cobalt blue, ivory black, and white, with cadmium red added in some areas.

When you have completed the sky, turn to the dark foreground. To capture the dark, rich shadows cast by the rain cloud, you want the ground to be dark, but don't let it become too black. Also important is the subtle modeling that conveys the roll of the hills.

In this painting, the foreground is painted mostly with thalo green and burnt sienna.

Once the dark sky and foreground are down, turn to the light-filled band that separates the two areas. This area is crucial: If you remember that it's really only a tiny strip of light, bright color, you won't be tempted to make it more dramatic than it really is. Take a medium-size bristle brush and quickly stroke your yellow paint over the canvas, then add modulations with small touches of green.

ASSIGNMENT
In this book the focus is on skies, and when you've gone through the lessons, you'll feel confident whenever you approach a new skyscape. But don't let what you learn here stop with paintings that just concentrate on the sky.

Flip through the pages of this book to find skies that would be at home in your landscape paintings, then use them. Soon you'll discover how to use your imagination as you construct your paintings and how to use skies as compositional devices.

Capturing the Subtle Beauty of a Rainbow

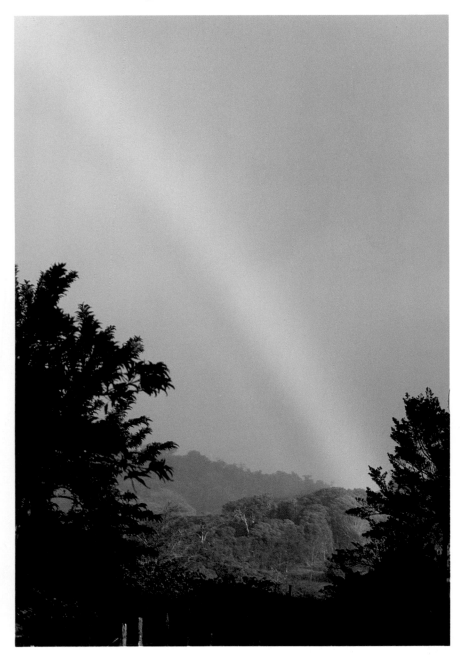

PROBLEM

It's easy to overpaint a rainbow and make it garish. If its colors are too bright, you'll lose the rainbow's fragile delicacy.

SOLUTION

To keep the edges of the rainbow soft and misty, use a wet-in-wet approach. Soften the rainbow still further by running a fan brush over it while the paint is still wet.

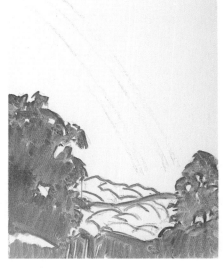

STEP ONE

Sketch the scene with soft vine charcoal, then blow on the canvas to get rid of any surplus charcoal dust. Reinforce the drawing with thinned color, then freely brush in the dark trees that are silhouetted in the foreground, using a wash of thalo green. As you paint the trees, be sure to leave some areas white to represent the patches where the sky breaks through the leaves.

In early spring, a rainbow arcs gracefully across a pale blue sky.

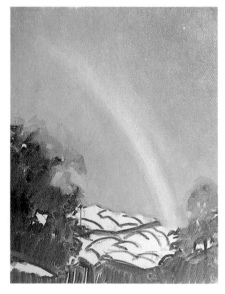

STEP TWO

With heavier opaque paint, lay in the sky, taking care to capture the subtle shifts in color and value that occur. Here it's primarily painted with white and cerulean blue; in places, touches of cadmium red are used to gray down the brilliance of the blue. As you paint, avoid the area where the rainbow lies. Now, while the sky is still wet, add the rainbow. To capture its pure color, use pigment straight from the tube, softened with just a bit of white. Begin with cerulean blue, then shift to cadmium yellow, then finally add cadmium red. As you add the yellow, keep it clean. If you aren't careful in laying it in, it will mix with the blue and form green. Don't apply too much pigment—you want the color to be thin and translucent. To soften the colors still further, run a fan brush over the rainbow while the paint is still wet.

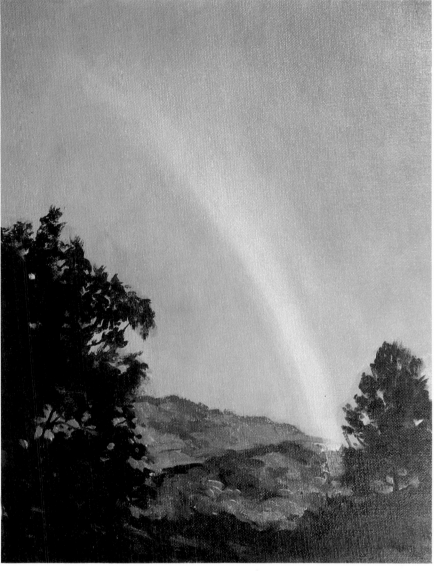

STEP THREE

Repaint the trees in the foreground with thicker, denser pigment. Try mixing together thalo green and burnt sienna; you'll find that they produce a very dark, rich green. Use short, broken strokes to capture the crisp, staccato feel of the trees and be sure to indicate the areas where the sky and the distant hills break through the dense foliage. To render the hills in the background, continue to use short, broken strokes with yellow-green and blue-green pigments. When the background is complete, quickly add the fence posts that appear in the foreground.

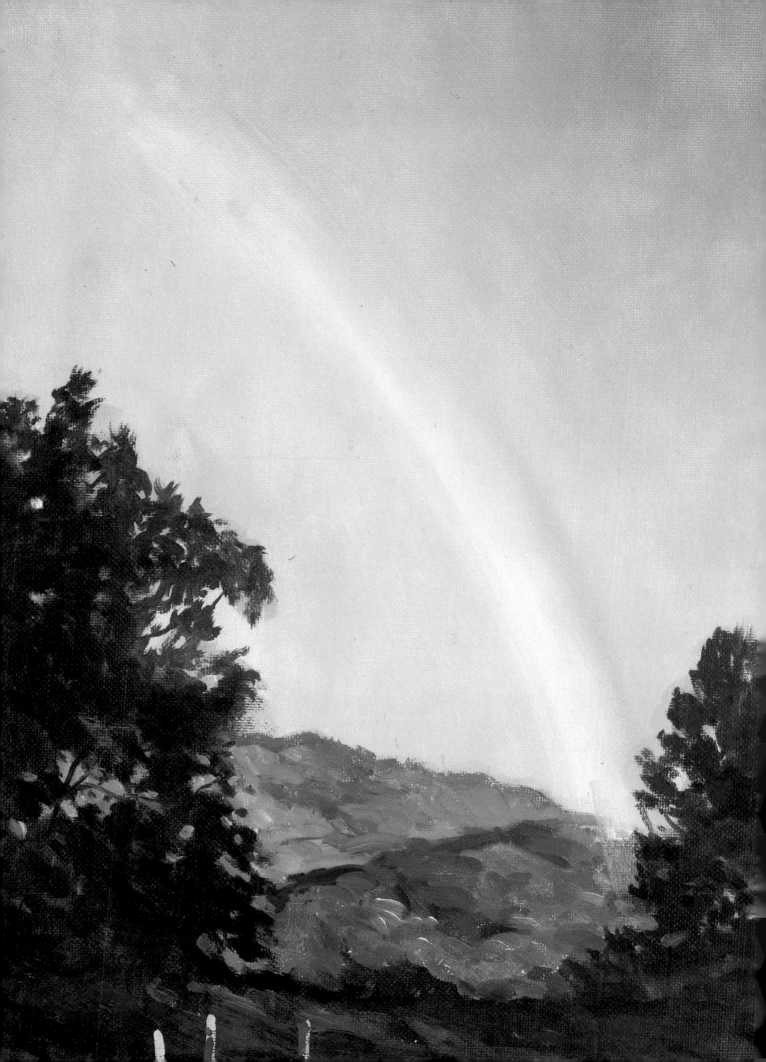

FINISHED PAINTING

In the finished painting, the strong shapes that dominate the foreground forcefully direct the viewer into the scene. The dark values in the front of the picture plane give way to slightly lighter values in the middle ground; the most distant hill is lighter yet, establishing a clear sense of depth.

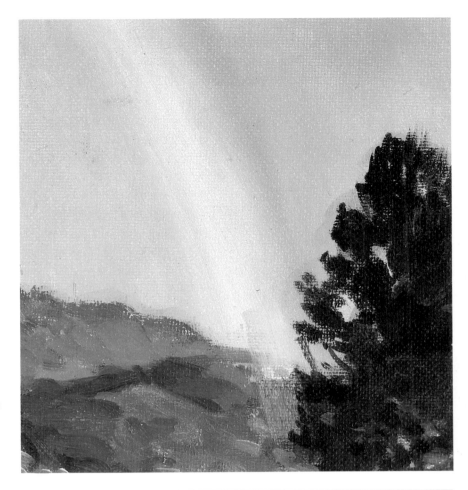

DETAIL

As a final step, bright cadmium yellow pigment was added to indicate the base of the rainbow, which had been obscured when the distant hills were painted. The pigment was rapidly pulled up the canvas to maintain a translucent effect, leaving the hill clearly visible through the patch of yellow.

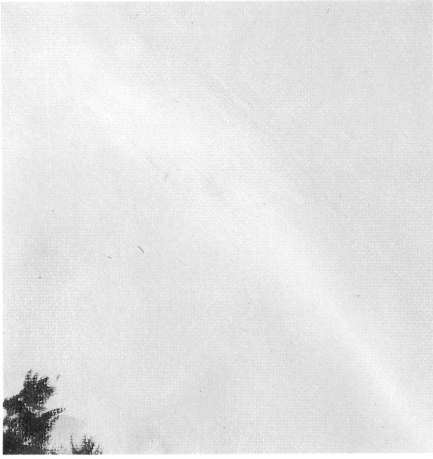

DETAIL

Seen up close, the pale colors that make up the rainbow rest effortlessly in the sky, the result of working wet-in-wet. To get rid of any brushstrokes that might interfere with the rainbow's soft, diffuse feel, a fan brush was run over the rainbow's arc while the paint was still wet.

Working with Strong, Brilliant Color

PROBLEM
The golden light that permeates this scene is very strong; it tinges every area with color. Furthermore, the colors at play are all closely related in value.

SOLUTION
To infuse your painting with an overall glow, stain the canvas with a rich wash of golden yellow. As you build up the surface, work wet-in-wet to capture the soft feel created by the fog.

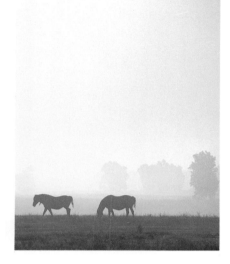

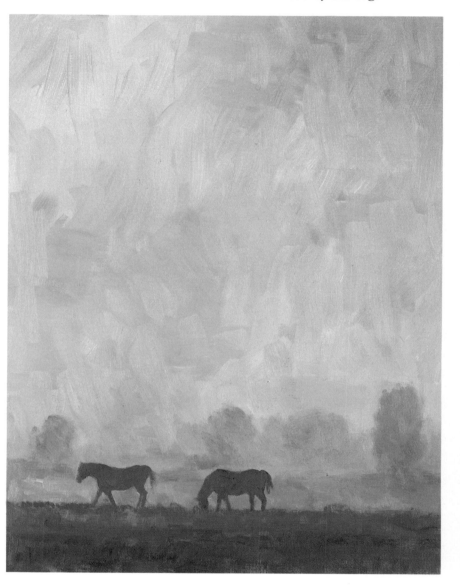

Just after sunrise, two horses graze peacefully, bathed by the deep golden light that breaks through the early morning fog.

☐ Lay in the basic lines of the composition with vine charcoal, then spray the canvas with a fixative. Once it's dry, tone the entire surface with a wash of cadmium yellow; the wash must be thin enough to let the drawing show through.

Immediately begin using heavier pigment. Don't be afraid to use brilliant yellow for the sky; if you add too much white to your pigment, you won't capture the strength of the early-morning light. To add interest to the simple foggy sky, use bold, crisp brushstrokes as you lay in the paint with a medium-size bristle brush. Let slight variations in color occur; take care, though, to brush each area into those that surround it, so no sharp edges show up in your painting.

Before you turn to the horses and ground, take a moment to analyze the sky. Are there jumps in value that seem too sudden? Are some of your yellows too pale? Make any necessary adjustments, then lay in the soft, shadowy trees along the horizon.

To complete the canvas, paint in the golden-brown foreground and the two horses. Mix plenty of yellow into your browns to relate these accents to the dominant area in the composition, the sky. Animate the grassy foreground by alternating bold brushstrokes with gentler, smoother passages of paint. Finally, when you paint the horses, don't get caught up in detail. Silhouette them boldly against the sky and you'll capture how they stand veiled by the morning light and fog.

DETAIL
The trees that lie shrouded by the fog are laid in mostly with the same gold that makes up the sky. A mere touch of brown darkens the cadmium yellow, relating the trees to the surrounding sky. In the sky, a rich mosaic of brushstrokes breaks up what could easily become a tedious stretch of unrelieved yellow.

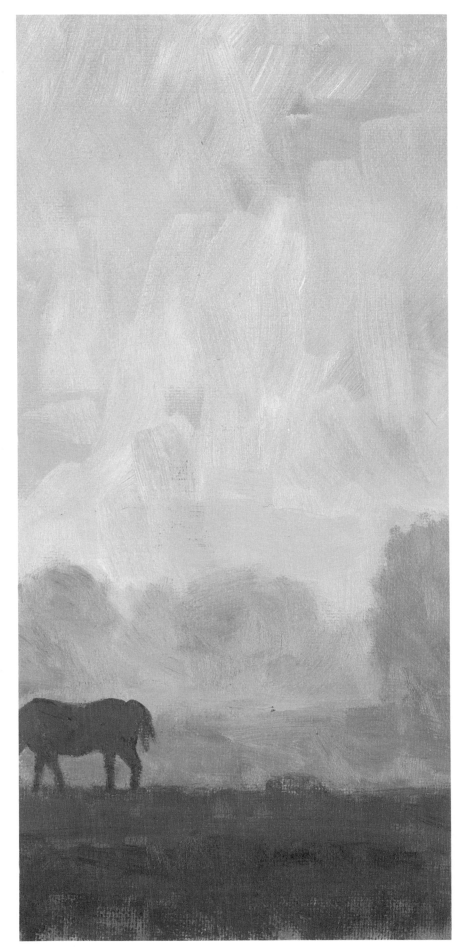

Capturing the Drama of Sunrise

PROBLEM
Because of the simplicity of this scene, and because of the unrelieved curtain of orange that washes across the sky, it's going to be hard to make your composition interesting.

SOLUTION
Treat the sky as an abstract subject, concentrating on subtle variations in its color and value. Make the color most intense at the top of the painting; toward the horizon, lighten it slightly to suggest the still-hidden sun.

☐ When a scene is this simple, there's no need for a preliminary drawing. Instead, turn immediately to the sky. Don't mix a great deal of color all at once; to get the subtle shifts in hue and value that you want, it is far better to mix many small batches of paint.

Take a large bristle brush, load it with the paint on your palette, then begin to tackle the sky. Start

At sunrise, a lone tree stands silhouetted against a brilliant orange sky.

at the top of the canvas and gradually work down toward the horizon. At the top, work with pure reddish-orange. As you move downward, gradually decrease the strength of the red. Near the horizon, use almost pure orange. Within each portion of the sky, let small variations in color occur. Remember: The sky has to have enough interest to carry the whole painting.

When the sky is complete, let the canvas dry. Once the surface is dry, sketch the lone tree and the horizon line. Try to render the shape of the tree as accurately as possible; it's the only accent in the painting, and consequently, it's very important. When you start to paint, use short, broken strokes to separate the tree visually from the sky. Use broken strokes, too, to lay in the foreground.

At the very end, you may find that the sky is too orange. To pull the entire painting together while you decrease the intensity of the orange, try using a glaze. Here a very thin glaze of alizarin crimson was applied over the entire surface—sky, tree, and foreground. The result: a rich, unified painting, one that truly captures the drama of sunrise.

Learning How to Exaggerate Slight Shifts in Value

PROBLEM
This composition is fairly simple, yet it does contain potential drama. The trees are partially cast in shadow and partially bathed with sunlight, and they stand aginst a clear, undifferentiated sky.

SOLUTION
The contrast between the trees and the sky is what makes this subject interesting, so emphasize it. Keep the shapes simple, and exaggerate the stark feel of the dead trees against the bare sky.

A clear, deep-blue summer sky acts as a dramatic backdrop for the spindly, dead branches of these cottonwood trees.

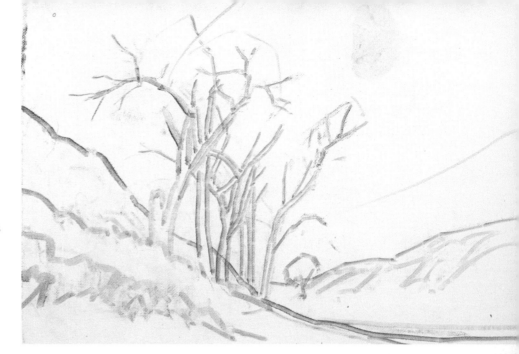

STEP ONE

Because this scene is relatively simple, there's no need for a charcoal sketch. Instead, dip a bristle brush into thinned raw umber and draw in the major lines of the composition with the edge of the brush. Your oil sketch should be fairly dark so that you can see it throughout the early stages of the painting. Remember, strong drawings can help you paint strong paintings.

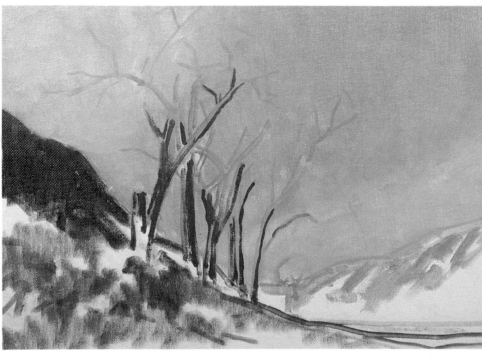

STEP TWO

Now establish major values and shapes. Begin with the very darkest area—the hill on the left. Once it's down, you can use it to gauge the strength of the rest of your values. Here it's painted with thalo green and burnt sienna. Next, lay in the blue of the sky. To capture the golden outcropping of ground on the hill in the background, use yellow ocher. The bright patches of grass are rendered with permanent green light. Finally, begin to build up the tree trunks.

STEP THREE

Now step up the drama of the sky. Using a scrubbing motion and an almost dry brush, work the blue pigment onto the canvas. Right behind the trees, increase the strength of the blue. This deep, rich color will act as a foil for the light branches of the trees. Now develop the grassy hillsides and the shadows that fall on the foreground.

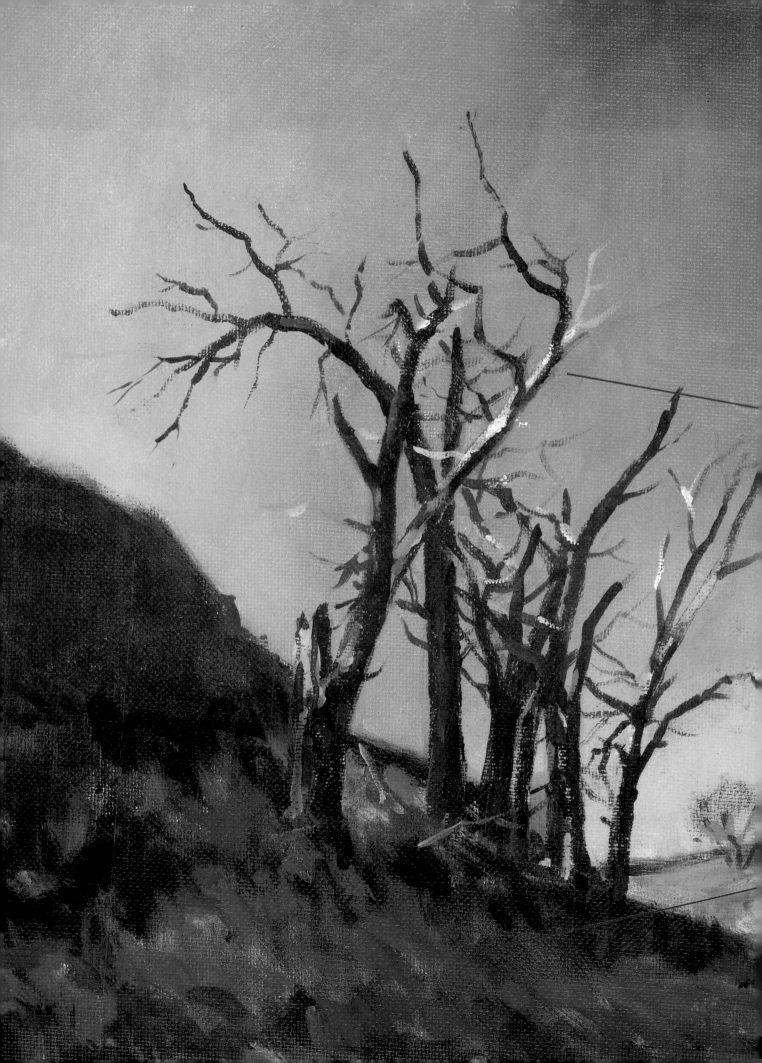

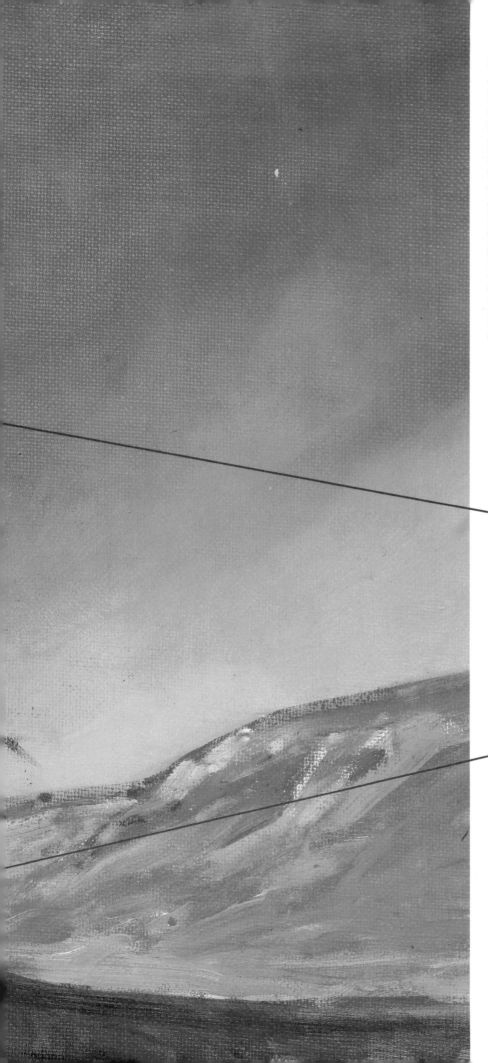

FINISHED PAINTING

After the paint has dried slightly, tackle the trees. Use deep, rich color to render the dark branches, and light brown and pure white for the highlights. Exaggerate both the lights and the darks to add emphasis to the trunks and branches, the focal point of your painting. When you begin to paint the terminal branches, use a brush that has been barely moistened with paint. Run it quickly over the canvas to achieve the rough, unstudied look you see here. As a final touch, refine the patterns that spill across the foreground.

The deep, rich blue of the sky acts as a foil for the dark and light branches. And because the sky is lighter toward the periphery of the canvas, the pool of deep blue in the center directs the viewer to the painting's focal point, the trees.

The grassy slope in the immediate foreground is painted with strong, rough strokes. The color of the grass is exaggerated, too; here it is much darker than it actually appears. The dark diagonal that results also acts as a compositional device to invite the viewer into the painting.

49

Selecting a Focal Point

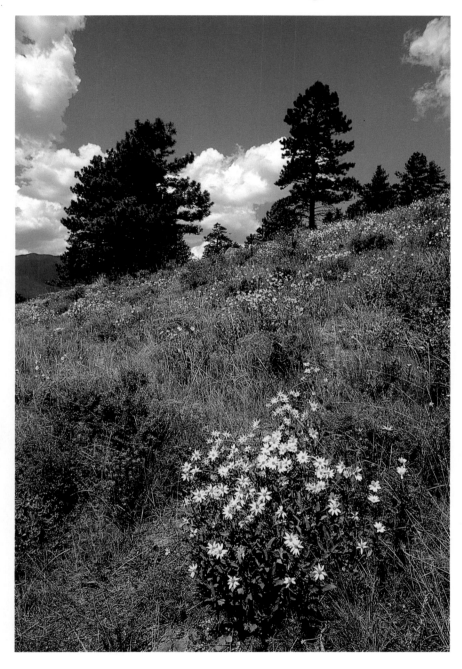

PROBLEM

Many elements are fighting for attention here. The bright yellow flowers in the foreground are tremendously appealing, but so are the trees and the clouds. Everything can't be given the same importance.

SOLUTION

Simplify the trees, then use the flowers as a compositional device to lead the viewer back to the dramatic cloud-streaked sky.

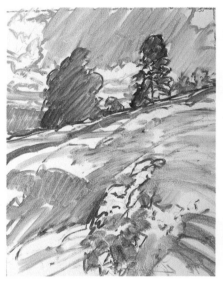

STEP ONE

Sketch the scene with vine charcoal, then reinforce your drawing with thinned color. Use thin color washes to establish the dark patterns that play over the scene—the trees and the shadowy areas of the hillside. This stage sets the overall design of your painting, so stop and analyze the lights and darks before you begin using washes. Complete this stage with a medium-blue wash for the sky.

As clouds sweep across the sky, golden asters decorate a hillside crowned with stately conifers.

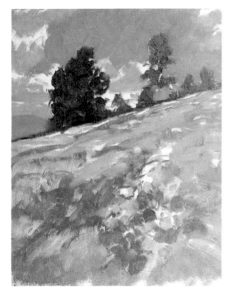

STEP TWO

Begin by laying in the trees; they are the darkest elements in the painting and you can use them to judge the rest of your values. For the time being, the whites of the clouds will represent the lightest areas in the painting. Next, turn to the sky. Keep in mind that because the hillside hides the horizon, you are looking at the darkest, richest part of the sky; so-make it fairly dark. Also add pale-blue shadowy areas to the clouds. Finally, build up the foreground. Let your brushstrokes suggest the rhythmic way the hill slopes upward.

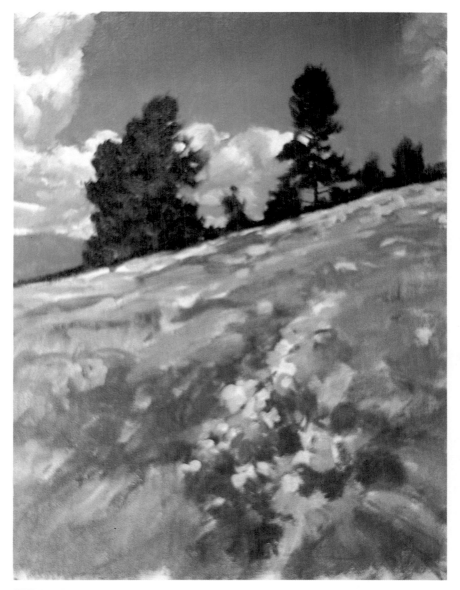

STEP THREE

Now build up the clouds. White will, of course, form their base, but don't be afraid to accentuate their shadowy areas with pale and medium shades of blue. Once you begin work on the clouds, you may want to intensify the blue of the sky. Next, finish the trees that hug the hillside.

FINISHED PAINTING

Strengthen the undersides of the clouds with a dull gray hue, then turn to the foreground. Don't get too concerned with detail; if you do, you'll lose the sweep of the hillside and the drama of the flowers. To keep your touch loose, work with a medium-size bristle brush. Search for the patterns—not the details—that run over the hillside. Use the bright yellow of the flowers as accents to further suggest how the hill slopes upward.

DETAIL *(right)*

The distant hill is rendered with a cool shade of purple—a great choice when you want to suggest vast distance. Note, too, how the simplified silhouette of the tree stands out clearly against the cloudy sky.

DETAIL *(below)*

The flowers may be what you concentrate on here, but they are certainly not painted in elaborate detail. Instead, quick, fluid strokes executed with a good-sized bristle brush suggest the sweep of the hillside and the drama of the golden asters.

ASSIGNMENT

Capturing the three-dimensional feel of clouds is one of the most difficult aspects of painting skies. It needn't be so.

Practice painting clouds at home before you tackle them outdoors. Select pictures of cloud-streaked skies from a book or magazine. Search for the shadowy areas that sculpt out the structure of the clouds. As soon as you feel comfortable with a particular scene, paint it.

You'll be executing studies—not finished paintings—so don't agonize over your choice of colors or your brushwork. Instead, work rapidly, aiming at an approximation of the colors and values that lie in the sky. Try using unexpected colors for the shadows—grays, violets, yellows, and even reds.

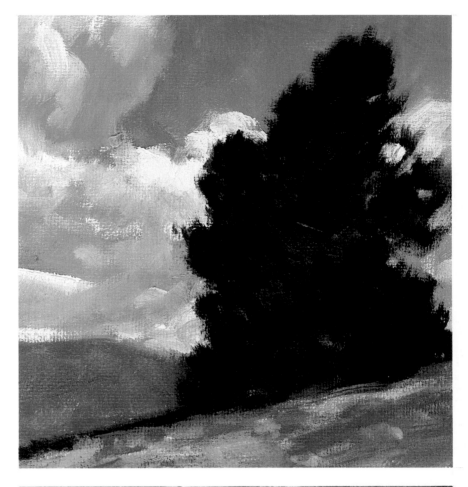

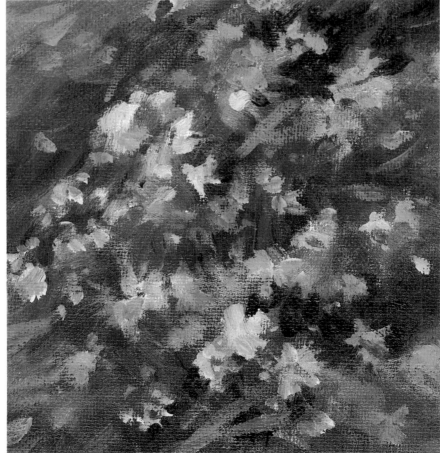

Exploring the Reflections That Clouds Cast in Water

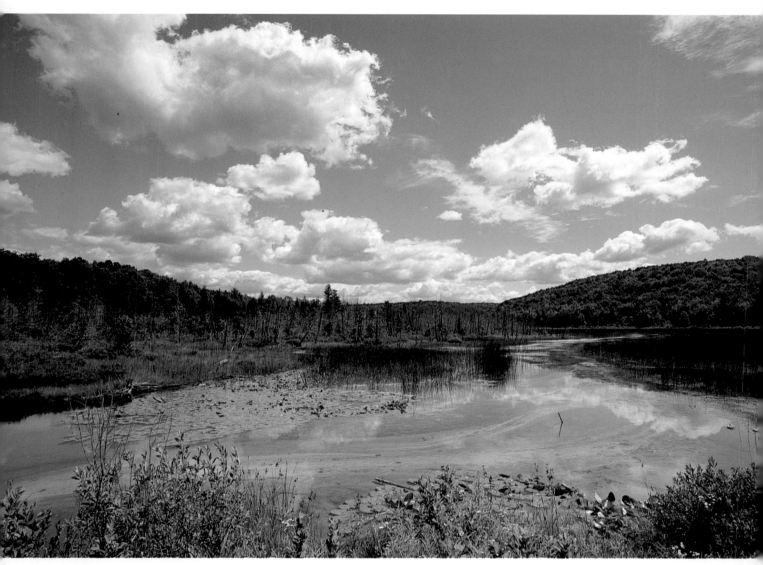

PROBLEM
In the sky, the clouds are lit from behind, making them the brightest element in the painting. The rest of the scene, including the reflections in the water, are darker and somewhat shadowy.

SOLUTION
Don't treat the water like a mirror by making the reflections as bright as the actual clouds. Instead, carefully depict what you see and render the water with darkish hues.

In July, soft fluffy clouds float lazily over the slowly moving waters of a stream.

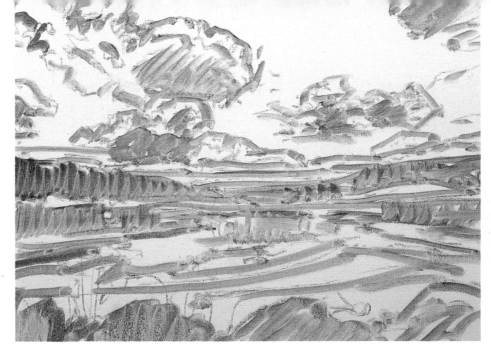

STEP ONE
Before you touch the canvas, analyze the composition. Note how everything—the water, the trees, and the reflections—sweep back toward the horizon. Sketch these major directional lines and the shapes of the clouds with charcoal, then reinforce your drawing with thinned color. Finally, begin to develop the darks, again working with turp washes.

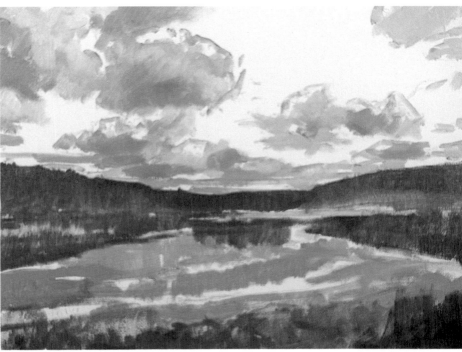

STEP TWO
Continue working with thinned color as you establish the overall color and value scheme. Start with the darkest area—the line of distant trees—then judge your other values against this dark accent. When you begin to paint the water, don't be afraid to use a strong, dark blue. Use a bright green for the vegetation in the water. For the time being, let the white of the canvas represent your lights—the clouds, the sky, and the reflections.

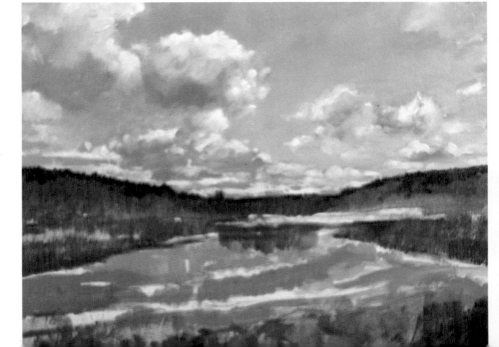

STEP THREE
Now it's time to work with thick, opaque pigment. Begin with the sky; lay in pure brilliant blue, then adjust the values of the clouds in relation to it. Note how, in many places, the shadowy portions of the clouds are actually darker than the sky. Next repaint the dark line of trees along the horizon.

FINISHED PAINTING

Now refine your work. Start with the water; mix together white and blue pigment, then gently add the reflections that are cast by the clouds. Use the same mixture of light blue paint to pull together the rest of the stream. Once the water is done, stop and evaluate your values. Here the painting was too light overall, and both the receding trees and the shadowy portions of the clouds had to be darkened. As a final touch, add bold touches of bright green to the immediate foreground.

In the clouds, strong, brooding grays contrast sharply with the crisp, brilliant white. Don't be afraid to paint strong, definite shadows when you are rendering clouds. They'll not only sculpt out the shapes of the clouds, but add a dramatic note to your paintings as well.

Added after the rest of the painting was developed, the reflections in the water are rendered with soft, delicate strokes. If they were painted more literally, they would steal attention away from the cloud-streaked sky.

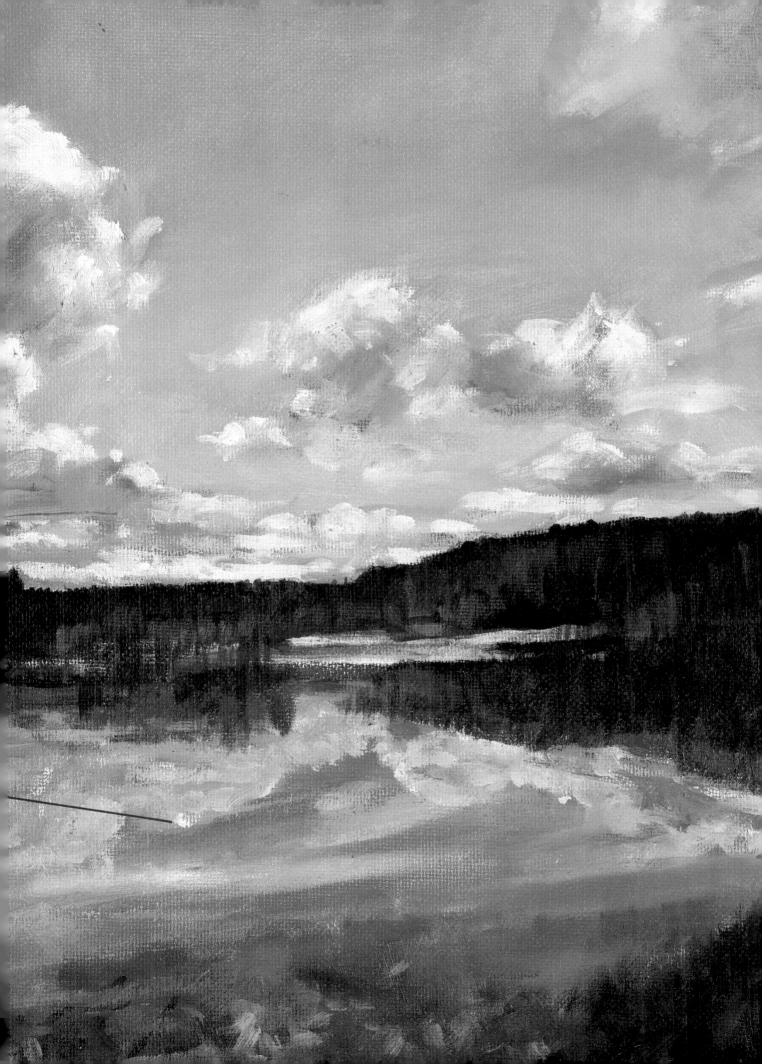

Learning How to Paint Dense Masses of Clouds

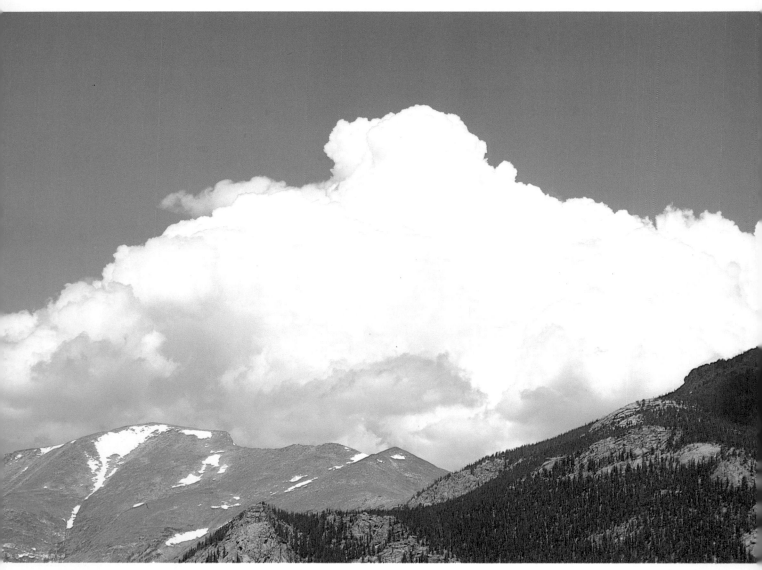

PROBLEM

The shape of the cloud mass resembles the shape of the mountaintops. This kind of similarity can result in a strong composition, but only if you carefully capture the individuality of both the clouds and the mountains.

SOLUTION

Emphasize the differences between the clouds and the mountains. First make the clouds look soft and lush. When you paint the mountains, use thick, heavy paint and strong, gutsy strokes.

In late summer, massive cumulonimbus clouds press down over the mountaintops, signaling an approaching storm.

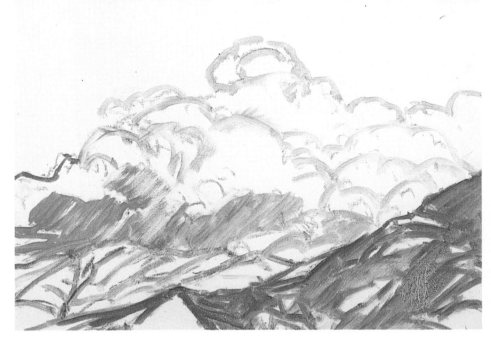

STEP ONE

Sketch the scene with vine charcoal, then dust off the canvas. With a small brush, redraw the scene with thinned color. Continue working with thinned color as you brush in the darks of the mountains in the foreground.

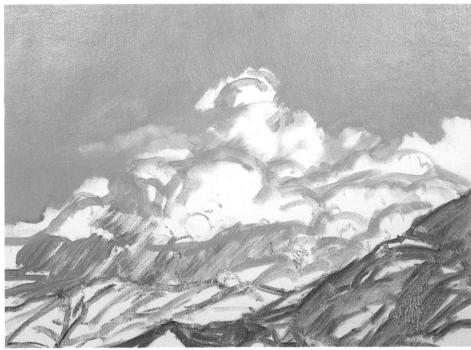

STEP TWO

Before you paint the clouds and the mountains, lay in the sky. Here it's made up of cobalt blue and cerulean blue, with just a touch of alizarin crimson near the horizon. Even when a sky looks flat and undifferentiated like this one, don't mix one huge batch of paint. By mixing smaller amounts repeatedly, you can add visual interest and variety to your painting.

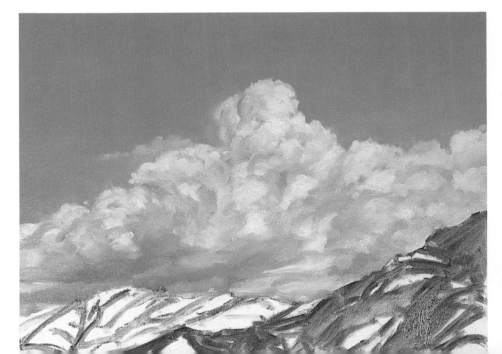

STEP THREE

Since you are emphasizing the soft feel of the clouds, paint them now. While the sky is still wet you can easily soften any harsh edges. Here the light areas are rendered with a warm creamy mix of white and yellow ocher. Tones of gray and blue make up the darks. As you develop the clouds, keep your eye on the overall pattern formed by the darks and lights.

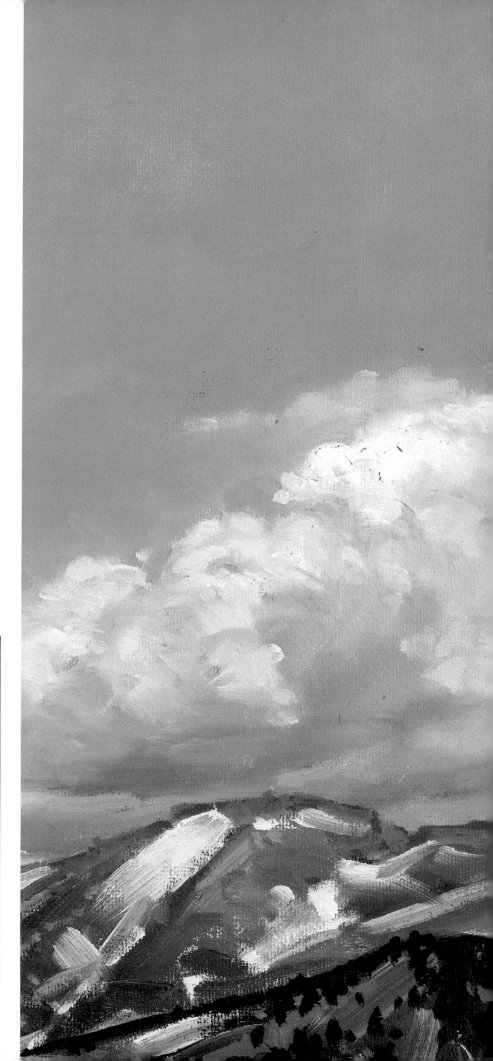

FINISHED PAINTING

As you move in on the mountains, change your plan of attack. Use a goodly amount of pigment and lay it on thickly and boldly. Exaggerate the contrast between the soft clouds and the craggy mountains with crisp, angular brushstrokes. Short dashes of dark green pigment suggest the individual conifers that line the nearby mountain. Majestic when seen up close, but dwarfed by distance, these trees also get across the scale of the scene.

ASSIGNMENT

By now you know how strongly the sky affects the feel of a landscape. To actually see the effect it has, try this: Take the mountain range shown in this lesson and experiment by painting it with different kinds of skies. First, make the sky pure blue. How does a clear sky change your treatment of the mountains? The chances are you'll want to use a softer approach on them. Next add some soft, broken clouds; use the photographs in this book as a guide to different possibilities. You may even want to paint the scene as you imagine it would appear at sunrise or strongly silhouetted by fading light at sunset.

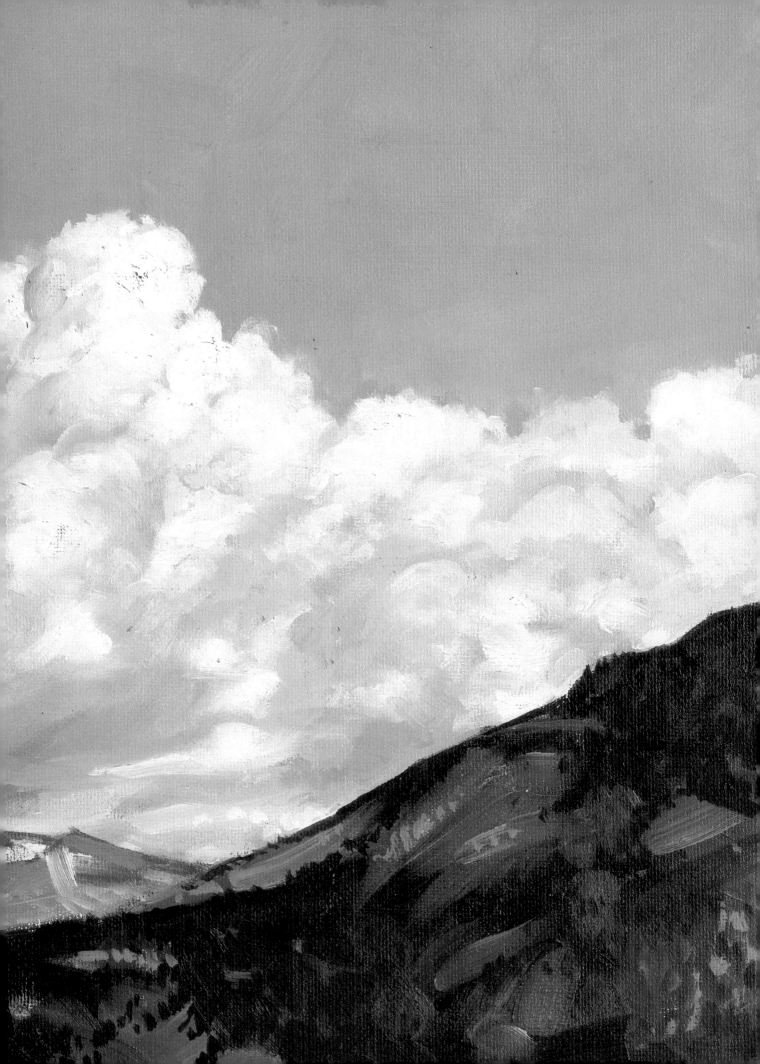

Creating a Convincing Sense of Space

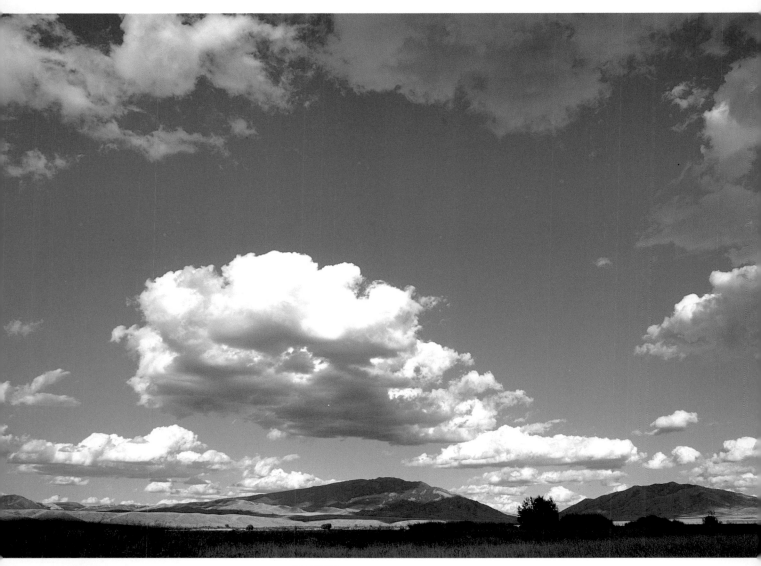

PROBLEM

The low-lying clouds are the subject of this scene—the land is incidental. The success of your painting hinges on how effectively you can portray their three-dimensional feel.

SOLUTION

Don't think of the clouds as soft, ephemeral objects. Instead, treat them as solid bodies that have real shapes. When you start to paint them, concentrate on their highlights and shadows.

In early autumn, thick, white cumulus clouds hover over the land.

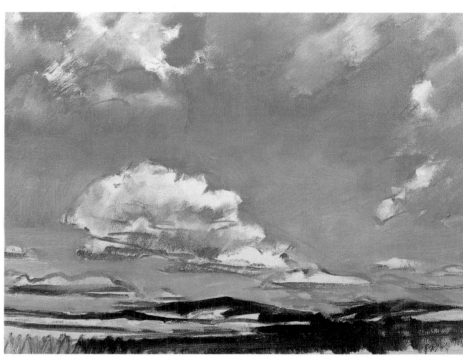

STEP ONE
In your charcoal sketch, concentrate on the clouds, then redraw the scene with thinned color. Now start to build up the volume of the clouds and the way the clouds recede into space. Throughout this stage, continue working with thin turp washes.

STEP TWO
The blue of the sky is the element that pushes the larger clouds forward; it has to be strong if it's going to work. Here a mixture of cobalt blue and cadmium red captures the strong hue at the top of the scene; toward the horizon, cerulean blue and thalo green come into play. Once the sky is down, turn to the ground. Working with cadmium orange and white, lay in the sunlit passages; don't mix the paint too thoroughly. Specks of orange in the pale paint will make it lively.

STEP THREE
In this step you'll start to work with thicker pigment; before you do, stop and analyze color and value. You'll see that the dark, shadowy portions of the clouds are the same value as the darkest areas in the sky; it's color that pulls them apart. Your previous work has established the volume and depth of the clouds; now gently build on what you've already done.

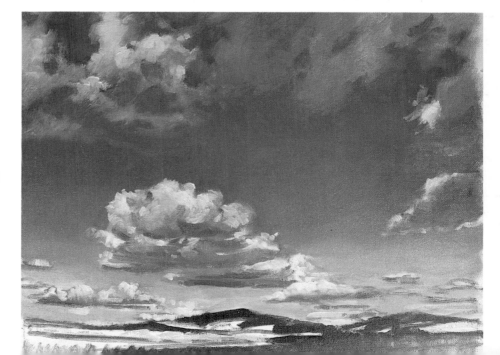

FINISHED PAINTING

Make sure that the shadowy areas in the clouds are very dark; if they're not, the brilliant light that falls onto the ground will never seem bright. Once you are satisfied with the sky, turn to the ground. Make the distant hills really dark. Next, boldly lay in the bands of color that appear in the immediate foreground. As a final touch, bits of green and orange suggest the sunlight that falls across the land.

ASSIGNMENT

Search for a flat, low-lying location, one in which you can frame a picture so that the ground occupies only a small bit of the picture space. The sky is what you'll concentrate on. Use a single canvas, 16 inches by 20 inches, and divide the area into four parts. In each part, paint a small cloudscape. Don't spend more than 20 or 30 minutes on any one; cloud formations change so quickly that spending any more time on a single study is usually futile. Paint two of the cloud formations in a horizontal format; for the other two, try working in a vertical space. When you're done, figure out which format works best for you.

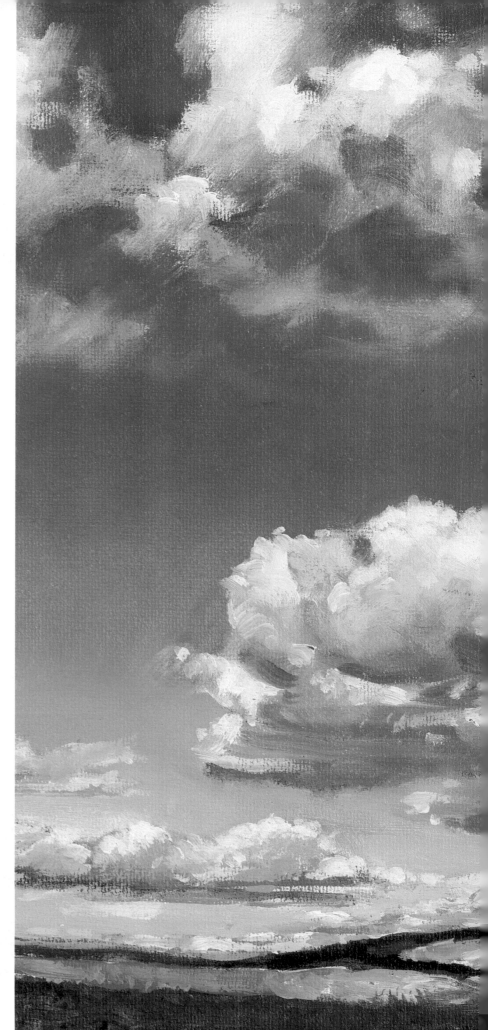

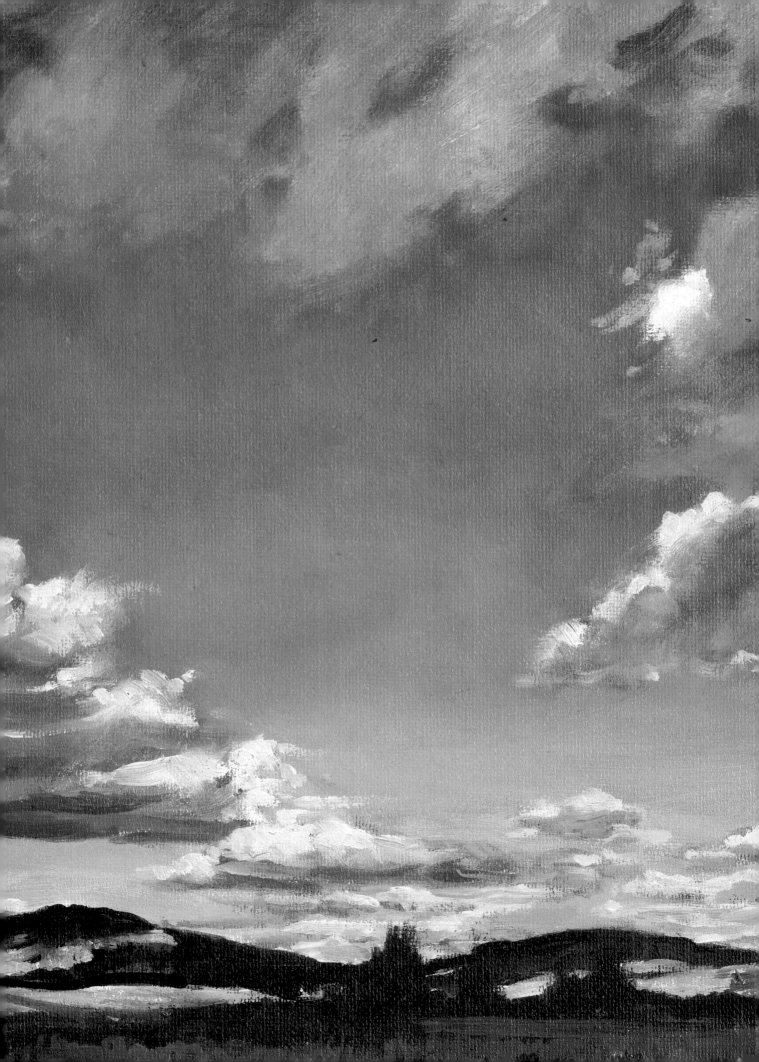

Painting Thin, Transparent Clouds

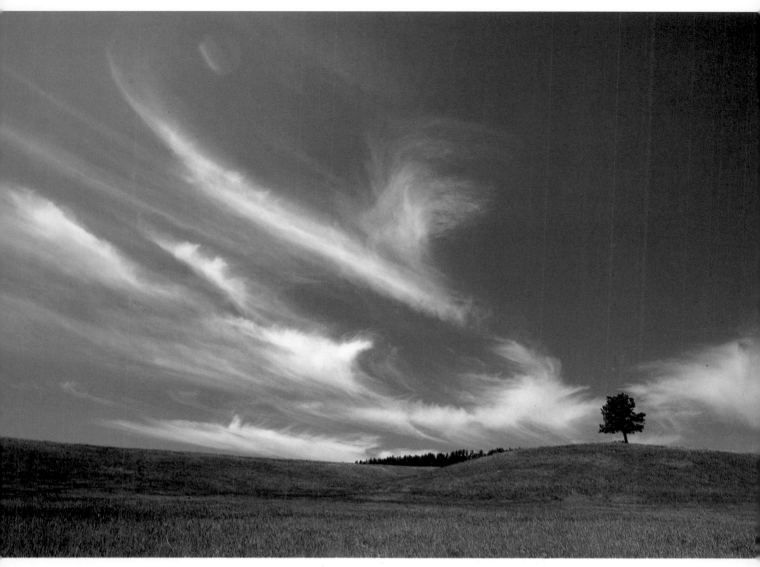

PROBLEM

The clouds make up two-thirds of this scene—they're the real subject. The challenge that faces you is capturing their thin, transparent character.

SOLUTION

Keep the foreground simple and it won't steal attention away from the clouds. When you turn to the sky, paint it in one quick session; working rapidly, you'll find that it's easy to depict the soft, airy look of the clouds.

Thin cirrus clouds streak bands of white across the deep blue sky.

STEP ONE

In your preliminary drawing, concentrate on the strong lines that sweep through the sky. Use loose, directional movements as you sketch; you don't want your drawing to look rigid. Now loosely reinforce the lines of your sketch with thinned color.

STEP TWO

Get the foreground down right away so you can devote all your attention to what matters most, the sky. With a medium-size bristle brush, pull the paint across the canvas. Use flat strokes, but do suggest the contours of the land. Now turn to the sky. Lay in a thin wash of cobalt blue and cadmium red light over the entire sky, then pull out the light areas with a dry bristle brush.

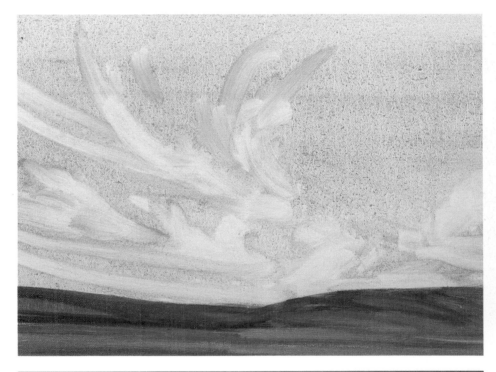

STEP THREE

Continue working with cobalt blue and cadmium red light as you begin to lay in thicker opaque pigment. Before you apply any paint to the canvas, mix together your basic blue as well as small amounts of white mixed with yellow ocher and white mixed with blue. Now start to paint. Rapidly lay in the deep, rich blue of the sky; then—following the direction of the clouds—pull your white paint through the blue sky. If any edge becomes too sharp, soften it immediately.

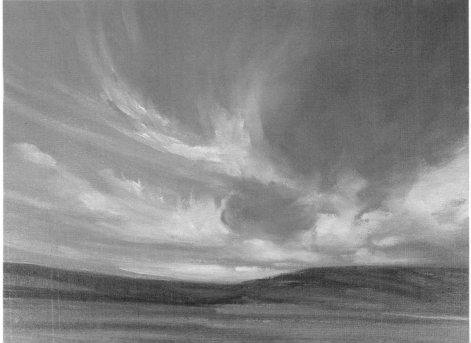

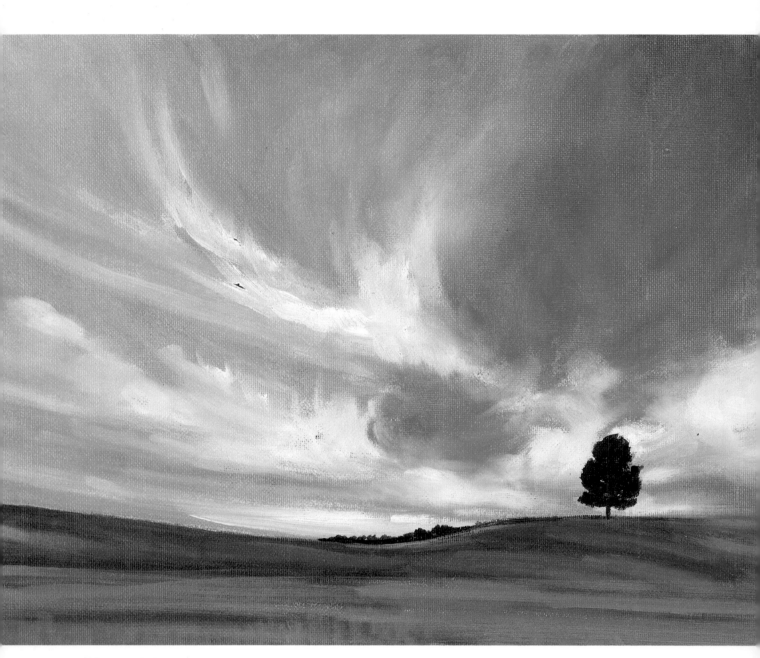

FINISHED PAINTING

To push the foreground back into space, add a line of low-lying trees to the horizon. Finally, paint the tree. Keep its silhouette simple and let tiny bits of the sky break through the foliage to create a realistic feel. In the finished painting, wind seems to pull the clouds across the sky. Their soft edges merge naturally with the dominant blue, and thick white paint contrasts powerfully with thinner passages of pale bluish-white pigment.

Working with Diffuse, Abstract Patterns

PROBLEM

These soft, misty clouds blend almost totally into the surrounding sky; they have no definite edges. In addition, they are made up of just a few colors and the value range is extremely limited.

SOLUTION

To capture the soft feel of this sky, work quickly and directly. Don't bother with a preliminary charcoal sketch; use color from the very beginning and plan to finish your painting in just one session.

□ Because of the subject's compositional simplicity, very little preliminary work is necessary. Take a bristle brush, dip it into thinned color, then quickly draw the shapes of the major clouds and the sweeping lines that they cut through the sky.

Now turn to opaque paint. You'll need cobalt blue, black, cadmium red, and white—the black to dull the blue, the red to give it a cool purplish tinge, and the white to lighten it. Start by brushing in the darker portions of the sky, letting the white of the canvas represent the clouds. Keep your pigment thick, and don't let obvious brushstrokes interfere with the soft surface you are creating.

While the sky is still wet, add the clouds. Brush them in gently, letting your strokes follow the movement of the clouds. Soften any sharp edges immediately. Once the basic patterns have been laid in, pull the paint across the canvas in the direction that the clouds take.

At the very end, work back and forth between the clouds and the sky, making any adjustments in value that seem necessary and softening any edge that has become too sharp. In this final stage, stop frequently to gauge your progress. As soon as you're satisfied with the effect you've achieved, stop. Pushed too far, this kind of painting can become totally abstract and the suggestion of clouds may disappear.

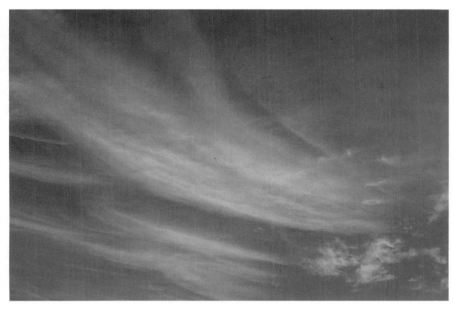

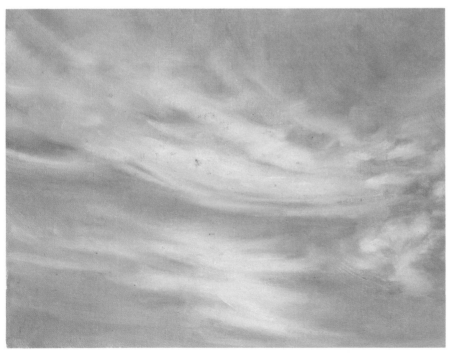

Early on a spring afternoon, pale cirrostratus clouds sweep boldly across the sky.

Rendering the Drama of a Cloudy Sunset

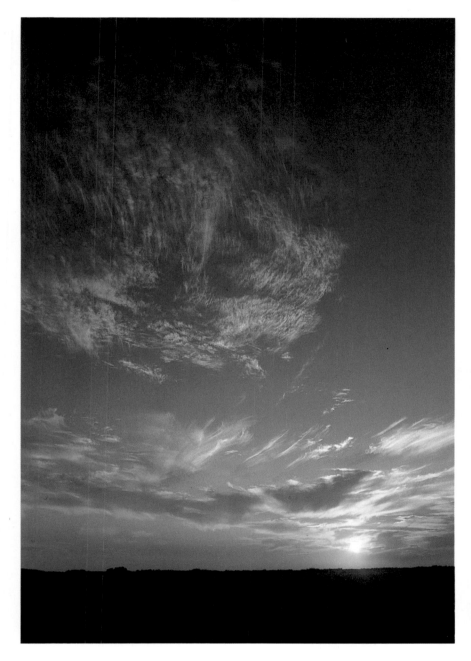

PROBLEM

When you encounter dramatic scenes like this one, you may be tempted to concentrate on the obvious and to downplay subtle points that matter. Here it's not just the brilliant colors of sunset that make the scene strong; the clouds are powerful, too.

SOLUTION

Analyze the entire composition before you start to paint. Note how the clouds that lie just above the horizon are heavy, while those higher up in the sky are thin and wispy. Paint the thin clouds rapidly, working wet-in-wet; then gradually develop the rest of the scene.

STEP ONE

With vine charcoal, quickly sketch the major shapes that fill the sky, then dust off the canvas. Next, reinforce your drawing with thinned color. Use short brisk strokes of brown to lay in the immediate foreground; use more fluid brushwork when you turn to the sky.

At sunset in the Everglades,
the bold colors of the descending sun
tinge the cloud-filled sky
with orange, gold, and blue.

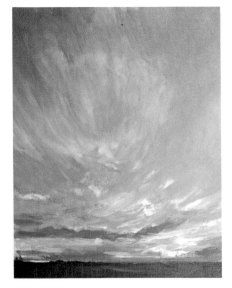

STEP TWO
Using heavier color, paint in the dark sky. As soon as it's down, turn to the thin clouds that float high above the ground. Working wet-in-wet, coax pale blue and pink pigment into the dark underlying blue, taking care to keep all the edges soft. Now add the very dark foreground and the brilliant colors of the fading sun. For the time being, use fairly thin paint to render the sunset and don't let any heavy ridges develop.

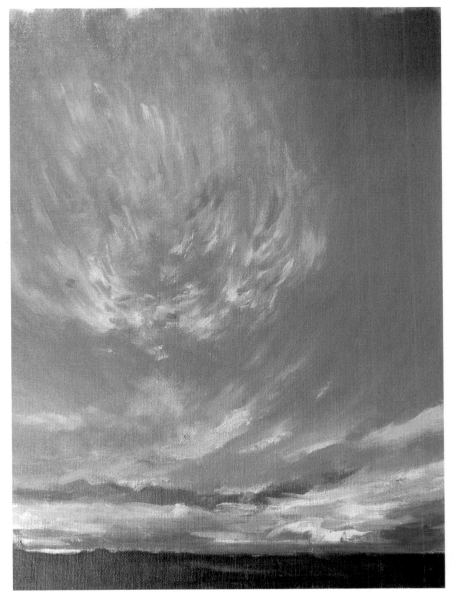

STEP THREE
Before you complete the brilliant area near the horizon line, finish the sky. Mix dark, rich blue with plenty of medium to keep the paint fluid, then carefully apply the color to the sky. Don't be afraid to use dark, intense blue; you want to indicate how the sky darkens in the evening as the sun slowly fades away. As soon as the blue is down, turn to the thin clouds; moisten a small brush with pale pink and quickly pull this through the blue.

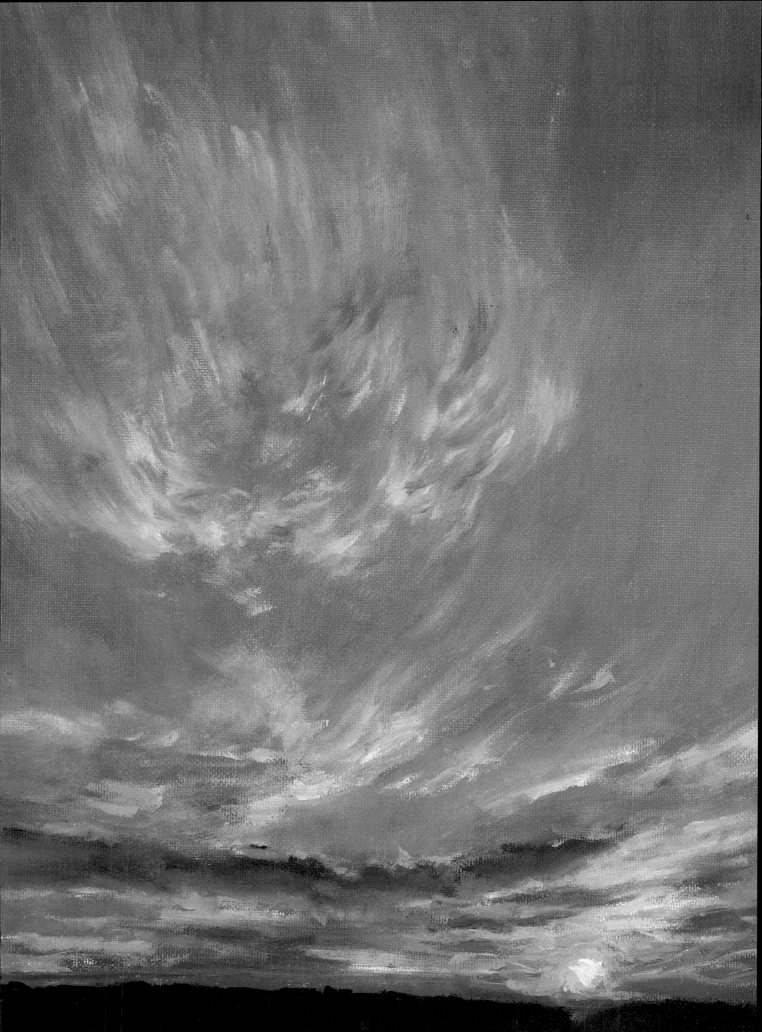

FINISHED PAINTING

At the very end, turn to the lower portions of the sky. First add touches of pure orange and gold to the canvas, then lay in the dark clouds that float in front of the sun. To achieve a bright, glowing look, don't add too much white to your strong reds, oranges, and golds. Instead, use them almost straight from the tube.

DETAIL

The wind-swept clouds that fill the upper reaches of the sky are painted wet-in-wet. While the underlying blue is still moist and pliable, touches of soft pink are quickly pulled through the blue. The soft, ephemeral look that results gets across the character of the clouds.

DETAIL

The brilliant gold sun and the orange-tinged sky are painted with almost pure color; just the faintest hint of white softens their intensity. The dark clouds that float in front of the sun are rendered with Mars violet and cadmium orange.

Working with Backlighting at Sunset

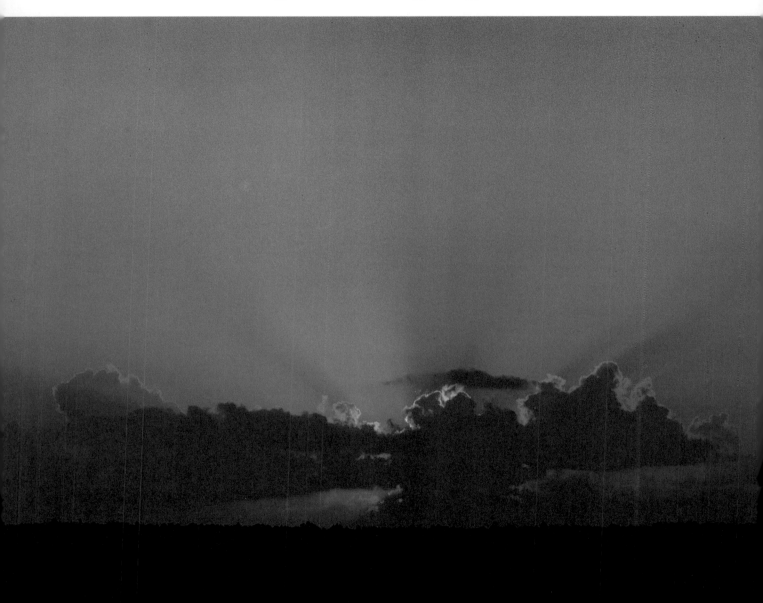

PROBLEM

The dark clouds lie directly in front of the sun. It will be difficult to convey how brilliant rays of light rim the clouds and shoot upward.

SOLUTION

Make the clouds even darker than they actually are and they'll contrast sharply with the light rays. This contrast will accentuate the brilliance of the setting sun.

☐ Execute a simple charcoal drawing, one that establishes the shapes of the clouds, the horizon line, and the rays of light that spread outward from the sun. Next, dip a brush into thinned color and redraw the basic lines of the composition. For the time being, let the white of the canvas represent your lights and concentrate on the darks.

Working with heavier pigment,

lay in the clouds. Keep your darks colorful; here they are rendered with cobalt blue and a very small amount of white. Don't use too much white—you need just the barest touch to temper the blue. Don't worry if the clouds seem too dark set against the white of the canvas. Remember that when the sky is painted, they will appear somewhat lighter in relation to the bright orange tone that dominates the sky.

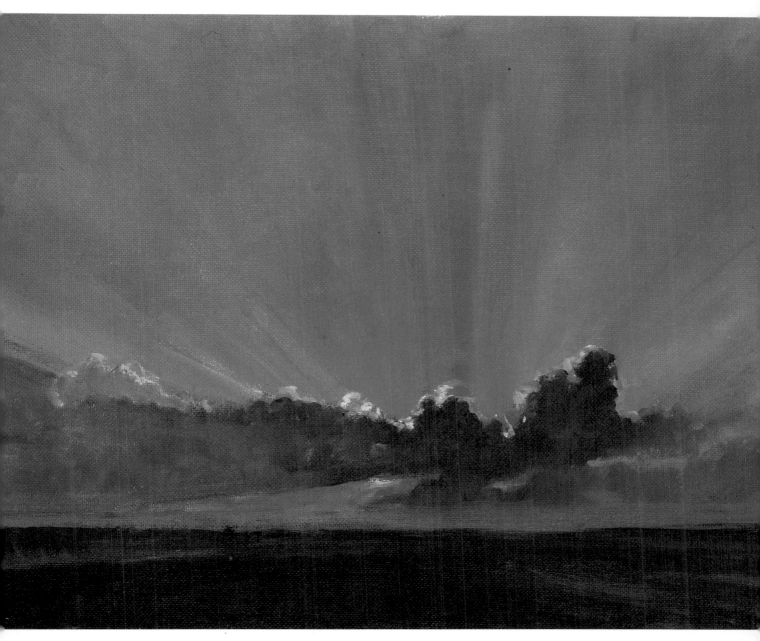

When you turn to the sky, don't be afraid to use really bright colors. Once again, if you add too much white, the brights will seem lackluster. Instead, use paint almost straight from the tube. Here the sky is mostly made up of cobalt orange. Cadmium red comes into play near the cloud formation; toward the edges of the canvas, the cadmium orange is grayed down with touches of cobalt blue.

While the paint is still wet, add the dark rays that radiate out from the cloud. Barely moisten your brush with a mixture of cadmium orange, cobalt blue, and white, then rapidly pull the brush across the canvas. When the rays are down, take a small sable brush and add the touches of bright color that rim the clouds.

The sky completed, turn to the foreground. You'll want a dark hue that is keyed to the rest of the painting, so use cobalt blue as your base, darkening it slightly with Mars violet. Keep the foreground fairly simple; it shouldn't compete for attention with the rest of the composition.

Now look at the painting as a whole. Make sure that it hangs together—that the clouds, sky, and ground are harmonious—and that your darks are intense enough to offset the brights.

Learning to Control Values

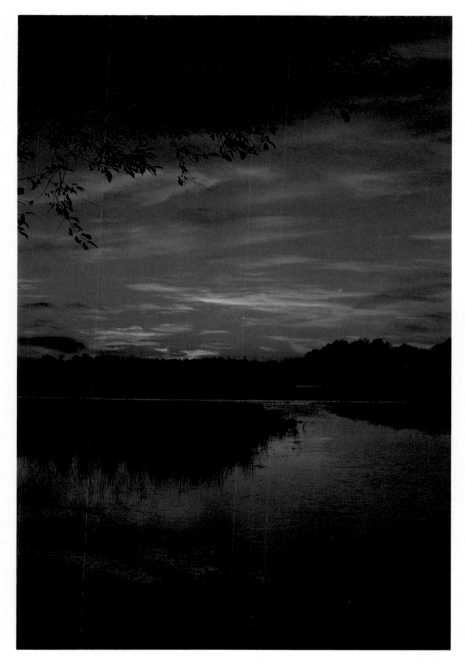

PROBLEM
Even though this scene is filled with brilliant color, it is set in early evening. If you simply concentrate on the bright colors, your painting may be too light in value. If that happens, you'll lose the special mood that occurs at sunset.

SOLUTION
Go ahead and use a broad array of brilliant hues, but keep your darks really dark. To help gauge your values, stain the canvas with a medium-value red before you sketch the scene.

STEP ONE
Start by toning the canvas. On your palette, mix together cadmium red and alizarin crimson. Add turpentine to the mixture, then sweep the color wash over the canvas. Concentrate the red wash in the upper half of the painting, where most of the bright colors lie. Now dip a small brush into a thinned but dark color and sketch the basic lines of the composition.

In early October, bands of brilliant orange sky and smoky clouds weave together as the sun slowly sets.

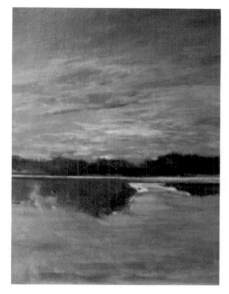

STEP TWO

You are going to be working with a vast array of colors, so make sure they are all laid out on your palette before you begin. Use these colors: alizarin crimson, cadmium red, ultramarine, Mars violet, cerulean blue, thalo green, cadmium yellow, cadmium yellow light, and white. As you lay in your darks and lights, let the stained canvas represent your middle tones. Use white sparingly; for the most part, you'll want deep, rich hues.

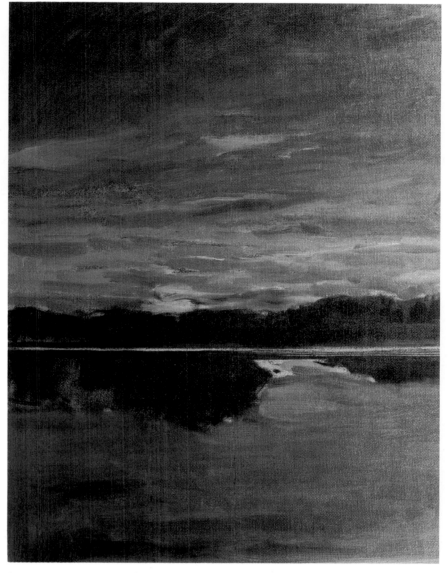

STEP THREE

Work back into the upper half of the painting, strengthening your darks and your lights and reworking the areas that until now have been covered with just the preliminary color wash. Use loose, fluid strokes, and let the layers of color blend together where they overlap. Once again, use deep, dark hues; the blue passages are, for example, rendered with pure cerulean blue.

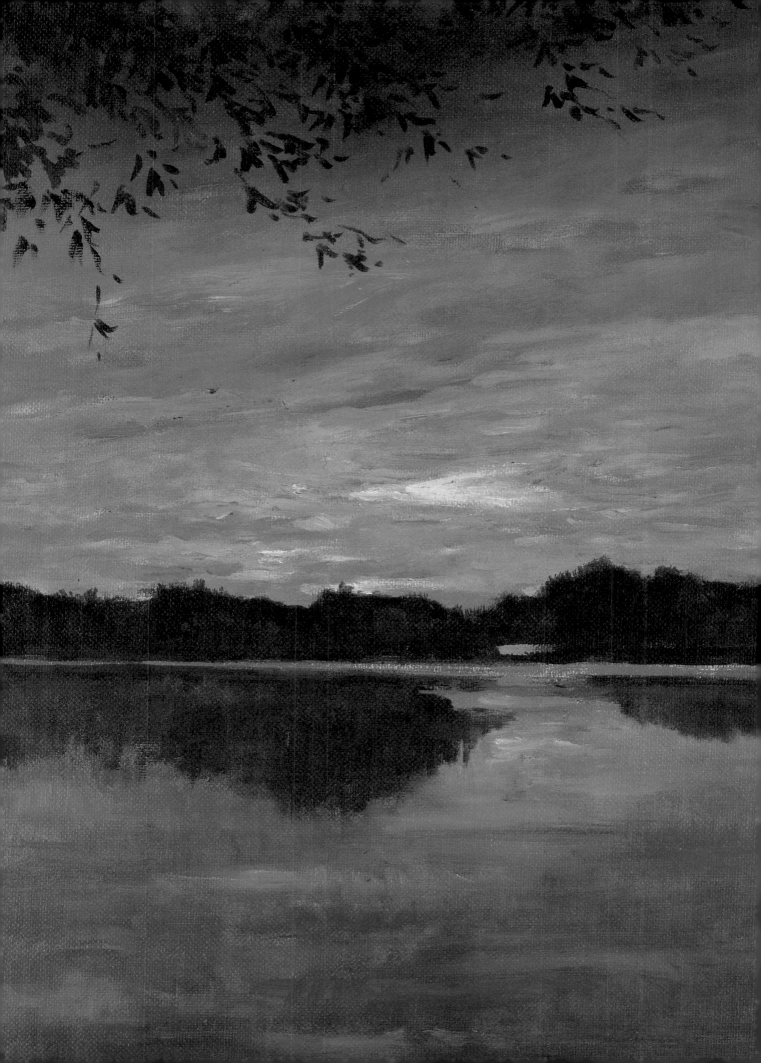

FINISHED PAINTING

Once the sky is complete, the foreground will probably look weak. Using the same colors that make up the sky, build up the dark shadows that run across the water. Keep the center of the water brightest to suggest the light of the setting sun. At the very end, paint in the branches in the upper left corner and refine the line of trees that run along the horizon. These crisp details add punch to your painting and establish a clear sense of space.

DETAIL

The sky is packed with pure, rich, vibrant color—oranges, golds, reds, and blues—yet it is dark in value because very little white was used. The middle-value red applied to the canvas at the very beginning sets the value scheme for the entire painting and makes it easy to adjust the darks and the lights.

DETAIL

A thin band of deep orange separates water from land and helps set up a convincing sense of space. The trees that lie above the band are crisply rendered; their reflections in the water are painted with looser strokes, suggesting how the reflections play upon the surface of the water.

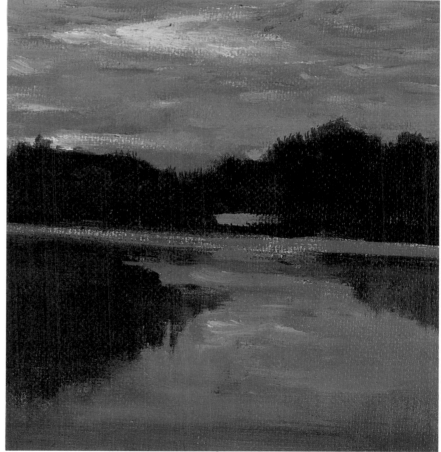

Using Varied Brushstrokes to Organize a Painting

PROBLEM

The bands of color that arc through the sky clearly dominate this scene. Unless they are carefully thought through, they may overpower everything else.

SOLUTION

Divide the composition into three distinct areas: the bold bands of light and dark color in the sky, the clear sky above the bands, and the land and water beneath them. Render each area with a different kind of brushstroke.

☐ Because the composition is simple, you don't need a charcoal sketch. Instead, set down the major lines of the composition with a small brush that has been moistened with thinned color.

Now working from dark to light and with opaque paint, develop the overall color and value scheme.

To depict the horizontal bands of color, use broad, sweeping strokes. Next, lay in the uppermost portion of the sky, exaggerating its texture by rapidly

scrubbing color onto the canvas with diagonal strokes that move upward from left to right. Finally, render the water with short, broken strokes.

Once you have established the sky and the water, turn to the dark line of trees along the horizon and the island that juts out into the lake. Try painting them with a mixture of thalo green and alizarin crimson—you'll find that this mixture creates a dark, yet colorful, hue.

*A lake lies frozen beneath a brilliant,
light-streaked December sky.*

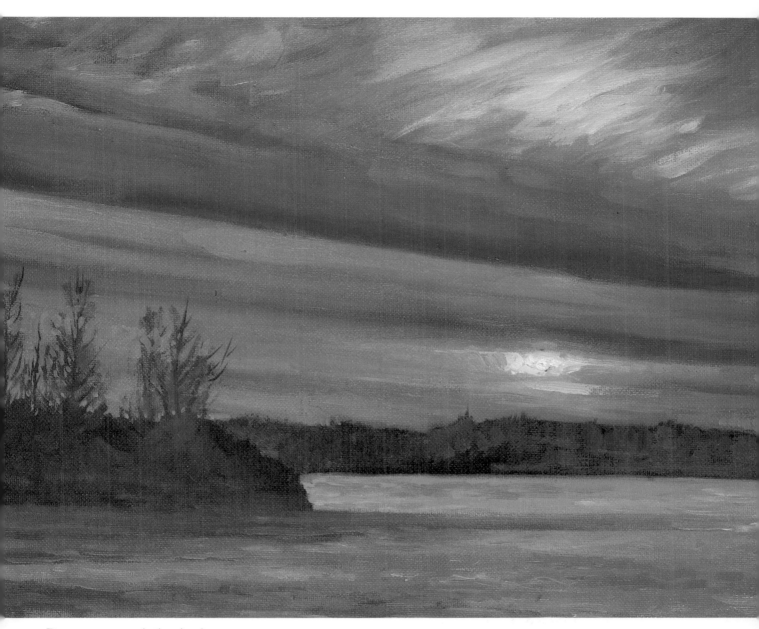

By now your painting is almost finished. Using the darks of the land as a guide, analyze the value scheme you've established. Work back into the sky, adjusting the areas that seem discordant and adding touches of pure yellow to indicate the sun. When you are happy with the sky, add the scraggly trees in the middle ground. Finally, turn to the water. To relate it to the rest of the painting, add small strokes of the gold and orange hues that dominate the sky.

ASSIGNMENT

At their most dramatic, sunsets are packed with rich, vibrant color. But color isn't everything in a sunset—patterns of dark and light matter too. To become conscious of the importance of value, try working with just black and white paint the next time you encounter a glorious sunset.

As you work, search for the light and dark patterns that fill the sky. Paint quickly, spending no more than ten or fifteen minutes on each monochromatic sketch. Don't work your studies up too much; as soon as you feel you have captured the basic configuration of the sky, move on to another study. You'll discover that within five or ten minutes, the sky can totally change.

Exaggerating Subtle Shifts in Color

PROBLEM

Except for the trees, all of the elements in this scene are very closely related in both color and value. If you approach the subject too literally and paint exactly what you see, your painting will be bland and uninteresting.

SOLUTION

Look for subtle shifts in color, then exaggerate them. In the end, the values may still be closely related, but your painting will be packed with lively, interesting hues.

☐ Sketch the scene with soft vine charcoal, dust and fix the canvas, then reinforce the drawing with thinned color. Now start to work with opaque pigment. As you develop your painting, mix your color in small batches; the subtle differences that occur from batch to batch will animate your painting.

Begin with the darkest area, the foreground. Here it is rendered with a mixture of cobalt blue, white, and alizarin crimson. Now turn to the sky. Working around the pale moon, lay in your color. Near the top of the canvas, work with thalo green, alizarin crimson, and white. As you move toward the horizon, gradually decrease the amount of thalo green. Near the ground, you'll be working with a mixture of alizarin and white, tempered with just a touch of green.

Next, paint the trees. To render them, use Mars violet, burnt umber, and white. First carefully paint in the trunks and branches with a small sable brush, then switch to a slightly larger bristle brush and a drybrush technique. Moisten your brush with pigment, wipe it off on a rag, then gently coax the paint over the skeletons of the trees. Before you move on, evaluate the trees. If the drybrushed areas seem too dark or too heavy, lighten them with touches of the mixture of alizarin crimson and white that you used to paint the sky.

At the very end, repaint the area of sky that surrounds the moon, using gentle, circular strokes and a slightly darker color to heighten the contrast between the moon and the sky. Finally, paint the moon in the middle of the halo of color that you have created.

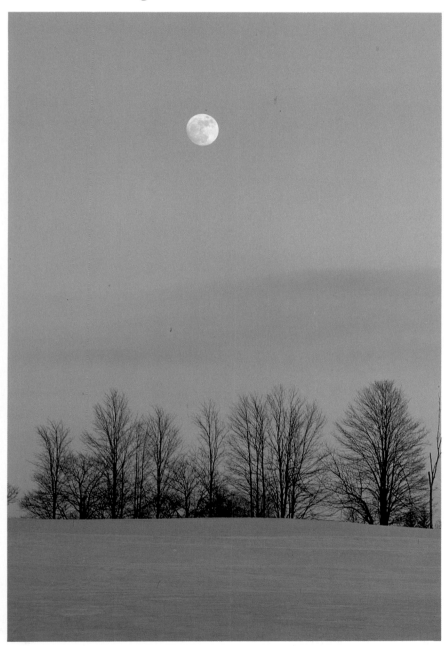

A pale moon floats high in a crisp, midwinter sky.

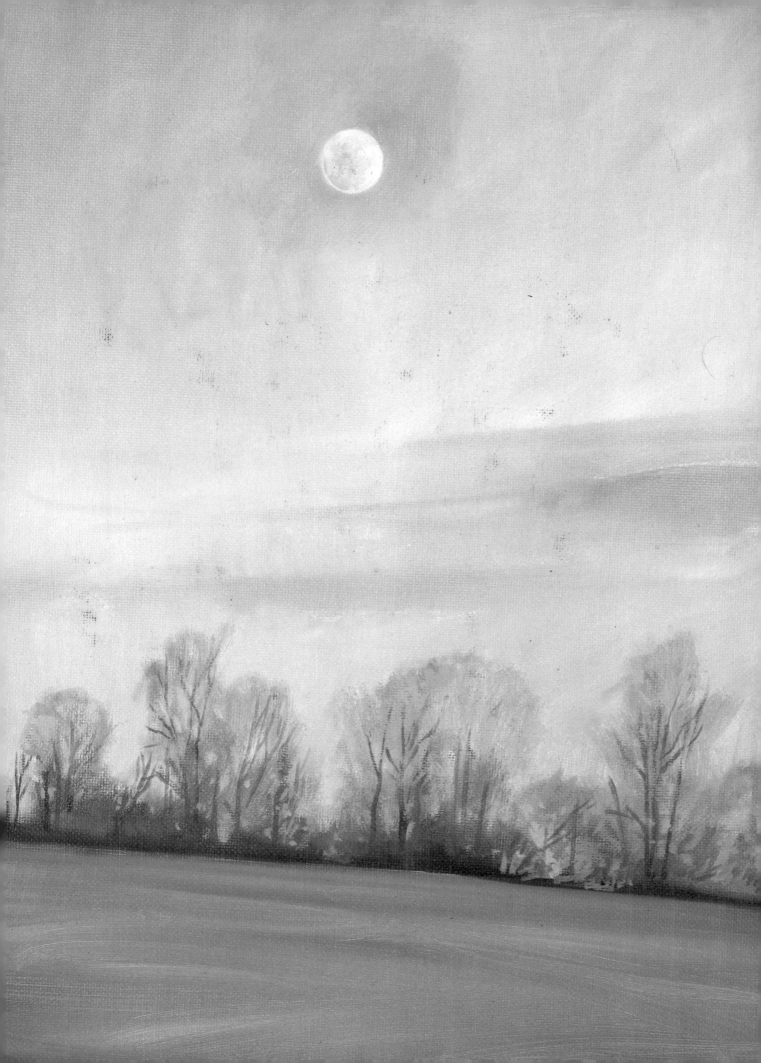

Painting at Night

PROBLEM

Painting at night presents its own special challenges. Even if you conquer the practical ones—such as seeing what you are painting— it's easy to make your colors too light and to lose the effect you are after.

SOLUTION

Keep the sky dark and the tree even darker to set up contrast between the two and to establish the mood of the painting. As you render the sky, look for subtle shifts in color and exaggerate them to break up what could be a flat, undifferentiated area.

☐ Sketch the branches of the tree with charcoal, then redraw the tree with a small brush and thinned color; make it really dark so the drawing will still be visible through opaque pigment.

Continue working with thinned color as you lay in the sky. Here it's made up of a mixture of cobalt blue and alizarin crimson. Even in this early stage, start looking for variations in color and value.

Now, working right over the darkly drawn tree, repaint the sky with opaque pigment. Try to finish the sky in one session. When the sky is completed, carefully paint in the moon; then proceed to paint the tree. A rich mixture of burnt umber and cobalt blue is perfect for rendering the tree. It is dark and dramatic, and the blue relates the color to that of the sky. Mix the two colors together on your palette, then add a goodly amount of painting medium. The paint has to be fluid if you're going to capture all of the thin, spidery branches.

Once you've painted the basic anatomy of the tree, go back and add a little modeling to its trunk. Here just a hint of white is added to the basic mixture of blue and brown, then the slightly lighter paint is quickly applied to the right side of the trunk.

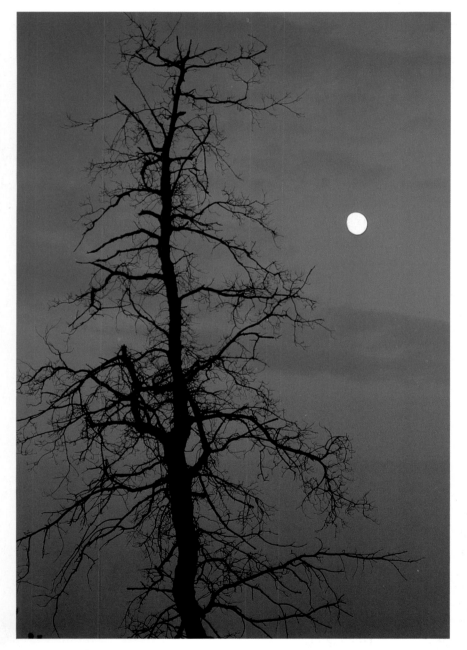

In late summer, moonlight illuminates the scraggly lines of a dead tree.

ASSIGNMENT

Try painting a night scene. Your subject doesn't have to be anything like this one. The important thing is to choose a scene that you can see from inside your studio or home.

When you start work on your painting, be sure to keep the darks really dark. If you have trouble working with very dark values, it may help to turn off the light you are working by, from time to time, and to contemplate your subject for a few minutes.

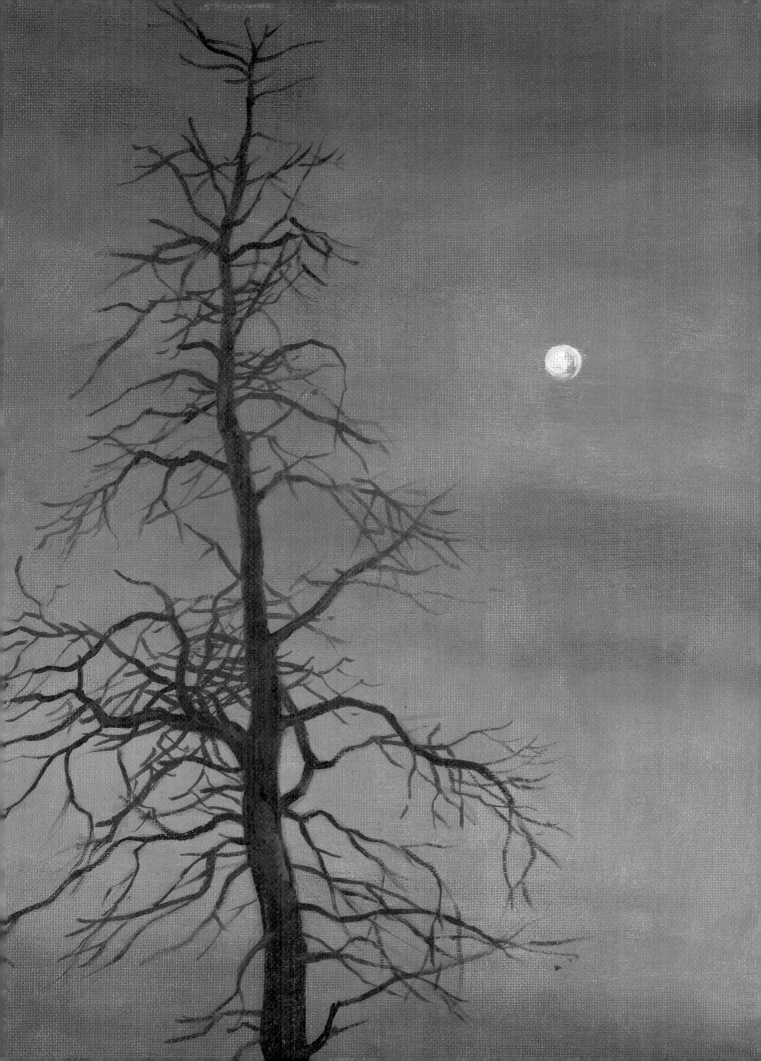

Using Texture and Bold Brushstrokes to Add Drama

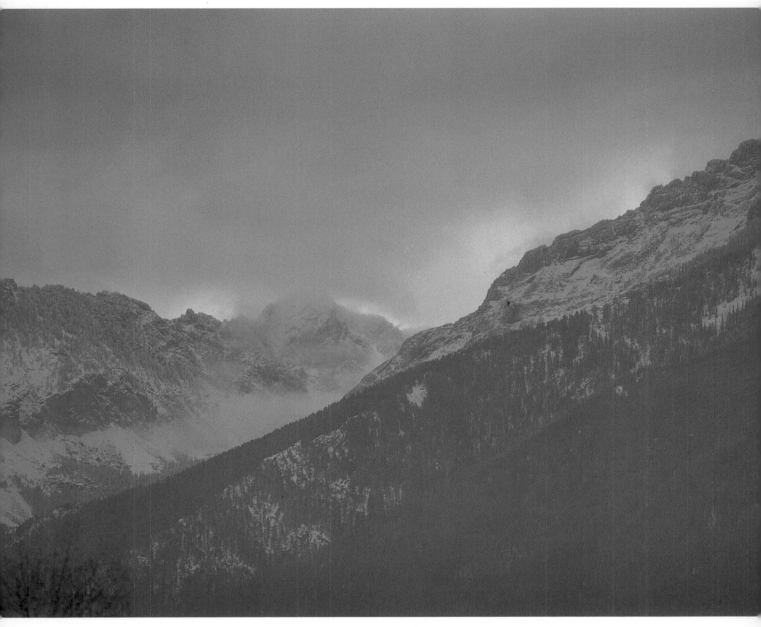

PROBLEM

This subject should be dramatic—after all, it's made up of majestic mountain peaks. The subdued light, though, produces a limited range of color and value.

SOLUTION

To add drama to your painting, emphasize the diverse textures of the mountains with bold brushwork. Next, exaggerate the darks of the mountains in the foreground to suggest the passing storm.

☐ Sketch the scene with soft vine charcoal, then reinforce your drawing with thinned color. Now quickly brush in the mountains with a bristle brush and a thin wash of paint. Keep the distant mountains light; make those in the foreground darker and more dramatic.

Once the basics are down, begin to use thicker, more opaque pigment. Start with the sky. Here

After a fierce autumn storm, light falls softly over a rugged mountain range.

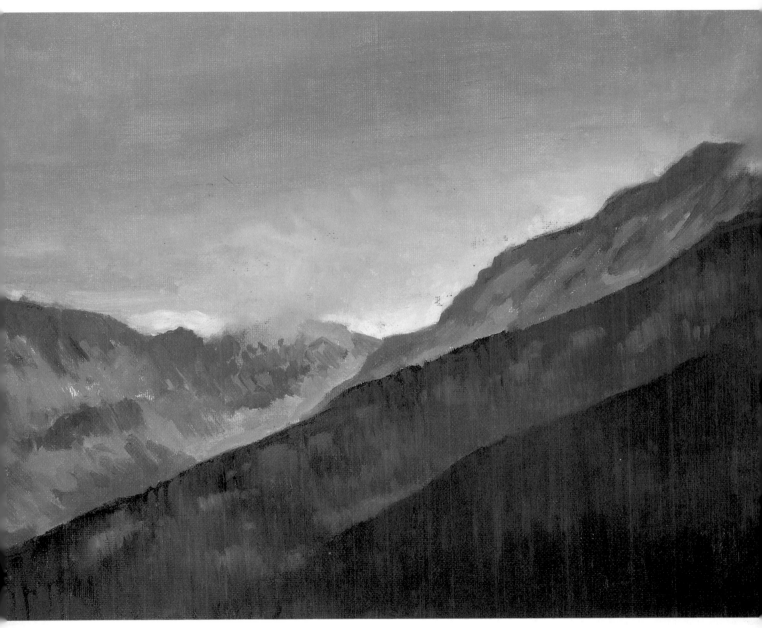

it's darkest at the top of the canvas and becomes noticeably lighter near the mountaintops—a device that effectively separates the peaks from the sky. Try using pale yellow for the light-filled strip; the yellow will stand out vividly against the blue. Take care, however, that your brush remains clean or you'll end up with green, not yellow. As you work, continuously wipe the brush off with a clean cloth.

Now develop the texture of the mountains. To suggest the patterns that the trees and snow form, work with short, brisk strokes. In the foreground, use crisp, vertical strokes and continue to keep your paint really dark; make the distant mountains paler and lay them in with looser, diagonal brushstrokes.

At the very end, you may find that you've lost the special feel created by the passing storm. If you do, try this: Add pale bluish-white paint to the lower part of the sky and pull the blue right over the central mountain peak. Right away, you'll see your work change; suddenly, it will seem as though a storm cloud has settled down softly, obscuring the distant peaks.

Discovering the Hidden Detail as the Sun Sets

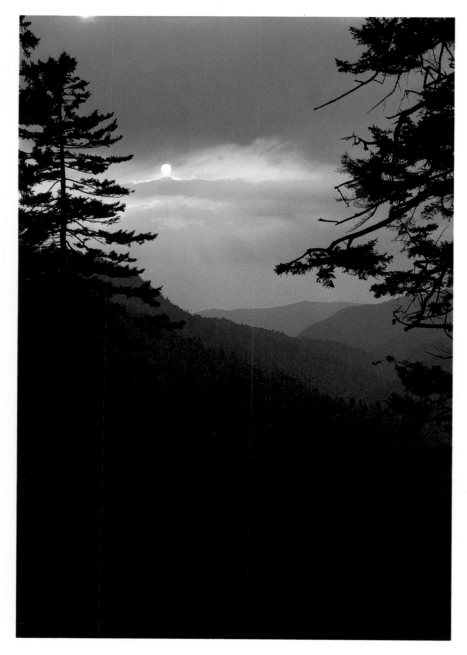

PROBLEM

When scenes are set in early evening, just as the sky darkens, it's easy to emphasize the drama of the setting sun and to treat the land superficially. If you do, your painting may well end up looking flat and uninteresting.

SOLUTION

In your sketch and later in your painting, search for the forms that lie shrouded by the failing light. Keep them clearly defined throughout.

STEP ONE

At first, concentrate on the foreground. Search for whatever detail you can find, then sketch it clearly on your canvas with vine charcoal. Now dust off and fix the canvas, and redraw the scene with a brush and thinned color. Note how the foreground shapes are drawn with a dark wash; those further back are lighter, creating a feeling of distance even at this preliminary stage.

In the Smoky Mountains, hazy air hovers near the ground while the sky fills with soft color.

STEP TWO

Quickly lay in the entire painting with thin washes of color. For the time being, let the white of the canvas represent the lightest, brightest portions of the sky. As you develop the shapes in the foreground, try to create a sense of depth. Render the trees that lie in the immediate foreground with very dark washes, and those further back with lighter color.

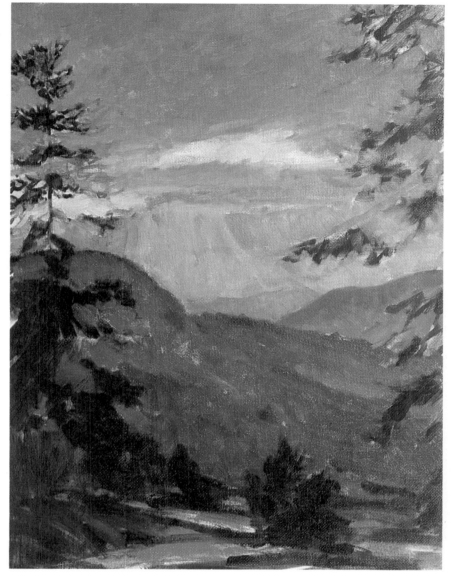

STEP THREE

Now start to use thick, opaque paint. Begin with the sky: It sets the scene's overall mood. Work wet-in-wet, beginning with the bright passages of pink and gold. As you lay in your blues, don't let the gold mix with them, or you'll end up with green. Once you're satisfied with the sky, turn to the mountains. Again, keep those in the foreground darker than those that lie further back in the picture plane.

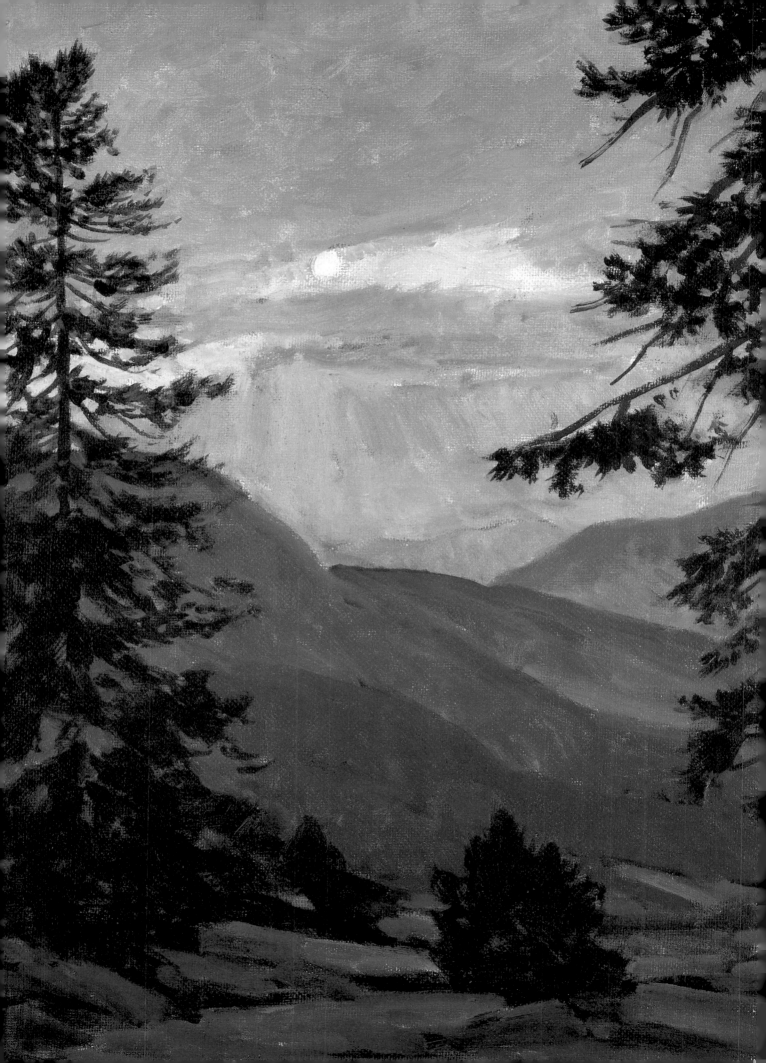

FINISHED PAINTING

At the very end, define the trees in the foreground, then build up the rest of the foreground.

DETAIL *(right)*

The trees in the foreground are rendered with a mixture of alizarin crimson and thalo green—a much more lively color than the black you might be tempted to use. The hills behind them are made up of alizarin crimson and cobalt blue.

DETAIL *(below)*

When yellow is placed right next to blue, it can be difficult to keep the yellow from becoming tinged with green. To avoid this problem, try this: After the yellow has been laid down, surround the area with a thin ring of red. When the blue is pulled close to the yellow, it will mix with the red, forming the interesting shade of purplish-blue that you see here.

ASSIGNMENT

Effects like the one seen in this lesson are fleeting; within minutes, the sky changes and darkness veils the landscape. But just because these moments are fleeting doesn't mean you can't paint them.

Choose a subject that you know well—one that is near your home and that you've seen previously at sunset. While it is still light out, do all your preliminary work on the scene. Execute your sketch, develop the painting with thin turp washes, and even lay in portions of the composition with thicker paint. As you work, anticipate how the scene will change as night approaches. When the light begins to fade, paint rapidly. Quickly capture the configuration of the sunset, then adjust the values of the shapes in the foreground. You want them to be very dark, but to still have enough detail to make sense.

Capturing Forms Silhouetted Against a Hazy Sky

PROBLEM
This scene is dramatic, but there really isn't much interest in the foreground. The trees are silhouetted against the sky and become abstract shapes.

SOLUTION
Don't be too literal in your interpretation. Instead, try to separate the trees into different planes to create a feeling of depth.

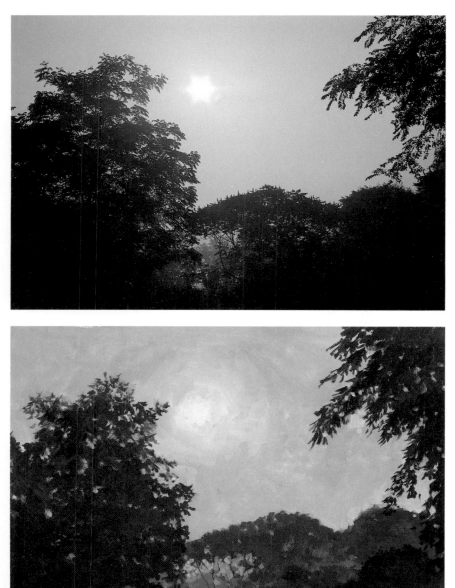

At sunrise, a warm, golden sky acts as a bold backdrop for this handsome grove of trees.

☐ In your charcoal drawing, place the composition's main lines, then reinforce your drawing with thinned color. Separate the trees into different planes by using darker washes for the trees in the foreground and lighter ones for those further back. Now loosely brush in the sky with a wash of cadmium yellow.

When you start to develop the sky with opaque paint, add a touch of cadmium orange to your cadmium yellow. Feel free to lay in the pigment all the way down to the horizon; you'll paint the trees over the sky once the paint is dry. Don't make the sky too flat; use short, broken strokes to apply the paint, and keep the orb of the sun lighter than the rest of the sky.

Once the sky is down, turn to the trees. Start with those furthest back; to create a sense of distance, render them with almost pure orange and yellow. Now move forward and paint the trees in the middle ground. For them, mix a touch of yellow into brown.

Continue moving forward, gradually darkening your pigment. When you turn to the trees in the immediate foreground, use a dark, rich mixture of thalo green and burnt umber. To capture their crisp, sharp feel, apply the paint with a small sable brush.

At the very end, go back and add touches of yellowish-orange to the trees to suggest where the sky breaks through their foliage. That done, stop and evaluate the painting as a whole. You may find that some of the shapes seem soft and unfocused or that the shifts in color and value are too sharp. Here, for example, touches of orange were added near the base of the tree on the left to show how the bright tree in the distance is visible through the darker foliage.

Using One Strong Element to Establish Space

PROBLEM

Once again, the light is hazy and diffused. Unless you are aiming for a flat, decorative effect, you'll have to find a way to give your painting focus and definition.

SOLUTION

Use the dark tree on the right to establish the immediate foreground. With that strong note down, it will be easy to set up the rest of the spatial relationships.

☐ When light is diffused, values are crucial, so, after sketching the scene, establish them right away in thin washes of color. Here yellow ocher forms the foundation for the sky, cadmium orange for the ground, and very light cobalt blue for the trees.

With the sky, begin using opaque paint. Break it up by using short, mosaic-like brushstrokes and warm and cool colors that have the same value. A mixture of warm and cool tones clearly conveys the feel of haze. Yellow ocher mixed with white is the most important color in the sky; in places, touches of cool, pale cobalt blue break up the dominant yellow. Use the same approach to render the distant trees, working with a mixture of white, Mars violet, and cobalt blue. With darker pigment, paint the small tree in the center of the painting. Since this tree is relatively close to the foreground, pick out its lines carefully. If the form is too soft, it will blend in with the trees that lie behind it.

Now lay in the ground, using short, vertical strokes. Start with burnt sienna and cadmium orange, then—as you near the bottom of the canvas—introduce Mars violet.

Turn to the tree. Break its color up by repeatedly mixing small batches of Mars violet, cobalt blue, and a little white. Begin with the trunk, using a small bristle brush; for the leaves, you'll need a small, round sable.

To paint the leaves, carefully dab small bits of pigment onto the canvas. Alternate medium-size strokes with tiny ones, and vary the hues that you use. Here there are touches of green and orange. What you're aiming for is a rich, lively blend of distinct and indistinct strokes—a blend that will fit in perfectly with the mosaic-like backdrop that you've created.

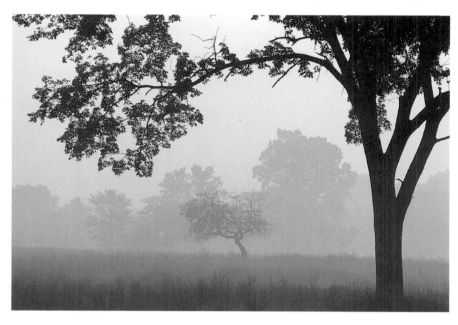

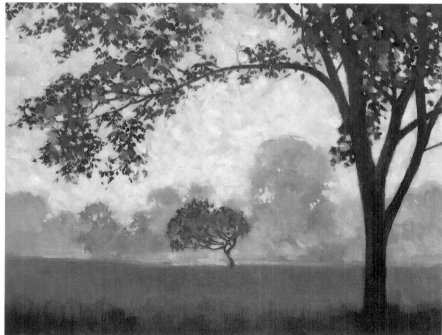

In autumn, haze steals across the land, obscuring the trees that lie in the distance.

Capturing the Delicacy of a Hazy Summer Morning

PROBLEM

The haze that envelops this scene softens the edges of the trees and reduces the strength of their colors. Yet you don't want to lose the landscape's distinctive look.

SOLUTION

To capture the particular character of this scene, let a careful drawing guide you as you paint. As you proceed, keep all the edges soft and use a very limited range of color.

☐ Carefully sketch the scene; pay special attention to the dominant tree. Now dust your drawing off, fix it, and reinforce it with a small sable brush that has been dipped into thinned color.

Continue using thin washes of color as you build up your painting. Begin with the dark shape of the central tree, here rendered with a combination of ultramarine blue and raw sienna. Use the same mixture to paint the low shrubs that hug the ground.

Move backward now, gradually making your washes lighter and lighter. When you have established a convincing sense of space, turn to the foreground and quickly lay in the grass with a wash of yellow ocher.

Now begin to use opaque pigment. As you work, move quickly and don't let your pigment dry. If it does, you may be left with sharp, harsh edges that will detract from the misty, soft feel that you are trying to achieve. Using

As hazy air presses close to the earth,
it gently transforms the landscape.

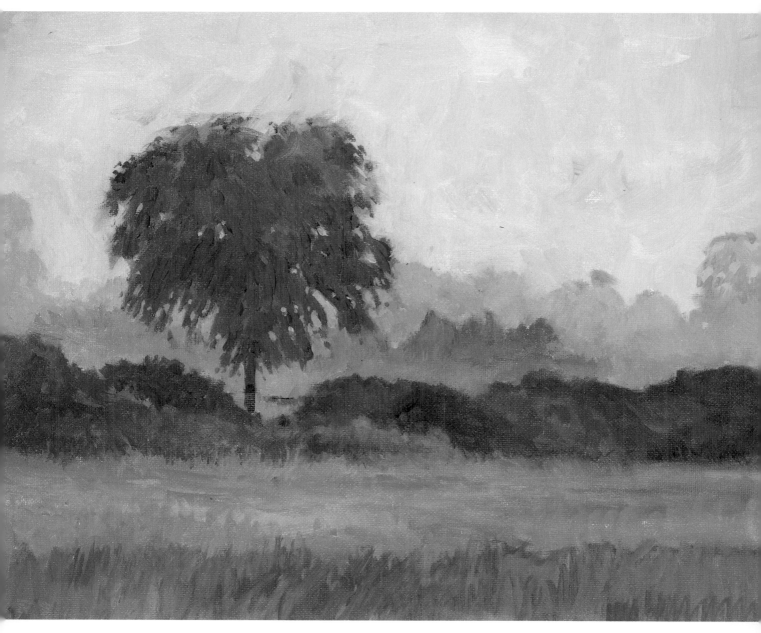

the same basic colors that you employed in your washes, go back and develop what you've begun.

As you paint, use loose, fluid brushstrokes; everything must stay as soft as possible. Once again, begin with the tree, then turn to the shrubs and the vegetation that lies beyond them. When those are built up, lay in the foreground with yellow ocher, permanent green light, and raw sienna. Use short, vertical strokes to render the grasses and don't be too fussy—what you want is a general impression, not a view of every individual blade of grass.

Next, lay in the sky with a mixture of permanent green light, yellow ocher, and white. The yellow ocher not only warms the green, it also suggests the sun that lies behind even the most hazy of skies.

When you've completed the sky, go back and break up the masses of distant trees by adding touches of yellow to them. Next, adjust any shifts in value that seem too abrupt or any shapes that seem too sharp or too soft.

In the finished painting, the low-lying bands of trees and shrubs create a calm, peaceful feel, and the horizontal strips of grass reinforce this gentle effect. The only accent note is furnished by the carefully painted central tree.

Balancing Darkness and Light

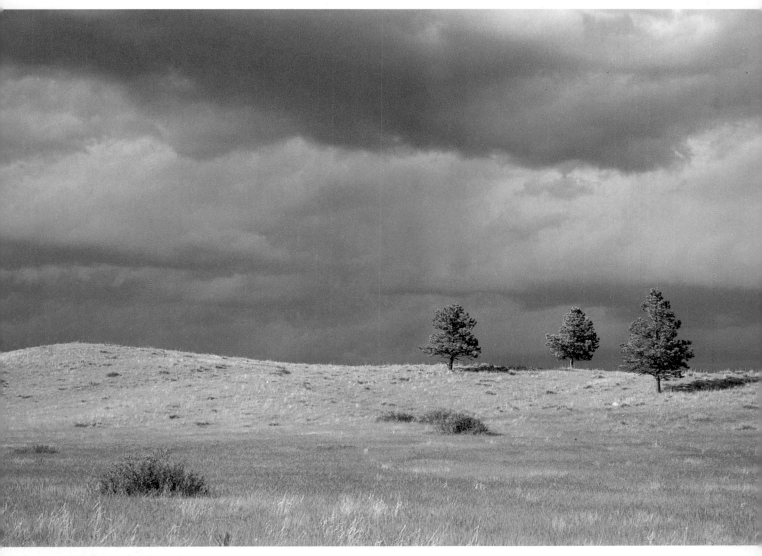

PROBLEM

The light-struck prairie seems oddly out of place here, set as it is against a dark, brooding sky. Making the two work together will be difficult.

SOLUTION

Exaggerate the contrast between the land and the sky. If the sky is dark enough and the ground light enough, you'll capture the drama of the scene.

Just before a summer storm, the rolling plains of a prairie are flooded with light.

STEP ONE

When you encounter a composition as simple as this one, don't worry about sketching it carefully with charcoal. Instead, draw directly on the canvas, using a brush dipped into thinned color. Next, lay in the darkest portions of the sky with thin turp washes.

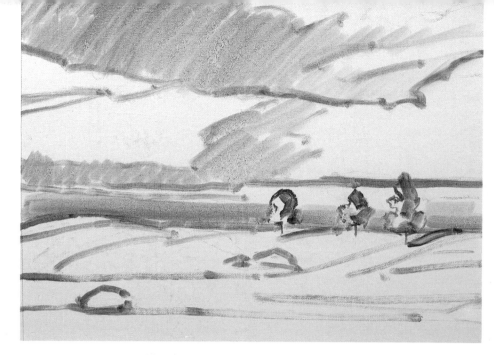

STEP TWO

Now begin to work with heavier color. Start with the sky; it will key the mood for the entire painting. As you put down your pigment, work quickly—the soft, fluid clouds must be worked wet-in-wet. Here cobalt blue dominates the sky; varying amounts of black and white darken or lighten it, and in places it is warmed with small touches of cadmium orange. The sky established, enrich the foreground with sweeps of thalo green and yellow.

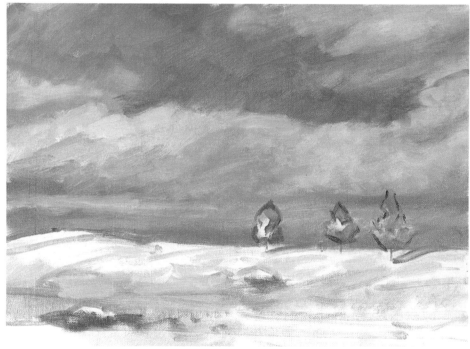

STEP THREE

Before you develop the foreground, complete the sky. The touches of bright green that you have just laid in will help you gauge how dark the sky must be if it's to work. Continue working wet-in-wet; if the surface has dried, you'll probably have to rework the entire sky to keep the edges soft and to blend the subtle shifts in color and value. Once you are happy with the sky, turn to the foreground. Make your brushstrokes curl back over the hill, following the contour of the land as it dips into the horizon.

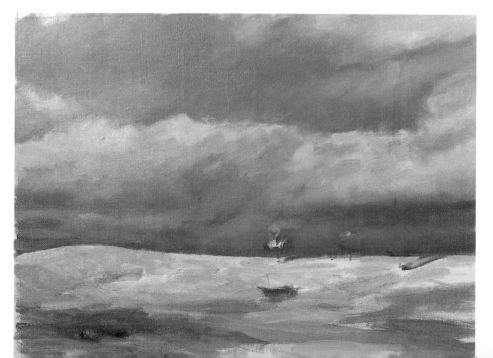

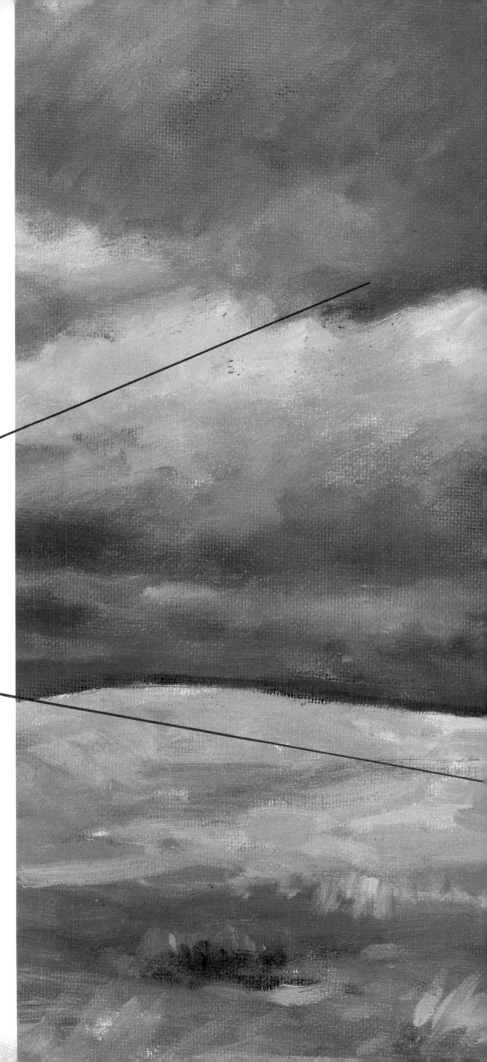

FINISHED PAINTING

With the dramatic sky completed, finish the foreground. Thalo green, cadmium yellow, and yellow ocher come into play here; in spots, touches of burnt sienna break up the brilliance of the bright yellowish-green. Next, add the trees that hug the horizon. Keep them small—their size gets across the vastness of the open prairie. Finally, use their shadows as a compositional device. Painted carefully, they show how the hill meanders upward, and how the land meets the sky.

Worked wet-in-wet, the sky is soft and fluid, without any sharp edges. Its stormy feel is captured through color; mixtures of black and white are cooled with cobalt blue or warmed slightly with cadmium orange.

The brilliance of the greens is exaggerated to set off the dark, gloomy quality of the sky. Touches of burnt sienna break up the bright-green tone that dominates the foreground; these strokes of brown sculpt out the shape of the hillside.

Constructing a Solid Underpainting

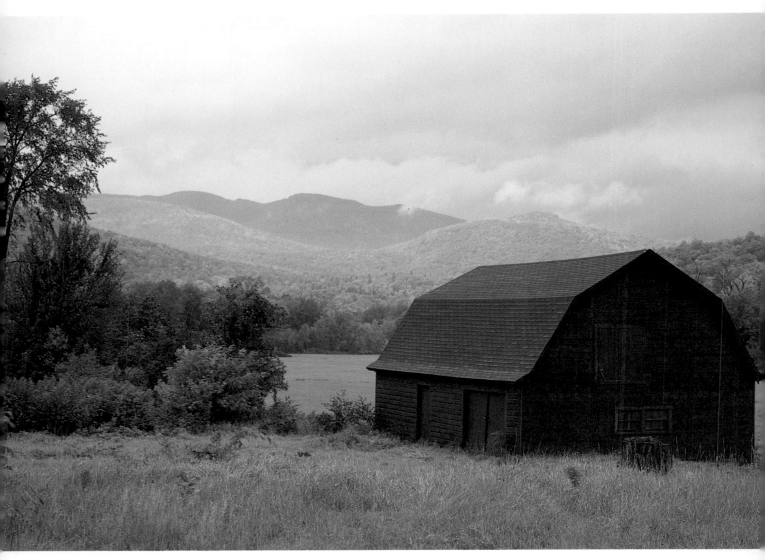

PROBLEM
Three distinct zones are present in this painting. Clear, even light bathes the foreground, storm clouds press down over the mountains in the background, and gentle mist washes over the middle ground. Your painting has to capture these different effects simultaneously.

SOLUTION
Capitalize on the clear division of space. Build up your underpainting slowly, carefully establishing each zone with thinned color. When it comes time to work with opaque color, you'll find it easy to complete your painting.

Bright green grasses surround a barn, setting off the cool colors of a stormy sky.

STEP ONE

Before you begin your sketch, carefully study the scene. Don't just study the obvious shapes—the barn, the mountains, and the trees and bushes—but the subtle ones as well. Try to discern the planes of the ground and the vague lines that define the clouds. When you are at home with the landscape, sketch it on your canvas with soft vine charcoal.

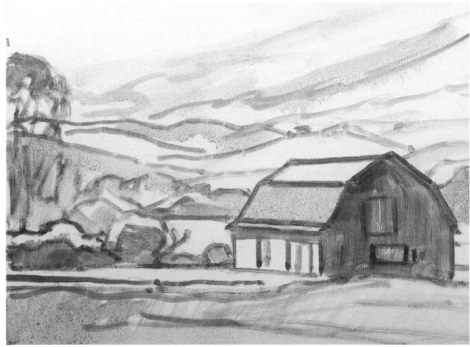

STEP TWO

Reinforce your drawing with thinned color, then continue to use thin color washes as you lay in the darks. For now, the white of the canvas can represent the lights. Even in this early stage, be conscious of shifts in color and value. Aim at getting as close to what you want to see in the final painting right from the start.

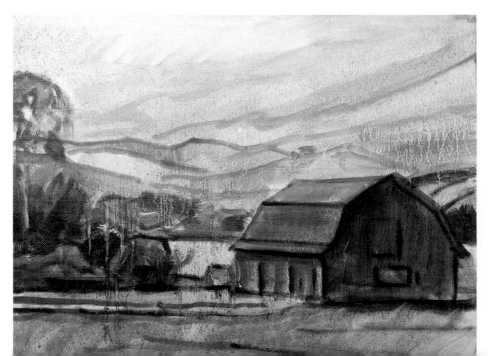

STEP THREE

You may be tempted to rush in with opaque pigment at this point—but don't. Instead, develop the entire surface with thin turp washes. You may find that your paint dribbles and runs when you are working with so much liquid, but don't worry about it. Concentrate on the overall color and value schemes. If portions of your drawing have been lost as you laid in the color washes, redraw them with a small sable brush.

FINISHED PAINTING

It took patience to develop a complex underpainting, but now you are ready to reap the rewards that this approach offers. You'll be surprised at how quickly the painting advances when you begin to lay in opaque pigment. As you work, remain faithful to your underpainting. You've established your values—minor adjustments are all that will be necessary. What's more, your colors are well developed, too.

The clouds and distant mountains are soft and unfocused. From the very beginning, they were handled more loosely than the foreground and middle ground. And, unlike the other areas in the painting that are rendered with bright color, smoky grays and cool blues are dominant here.

When one element is as prominent in a painting as this barn is, start work on it right away. Carefully decipher its lights and darks, then slowly build them up. If you save a building for the very end, the chances are that it will look out of place in your painting and that it won't relate to the rest of the work.

Bright, vivid color dominates the foreground: It's made up of permanent green light and yellow ocher. Laid in with quick, upright strokes, the tall yellow grasses spring forward and make it easy for the viewer to enter the picture space.

ASSIGNMENT

Try this approach with one of the other compositions in this book. As you paint, forget for a while that your medium is oil paint: Think of it as watercolor. You'll be forced to solve problems in value from the very beginning and you'll become increasingly conscious of the importance of color.

Once you are comfortable with this method, try it outdoors when you are faced with a difficult composition. You'll soon discover that the pains you take initially are well rewarded in the end.

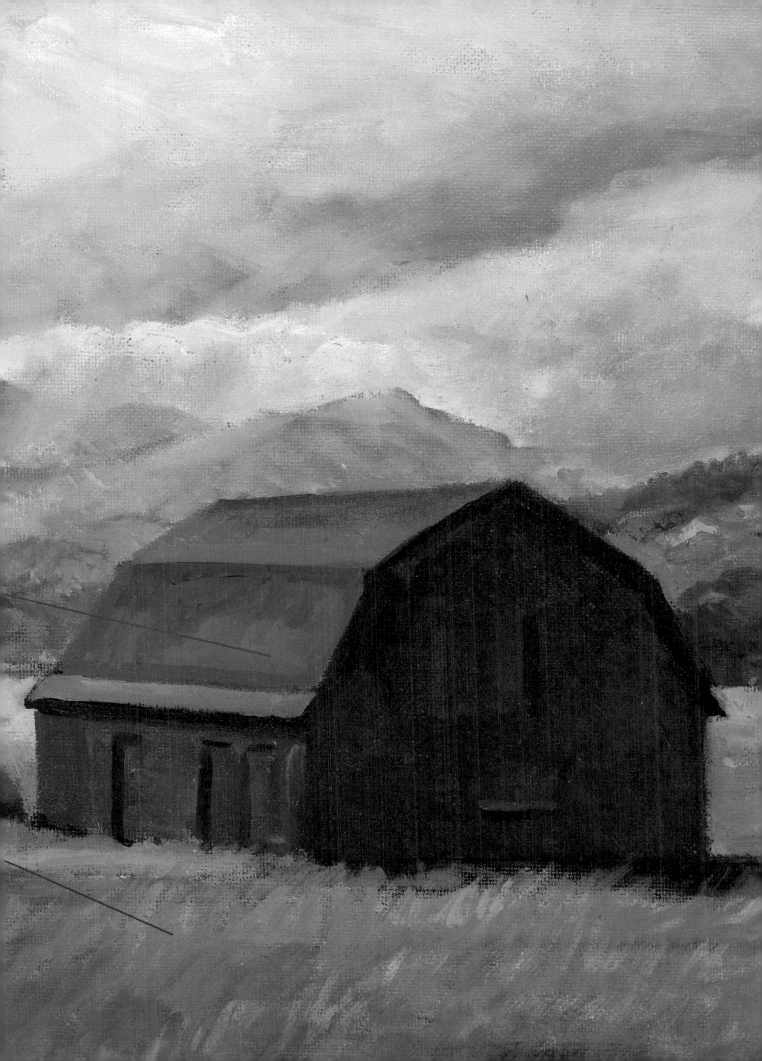

DARK, BROODING SKY
Making the Unusual Believable

PROBLEM

It's not often that you see scenes like this one. Except for the sliver of light along the horizon, it's made up of dark, brooding tones.

SOLUTION

Start with the most dramatic element, the sky. Keep its color very dark, then use it to gauge the rest of the values in your painting.

☐ With a small brush moistened with thinned color, lay in the composition. Now turn to the sky, working with opaque color. In one painting session, try to capture the effect that you want for the sky in the finished painting.

Here cobalt blue and cadmium red were mixed repeatedly together in small batches, then applied to the canvas. The shifts in color and value that result are slight, yet they animate what could become a dead, lifeless area.

Next, take a fan brush and run it over the surface of the canvas.

The foreground requires more care. Build it up slowly, introducing as much variety as possible. To link the ground to the sky, choose cobalt blue as your base. Break the blue up with touches of thalo green and yellow ocher, concentrating all the while on the contours of the ground. Downplay the patch of light that runs along the horizon; if it is too conspicuous, it won't be believable. At the very end, add the fence posts that march back toward the horizon.

When one color dominates a large portion of a painting, the rest of the work may seem unharmonious. That happened here. To tie the land into the sky, try applying blue glaze over the shadowy areas of the foreground. Let the painting dry, then mix a moderate amount of color with a good deal of painting medium. Freely brush the mixture over the shadows that play across the ground.

In the finished painting, the blue glaze applied at the very end links the prairie to the dark, dramatic sky, and the sliver of light that creeps along the horizon is bright, unexpected, and full of life.

In South Dakota, a patch of light steals down upon a prairie as a dark and dramatic sky signals the approach of a summer rainstorm.

Learning How to Emphasize the Sky

PROBLEM

The sky is what matters here—it's streaked with subtle yet glorious color. But unless you are careful, the dark foreground may become the focus of the painting. Because it's so dark, it can easily overpower the delicate sky.

SOLUTION

Make the clouds as interesting and lively as possible, then paint the ground a bit lighter than it actually is. With the ground lightened, the sky will dominate your painting.

☐ Once again, the subject is simple and there's no need for a careful charcoal sketch. Instead, draw directly on the canvas with a brush that has been dipped into a thinned color. Continue working with thin washes of color as you lay in the darkest areas in the painting.

Once your thin underpainting is well developed, switch to opaque pigment. Use a wet-in-wet approach to render the sky. Near the top of the canvas, make your colors blend into one another. As you approach the horizon, lay in stronger bands of color.

Study the foreground carefully before you develop it. Pattern matters here; it will break up the dark, dense ground and make it less oppressive. Exaggerate all the nuances that you see; what you are aiming for is a lively feel.

When the foreground is down, you'll no doubt need to return to the sky, to balance it against the powerful darks that you have just laid in. If it seems too light, darken it a bit, but don't get too fussy. As a final step, sharpen up the area where the land meets the sky. A clear, crisp horizon line will pull the two areas apart neatly.

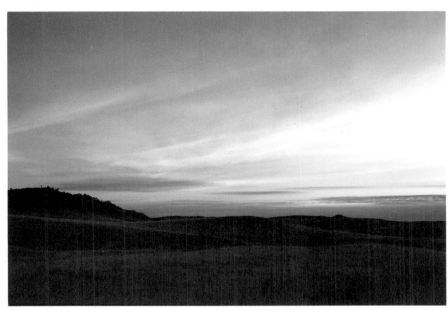

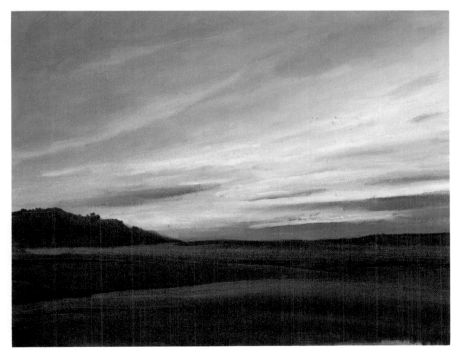

Streaks of pale, luminous color shoot through a cool winter sky.

Laying in a Dark Yet Lively Sky

PROBLEM

When scenes look as simple and straightforward as this one does, it's easy to become lazy. If the sky becomes too flat, or the trees too simplified, your painting won't look realistic.

SOLUTION

Break up the sky with slight variations in color. When it comes time to paint the trees, carefully portray their individual character and keep your paint fluid so that it can glide easily over the canvas.

☐ Execute a careful charcoal drawing, then spray it with a fixative. Now lay in the sky with thin turp washes. Start at the top of the canvas, using a wash made up of cobalt blue and alizarin crimson. As you approach the horizon, gradually introduce cadmium red into your wash and reduce the amount of alizarin. Right near the horizon, add just a touch of cadmium orange. Don't worry if your wash runs and streaks during this stage; you'll eventually cover this.

When the sky is laid in, quickly brush thinned color—Mars violet and cobalt blue—over the foreground. Then reinforce your drawing of the trees with thinned color. Keep the color really dark; it has to show through when the sky is overpainted.

Now prepare your palette for the execution of the sky. You'll need the same colors you used for your preliminary underpainting. Squeeze a little white onto your palette as well. Mix small amounts of color repeatedly, not one big batch when you begin.

Starting at the top of the canvas, lay in the sky, working wet-in-wet and from light to dark. Paint right over the trees; you've reinforced the drawing so they won't become lost. Next go back and lay in the gently rising mist with a mixture of cobalt blue and alizarin crimson. Now paint the dark foreground, using Mars violet and cobalt blue. To render the long, thin tree branches, you'll need fluid pigment, so thin your color—here Mars violet and cobalt blue—with plenty of painting medium.

Paint the trees with a small sable brush, using long, unbroken strokes. Most important, be faithful to what you see: If you start to embellish the patterns of the branches, you'll lose the realistic look.

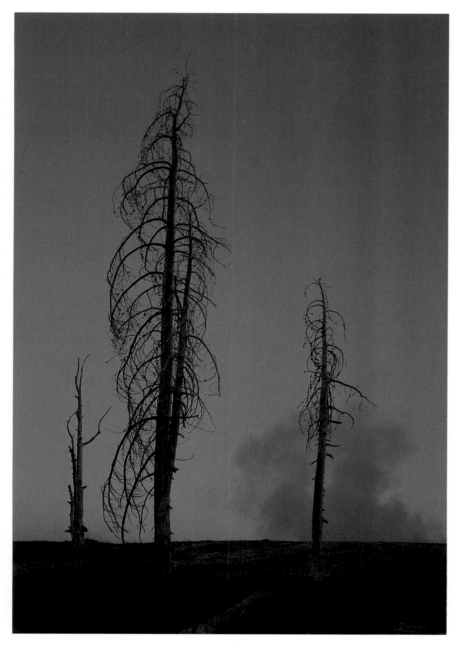

In Yellowstone Park at twilight, tall, thin lodgepole pines stand silhouetted against a cool purple sky as mist from a geyser rises behind them.

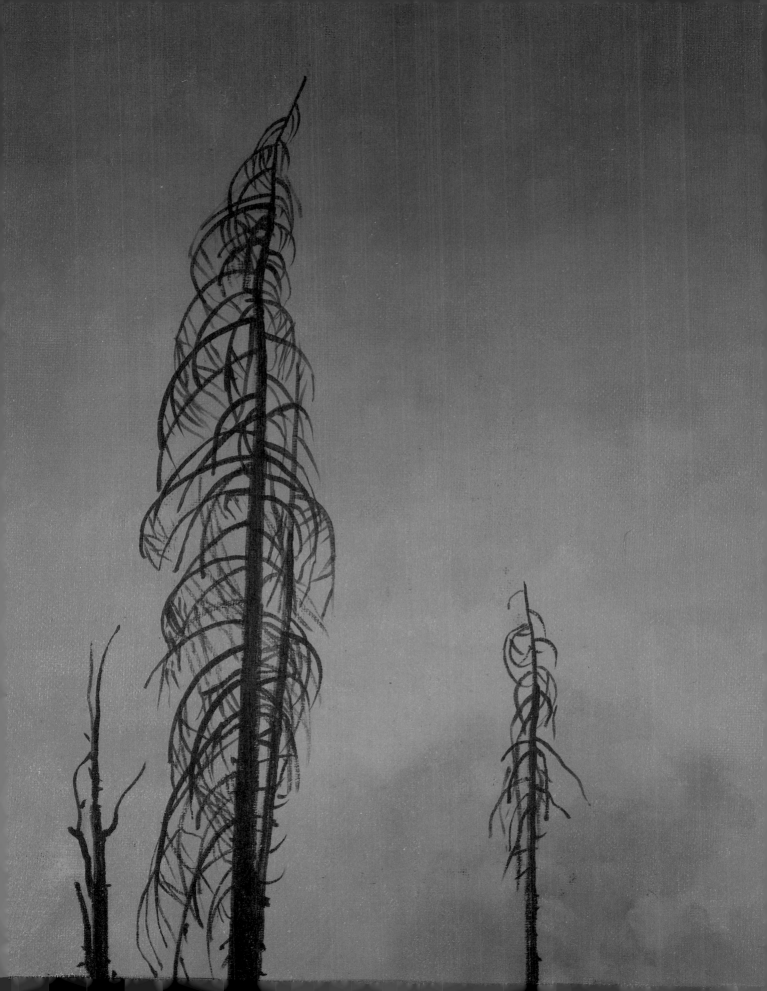

Deciphering a Landscape Partially Hidden by Fog

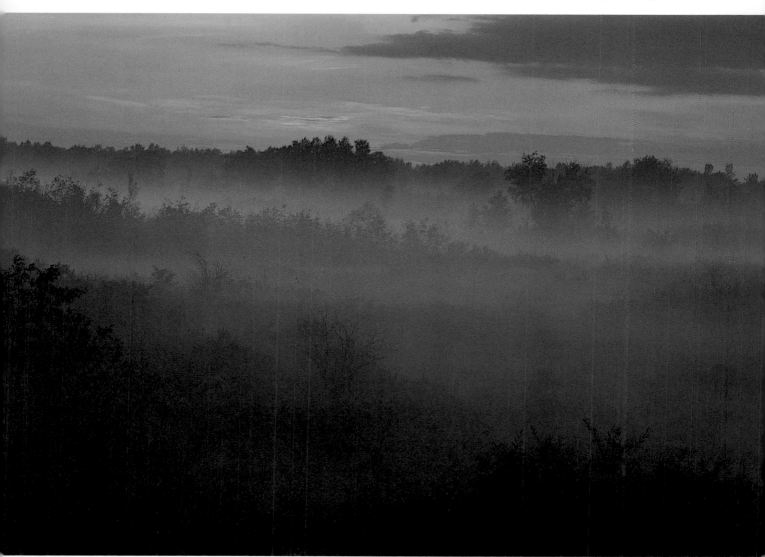

PROBLEM
Simply stated, this subject will be difficult to capture because you can't really see what you are painting: Delicate, misty fog covers most of the landscape.

SOLUTION
Simplify the major shapes in the composition, but keep them sharp enough to suggest what lies behind the fog. You'll have to use your imagination because the mist obscures most of the forms in the foreground.

As the sun slowly sets on a summer evening, soft fog floods a valley.

STEP ONE

Since there isn't much to grab onto here, don't try to capture the scene with a preliminary charcoal sketch. Instead, work directly with a small sable brush. Concentrate on the patterns that lie in the sky and the lines that separate the tree tops from the fog. Don't let your drawing become too complex; deal with overall patterns and shapes.

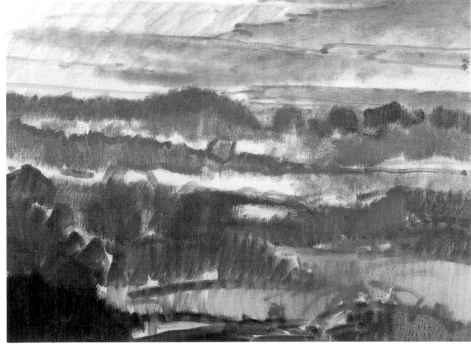

STEP TWO

As you begin to establish the dark patterns that run throughout this scene, paint them with very dark washes. Remember that anything you lay in at this stage is bound to look dark against the white of the canvas. To capture the indefinite feel of fog, scrub the paint onto the support with a bristle brush; the weave of the canvas will mimic the softening qualities of the mist.

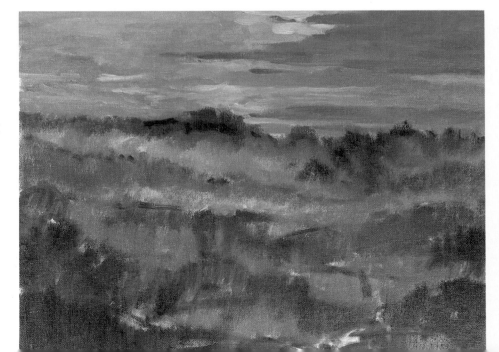

STEP THREE

Move to the sky. Work back into it with thicker pigment, using long horizontal strokes to trace the shapes of the clouds. If the darks that you have already laid down are strong enough, the lights that run through the sky should be easy to capture. Next, suggest some of the foggy foreground by applying color, then pulling it down over the canvas.

FINISHED PAINTING

As you move in to complete the foreground, let the sky key the painting's overall mood. Judge each value in relation to what you have already established in the sky. Continue working with a bristle brush, scrubbing paint onto the canvas; the soft, undefined feel that results is perfect for depicting fog. Don't let your color become too light: The foreground is much darker than the sky.

At the very end, take a small sable brush and define the area where the trees meet the sky. This sharp edge is important—it emphasizes the soft feel of the fog.

The sky is what anchors the whole scene—everything else is softened by fog. And because soft mist permeates the land, it's easy to make the sky soft, too. When you are faced with this kind of situation, play up the contrast between the two moods. Make the sky sharp and definite, laying it in with long, forceful strokes.

When you start to work on the hills, don't let your paint become too thick. The secret to capturing a gentle, misty feeling is scrubbing the paint on thinly over the canvas. When you scrub paint onto canvas, it breaks up any strong, thick passages of pigment.

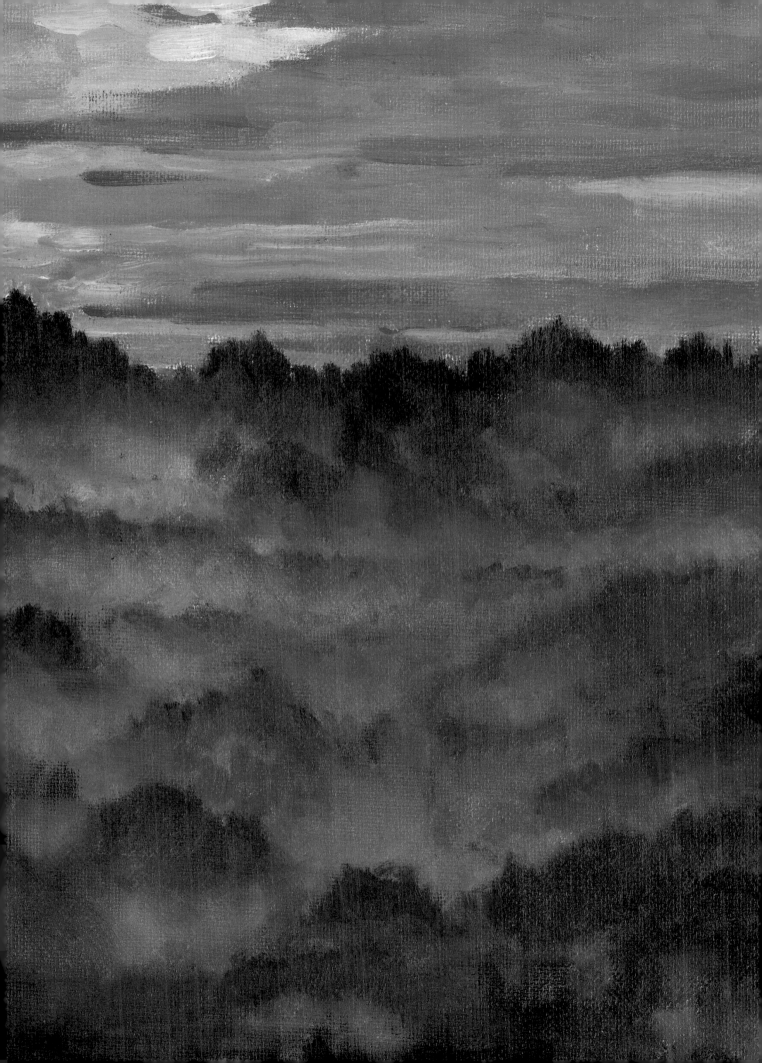

Making a Dark Foreground Spring to Life

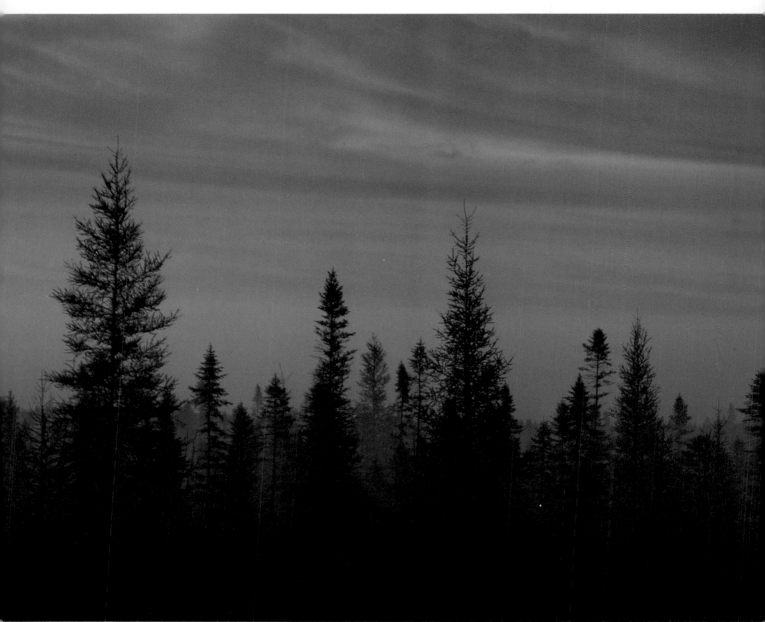

PROBLEM

The entire scene is hushed and dark. If your painting is too faithful to what you see, it will be too dark and forbidding.

SOLUTION

The key to animating a dark, flat foreground is to inject life into its darkest corners. Use subtle touches of color to break up the monotony of the trees.

☐ Sketch the scene with vine charcoal and apply fixative. Working with thin washes of color, lay in the patterns that sweep through the sky. Use thin washes to establish the darks that lie in the foreground.

Now that you've established the foundation of your painting, start to use opaque pigment. Slowly work back into the sky, moving from dark to light. At first, paint the dark patterns with a mixture of cobalt blue and

cadmium red. Once they're down, brush in the lighter areas of sky lying between the dark bands and below them. Don't add too much white to your pigment; if you do, you'll lose the intense color that pervades the sky. And be sure to cover portions of the sky that lie between the trees; it will be difficult to go back to them later and still achieve the soft, fluid effect that you want.

Now comes the step that matters most: Paint the trees. You'll

Brilliant bands of deep red spill out across the sky, boldly silhouetting tall, handsome spruce and tamarack trees.

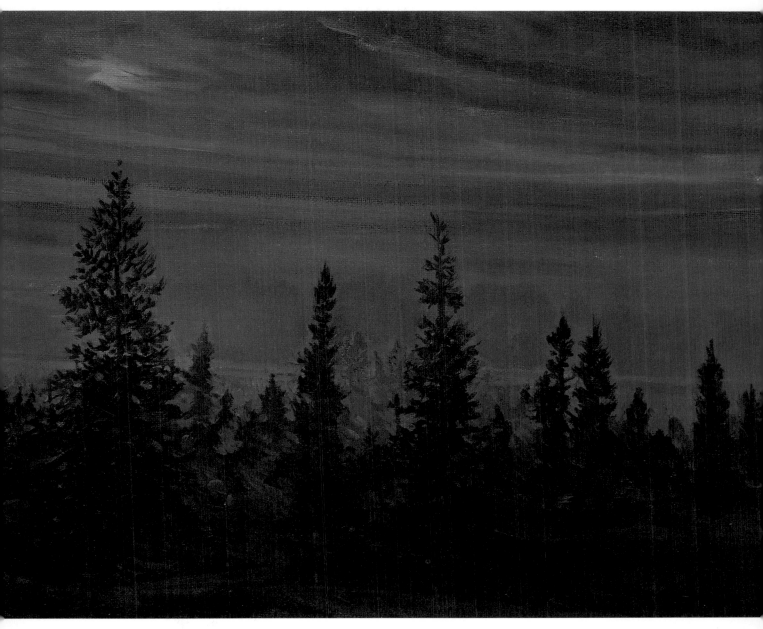

need the following colors: thalo green, alizarin crimson, cobalt blue, cadmium red, and white. Start by sweeping a pale blend of cobalt blue and alizarin over the entire foreground with a medium-size bristle brush, then slowly build up individual trees with a small sable brush.

As you work, remain conscious of the distinct layers that the trees form. For the background trees, continue using cobalt blue, alizarin crimson, and white; grad-ually decrease the white as you move forward. When you reach the trees closest to the fore-ground, substitute thalo green for the cobalt blue. Continue working with a small sable brush—one that can pick out the individual silhouettes of each tree.

When you've established the silhouettes of the major trees, break up their dark bodies with small touches of strong color—the same hues that you used in the sky. Try mixing alizarin crim-son with a little thalo green, then gently dab the color onto the canvas. Pick out the highlights that would be there if the fore-ground were lighter and brighter.

At the very end, evaluate how successfully you have established the different planes. The trees in the foreground should be darker and more strongly developed than those that lie further back. If the distant trees seem to meld to-gether with those closer to you, make them softer.

Learning When to Lay in Your Darkest Values First

PROBLEM
There's so much action in the trees that the special feel of the cool morning sky might easily be lost. And if you lose it, you'll lose the glowing quality that makes this particular scene special.

SOLUTION
It's tempting to lay in the sky first, then to concentrate on the trees. But if you do, the sky may end up too light or too dark to offset the power of the trees. Try a different approach: Establish a few of the major trees, then move on to the sky.

STEP ONE
In your preliminary charcoal sketch, concentrate on the shapes of the largest and most important trees and on the shadows that spill across the snow. Once they're down, reinforce your drawing with thinned color.

On a cold, crisp February morning, sunlight breaks through a stand of trees and illuminates a deep blanket of snow.

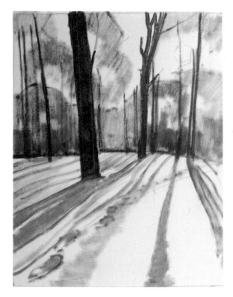

STEP TWO

Working with opaque color and very little painting medium, establish the trees that dominate the scene and the shadows that they cast. Scrub your pigment onto the canvas with a bristle brush; even though the color is opaque, it shouldn't be too dense. Now, working with paler color, lay in the overall shapes of the finer branches and twigs that make up the trees in the background.

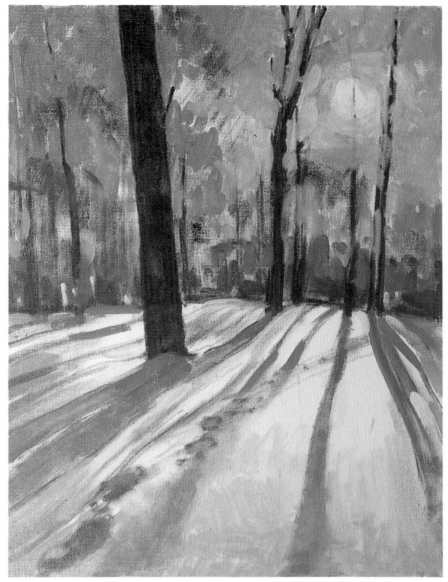

STEP THREE

Paint the sky through and around the tree forms that you have started to establish. Use fluid pigment and soft strokes that suggest the dappled quality of the light. Before you move on, turn to the broad shapes of the background trees. With a drybrush technique, soften their edges against the sky. When the sky has been painted, you'll find that small adjustments in color and value are necessary to make the snow and the shadows realistic. Adjust the shadowy portions, but for now, let the white of the canvas continue to represent the lightest areas.

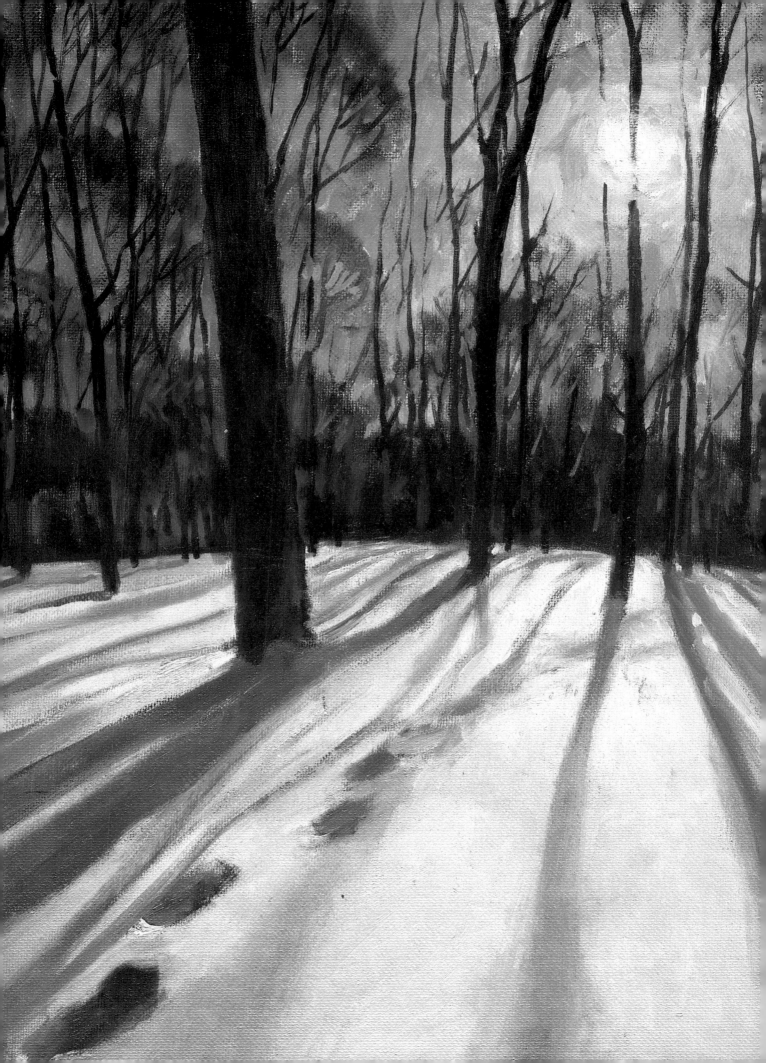

FINISHED PAINTING

At this point, all the hard work is done. The values are right, the perspective is clean and sharp, and the warm and cool colors are well established. It's time to have fun. Take a small sable brush and develop the twigs, branches, and trunks that dominate the scene.

At the very end, cover the snow-blanketed areas with a mixture of blue and white, then blend the light areas into the darker portions of the ground.

DETAIL *(right)*

Note how the trees and the sky weave together. Working back and forth between the trees and the sky results in a natural, unstudied effect.

DETAIL *(below)*

The cool blue shadows that rush forward were among the first elements painted. Along with the dark trees, they key the value scheme for the entire painting. More than just that, they direct the eye back toward the horizon and the sky.

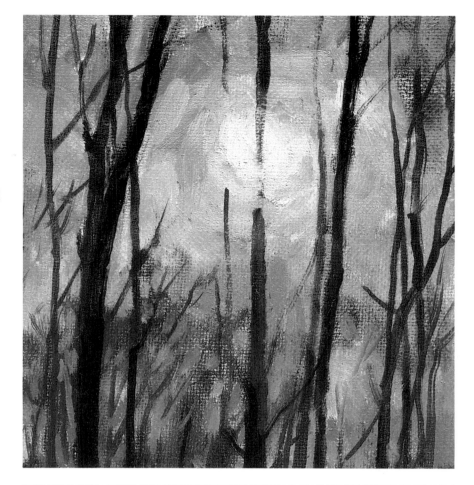

ASSIGNMENT

It's easy to think of snow as white—after all, that is its basic color. However, snow is actually made up of many different colors, colors that the sky determines.

In winter, go outside and make quick color sketches of snowy scenes. Plan to do this assignment over several days, or at different times of day, so you can work with a variety of conditions. When the sky is cool you'll probably find that the snow seems bluish or even gray. On bright, sunny days look for touches of unexpected color—reds and yellows—in the snow.

After you've experimented with color sketches, try executing a major oil painting. Force yourself to apply what you've learned: Don't let pure white figure in your painting. Instead, use pale blues, purples, grays, yellows, and reds.

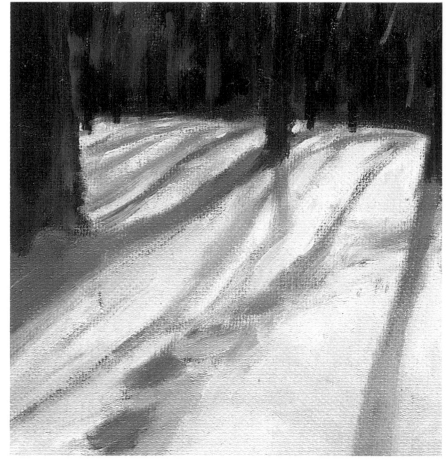

Using Glazes to Pull a Painting Together

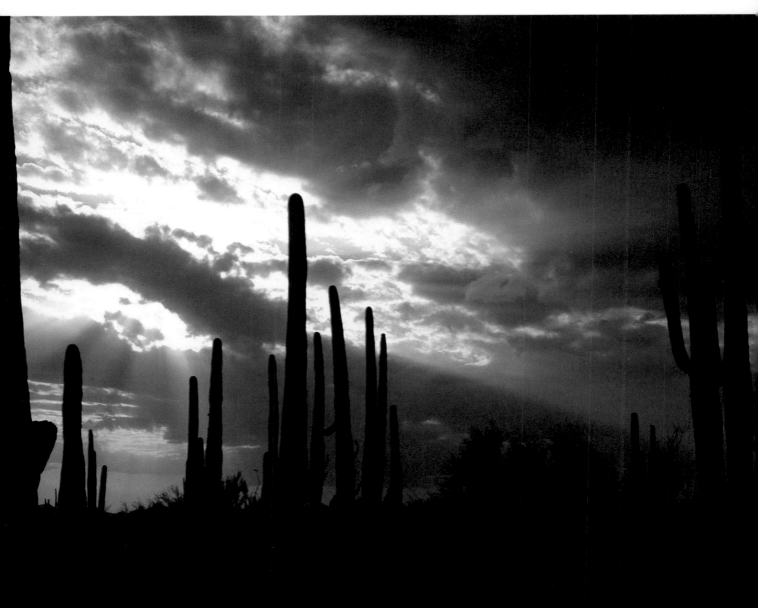

PROBLEM
This scene is mostly made up of darks, but the lights are what make it exciting. It will be important to capture the bright sun that lies behind the clouds.

SOLUTION
Keep the clouds and the surrounding sky really dark. Then, when you add the bright patches of light, the contrast between the two will be sharp and vivid. Finally, pull the sky together with a thin application of glaze.

☐ Sketch the scene with charcoal, dust off and fix the canvas, then reinforce the lines of your drawing with thinned color. In your sketch, concentrate on the patterns formed by the clouds. Don't get caught up with the cacti; their forms are very simple and can easily be added toward the end.

As soon as your preliminary work is complete, begin to paint the sky. Take a medium-size bris-

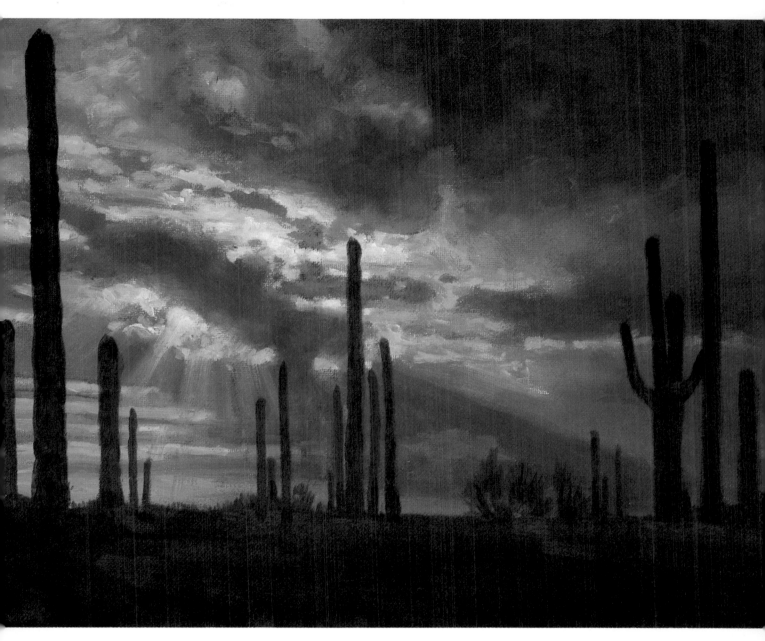

As the sun sets over the Sonora Desert, thick, heavy clouds race across a dramatic gold sky.

tle brush and opaque paint and scrub in the darks of the clouds. Here they are rendered with mixtures of yellow ocher and Mars violet.

Before you lay in the lights, cover the entire sky with a warm glaze of yellow ocher and cadmium orange. The glaze will pull together the dark clouds and tone the white portions of the canvas, making it easier for you to gauge your values. While the glaze is still wet, paint the light areas of the sky and the light-struck edges of the clouds. Use a wet-in-wet approach to keep the sky soft. Cadmium yellow and white come into play here; in places, cadmium orange is added to the yellowish pigment to give the lights warmth and depth. When the basic lights are down, paint the bands of sunlight that break through the lower clouds at the left by dragging light paint down.

The rest of the procedure is simple. Add the cacti, using warm, rich darks made up of Mars violet and cobalt blue. Keep as much variety as possible in these darks by mixing several small batches of color rather than one large one. Don't feel obliged to paint each and every cactus. Here, only the major plants work their way into the painting; if more were present, the drama of the scene would be diminished.

Capturing the Brilliance of the Setting Sun

PROBLEM

Ths sun is always difficult to paint. Whenever it appears in a painting, there is a tendency to paint the sky too light. And if the sky is too light, you'll lose the contrast that makes the sun seem brilliant.

SOLUTION

Consciously exaggerate the darkness of the sky. As you paint, remember how deceptive your first strokes are. Set against the white of the canvas, the color you are laying in seems much darker than it actually is.

☐ Establish the anatomy of the trees in a charcoal sketch, then dust off the canvas, leaving just enough of the drawing to serve as a guide as the painting develops. Spray the canvas with a fixative.

With thinned color, brush in the sky and establish the dark patterns that lie in the foreground. Don't let the foreground become too flat; break it up with shifts in value and color and separate it into distinct planes.

Now work back into the sky with opaque color. With broad, sweeping strokes work from the edges of the canvas toward the sun. Keep your color dark— darker than you think it should be. Near the sun, make it slightly lighter, but don't add white to your pigment. Even the smallest touch will diminish the brilliance that you want to achieve.

Before you paint the sun, build up the foreground, painting the trees up over the sky. Continue to break the trees into distinct layers; those in the distance are softer and less distinct than those in the middle ground or the foreground.

To paint the large tree that dominates the foreground, use a small sable brush that has been moistened with just a small amount of pigment. The broken strokes that result when you work with a slightly moist brush are perfect for depicting leaves and branches.

Finally, paint the sun. Here it's rendered with white and cadmium yellow. Don't mix the two colors completely; flecks of yellow in the white will make the sun seem to shimmer softly.

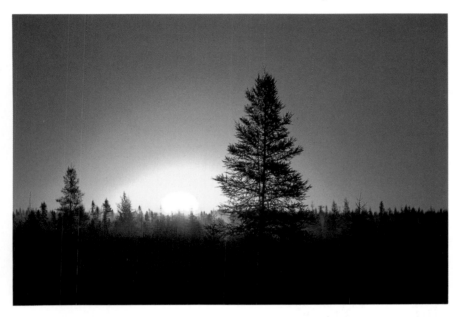

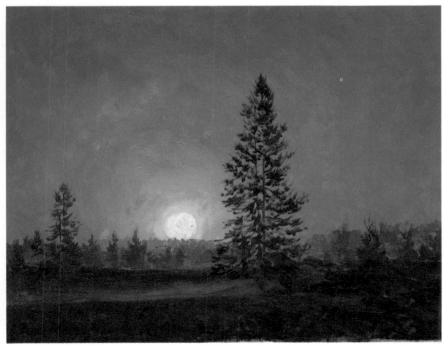

As the sun sinks below the horizon, a brilliant sky silhouettes stately tamaracks.

Working with Simple, Flat Shapes and Vibrant Color

PROBLEM

When you approach very simple subjects like this one, color is your main tool in creating an interesting painting. If you are insensitive to the colors that you see, your painting will be flat.

SOLUTION

Keep the color as rich and exciting as possible—even the dark foreground should be loaded with color. As you work, don't be afraid to develop your painting in a decorative fashion.

☐ Since the subject is so simple, skip the usual charcoal sketch. Instead, quickly draw the scene with a small brush that has been dipped into thinned color, then brush in the colors and values of the mountains and sky. Keep everything flat.

With heavier color, work back over the underpainting. At this point you have two options: Either add texture to the flat planes you've established, using strong, heavy brushstrokes; or let the hot, glowing color carry the entire painting. No matter which direction you take, keep the color hot and lively.

Next, refine any edges that are fuzzy to achieve the kind of crisp ornamental effect you're after.

At the very end, paint the sun. If you've chosen to enrich the surface with texture, you may want the sun to have a soft, gentle edge. If so, paint it while the sky is still wet. If you have chosen to emphasize color, a crisp sharp edge will probably be more at home in your painting.

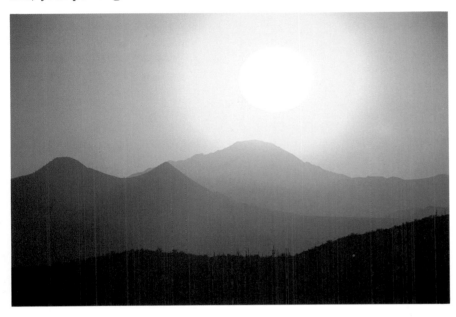

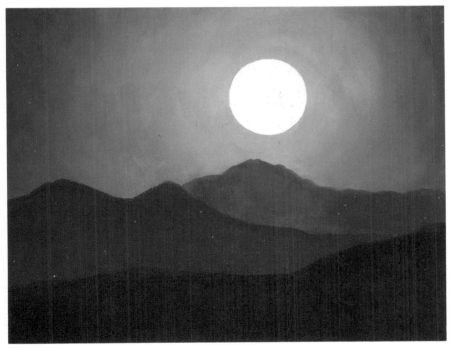

ASSIGNMENT

If you like the decorative effect that you have achieved here, apply what you've learned to another subject illustrated in this book. You'll find that reducing a scene to stark, simple lines can transform any subject, even one that is packed with detail.

Before you begin, divide the scene into distinct planes, then make sure that each one is rendered with a different value. Experiment with a variety of subjects. You'll find that misty or foggy landscapes lend themselves particularly well to this kind of treatment.

Warm golden light washes over the gently curving mountains of the Sonora Desert.

Working with Diverse, Complex Elements

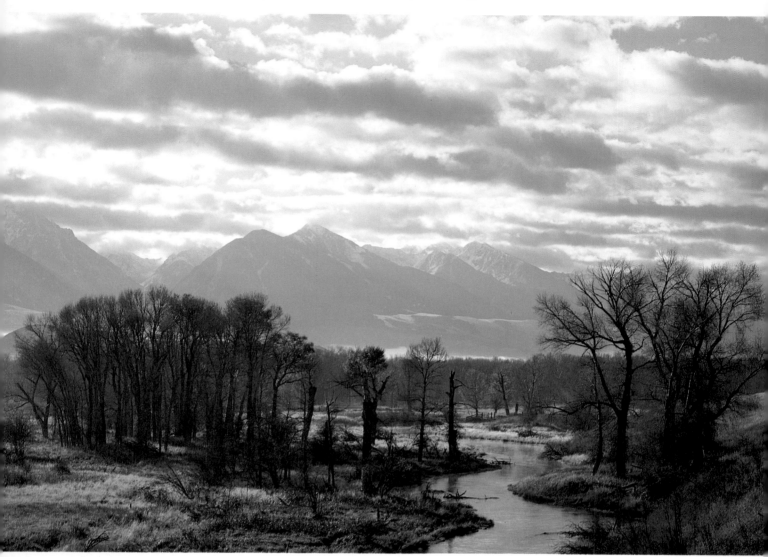

PROBLEM
A lot is going on here. Brilliant sunlight breaks through a thick bank of clouds, then spills across a complicated landscape. When you are working with so many diverse elements, it can be difficult to create a unified painting.

SOLUTION
Don't rush into your painting too quickly. Complicated subjects require careful planning. Think through your approach and execute a detailed drawing before you start to work with color.

In Montana, the Yellowstone River meanders slowly backward toward majestic mountains and a cloud-filled sky.

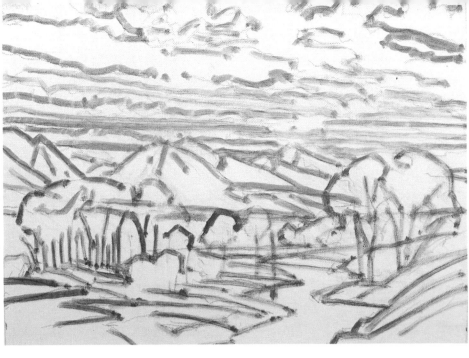

STEP ONE

Place all the elements in the composition with a careful charcoal drawing. Break all of the elements into simplified shapes. Here, for example, the trees are drawn as rough masses, disregarding their individual branches. Add the shapes formed by the shadows, too, and the contour lines that define the landscape. Now reinforce your sketch with thinned color.

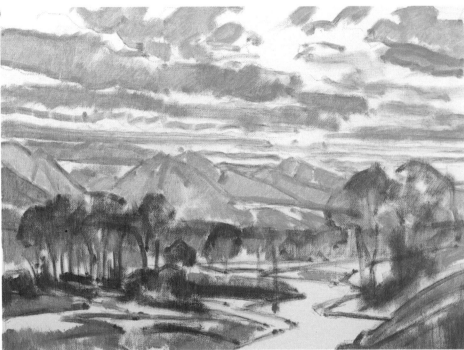

STEP TWO

Instead of using thinned color to build up the painting, try scrubbing opaque pigment onto the canvas. You'll find that by using this approach, you can achieve accurate colors and values much more quickly—an important consideration in a complex scene. Don't let patches of thick color occur; really scrub the paint onto the support.

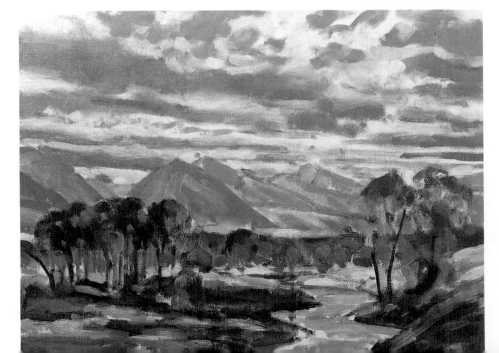

STEP THREE

Continue to develop your painting by laying in small strokes of color, one over the other. Start with the sky; it sets the mood of the entire painting. As you proceed, key the rest of the work to the sky. Don't let your strokes become too fussy; you are still trying to build up overall shapes, not details. Note, for example, how the trees are still rendered in a simplified fashion.

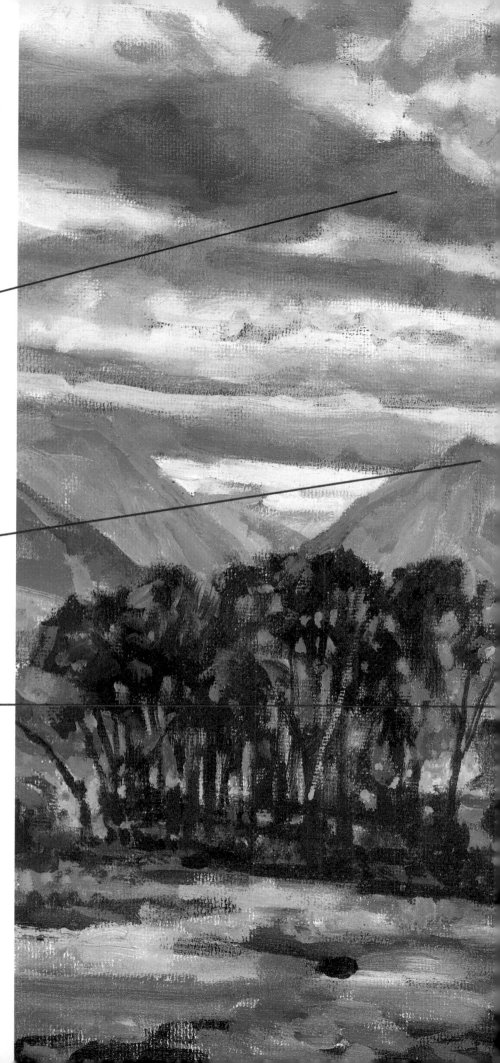

FINISHED PAINTING

At the very end, paint the white clouds, then add details, and strengthen the color and values of areas that seem weak. With a small sable brush, pick out the branches of the individual trees, then sharpen the line where the mountains meet the sky.

From the very beginning, the complex sky was simplified. First, it was broken into individual shapes in the preliminary drawing, then these basic shapes were retained as color was added to the composition. Cerulean blue mixed with a touch of thalo green and white forms the brightest portions of the sky; the darker areas are rendered with cobalt blue and cadmium red.

The simplified volumes of the mountains dominate the background. Like the sky, they were rendered slowly and carefully, with emphasis on their overall shape.

Until the very end of the painting, the trees were rendered as simple, abstract shapes. As a final touch, their individual trunks and branches were picked out with a small brush. If they were painted more elaborately, they would make the final painting overly complex and hard to understand.

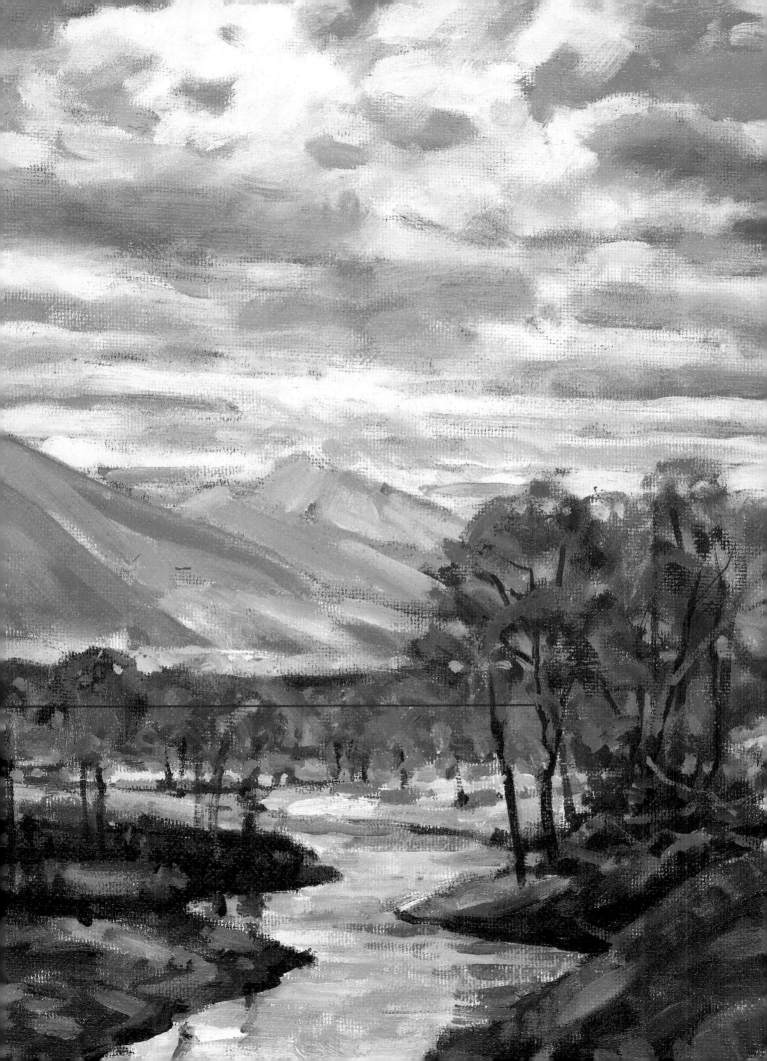

Painting a Building Set Against a Cool Winter Sky

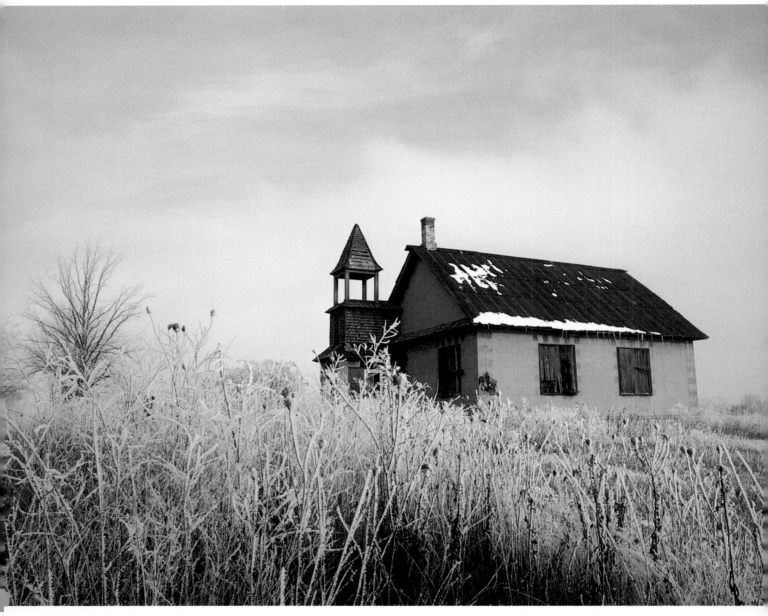

PROBLEM

You may be tempted to concentrate on the frosty grasses—after all, they dominate the foreground and set the mood of the painting—or on the church. But if you concentrate on just one part of the composition, you may lose the delicate feel that characterizes the whole.

SOLUTION

Analyze the overall effect you want to achieve and decipher all of the elements that set the scene's mood. Here they include not just the frost-covered grasses and the church, but the pale morning light, the soft clouds forming in the sky, and the shadows that spill over the foreground.

☐ Before you begin, a precautionary note: When you are working from photographs, be aware of the distortions they sometimes create. Here, for example, the vertical lines of the building slope in far more than they would in nature. If you draw them as they appear in the picture, the church will look as though it is falling over. Straighten them out in your drawing.

Use your charcoal drawing to place the major elements of the composition then strengthen its

On a frosty January morning, an old church stands proudly against a cool blue sky.

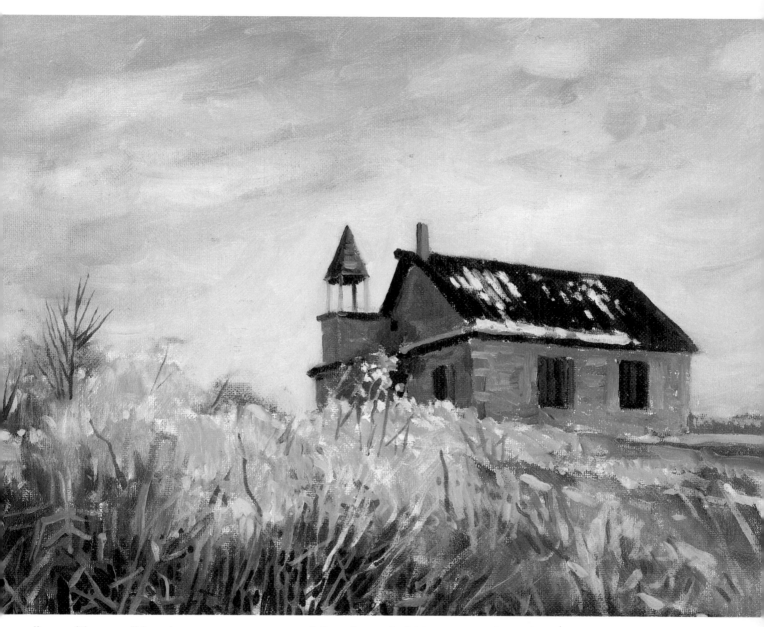

lines with a small brush moistened with thinned color. Continue working with thinned color as you lay in the dark shadowy side of the building and the dark patterns that define the grasses.

Now that the darks are down, lay in the sky. Working with opaque pigment and forceful strokes, apply the paint to the canvas. Begin with the darker blues; while they are still wet, add the lighter clouds. Your strokes should have a definite

sense of direction, mimicking the way the clouds move across the sky.

To build up the foreground, pack many small brushstrokes together, working back and forth from dark to light. Don't try to paint the frost at this stage. Keep your strokes crisp and definite to suggest how close the grass is to the front of the picture plane.

All along, you've concentrated on the sky and the ground; now turn to the church. Lay in the walls and the roof with a medium-

size bristle brush, then rely on a small sable for details like the windows.

All that's left to do now is to paint the frost that clings to the grasses. Use white pigment that has been subdued with a touch of brown and apply it to the canvas with a soft sable brush. Don't get too caught up in detail—if the grasses become too important they will overpower the rest of the landscape and destroy the mood that you have created.

Capturing Mood with Color and Value

PROBLEM

Here you're confronting two problems. First, the cool bluish-gray sky might easily become flat and uninteresting. Second, the bits of snow that cling to the trees have to be rendered realistically if they are going to work.

SOLUTION

First, let subtle shifts in color and value animate the sky. When it comes time to paint the trees, render them carefully, paying attention to their anatomy. If the trees look realistic, it will be easy to show how the snow rests on their needles.

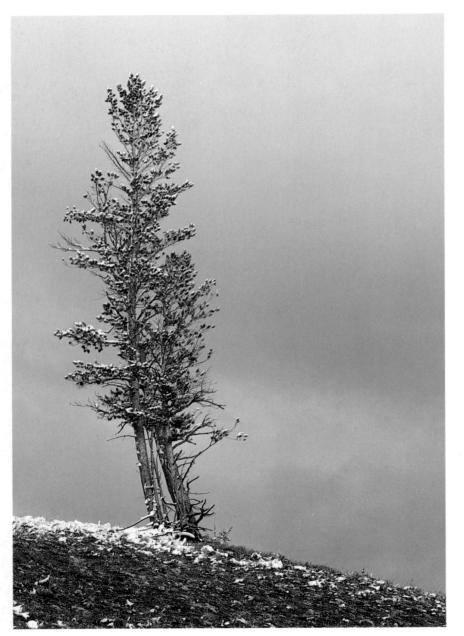

After the first snowfall of the year, two lodgepole pines stand tall against the cool winter sky.

☐ Carefully draw the trees with charcoal, dust off and fix the canvas, then strengthen your drawing with thinned color.

While you are waiting for the paint to dry, think through your approach. Because the sky sets the scene's mood, it's important that you capture its color and value accurately. Lay it in first, then key the other elements to it. And it's important that the sky seem soft and fluid, so try to complete it in one session.

Cool cobalt blue is perfect for winter skies. Working with cobalt and varying amounts of white, paint the sky. Keep the blue fairly dark, darker than it actually appears. Not only will a darker blue set off the white of the snow, it will also help establish the feel of the cool winter sky.

As you work, let your brushstrokes overlap to add a little texture to the sky. Pay attention, too, to value. Toward the top of the canvas, the sky is pale blue. Near the center, the blue becomes darker; as it nears the horizon, the blue lightens again. In the center, where the color is most intense, small touches of warm cadmium orange are added to the basic sky mixture.

Before you move on to the trees, paint the dark foreground with opaque pigment. When the canvas is dry, use a small sable brush and carefully paint the tree trunks and the major branches. Next, take a soft brush and gently add bits of green to suggest the pine needles. Now add the snow to the trees. Working with the same soft brush, dab white paint onto the canvas. As you work, concentrate on the pattern that the clumps of snow form.

All that's left now is to complete the foreground. Using bold, overlapping brushstrokes, paint the earth, then add the sweep of snow that lies along the horizon.

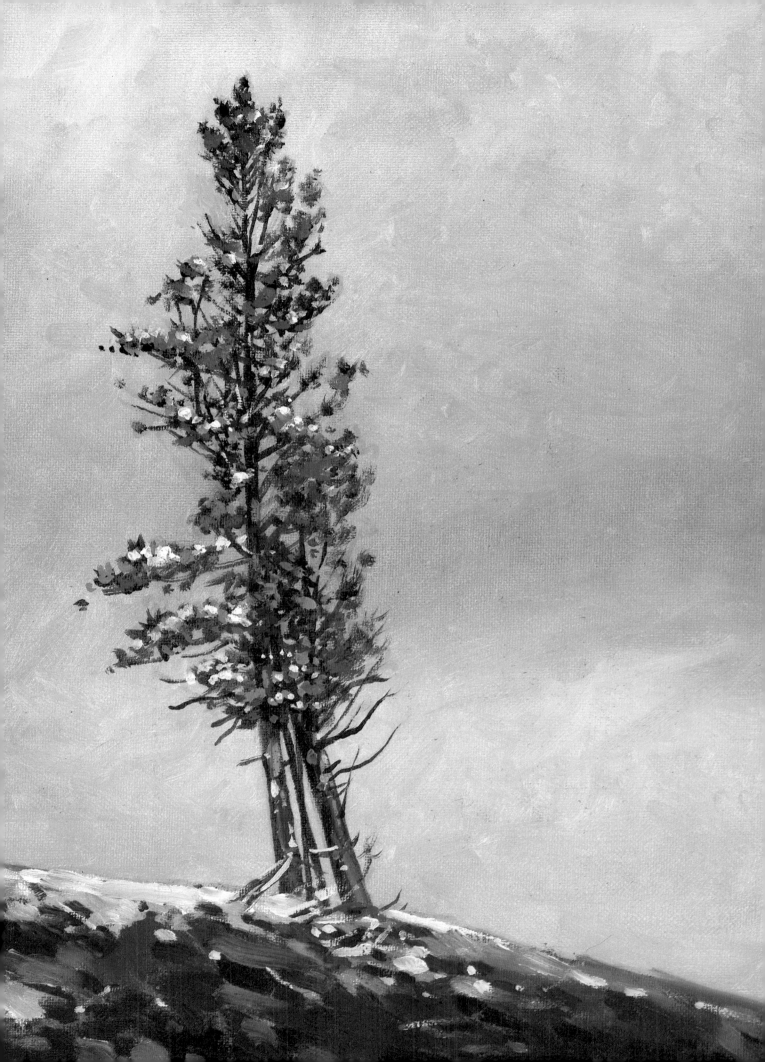

Painting an Expansive Sky

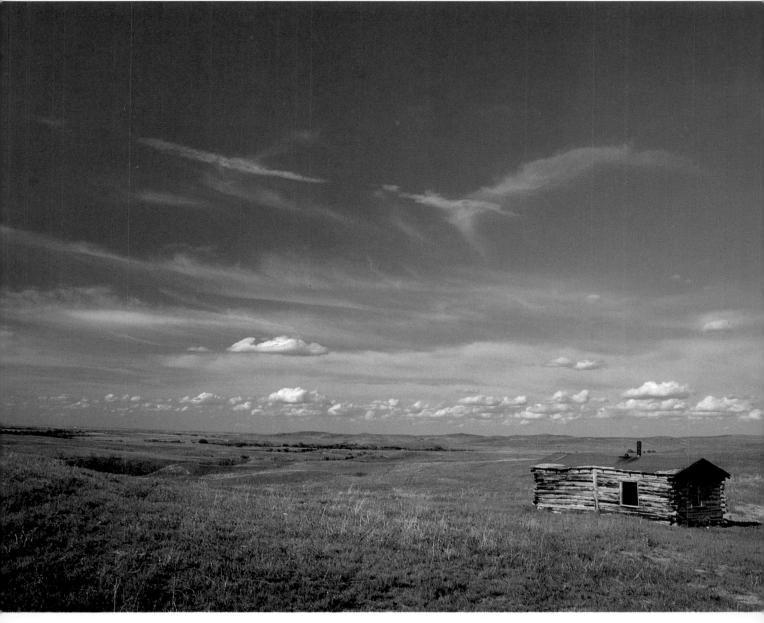

PROBLEM
The sky is obviously the main subject here—it dominates the entire composition. But you may be tempted to emphasize the cabin.

SOLUTION
Think of the cabin as an accent, one that establishes the scale of the scene. Don't let it become too large or important.

□ After you have completed a simple charcoal sketch, begin to develop the surface of the canvas with thin turp washes. Work from dark to light, starting with the sky. In this stage of the painting, your goal is to cover the entire surface with the approximate colors and values that you want to see in the finished work. Later on, when you work back into the painting with opaque pigment, you can adjust any false color or

In June, a cabin nestles close to the ground as clouds sweep through the brilliant blue sky.

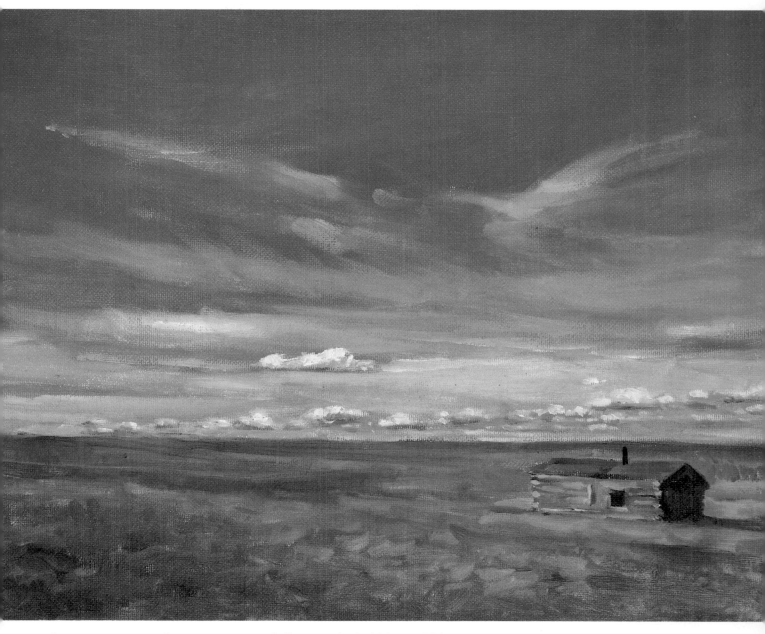

value statements and correct any errors in your drawing. After you have established the foreground, middle ground, and background, let the canvas dry.

Work back into the sky first. Use a wet-in-wet approach to paint the upper reaches of the sky. These clouds seem relatively dark because they are so thin that the sky shines through them; carefully brushing their edges into the blue sky will make them seem delicate and wind-blown. Using a wet-in-wet approach also helps separate these thin clouds from the heavier clouds on the horizon. As you move down the canvas, gradually make the sky lighter; then, with a small sable brush, paint in the low-lying clouds.

Next, turn to the foreground. Interpretation is important here because the prairie is flat and relatively uninteresting. Build it up with many short, layered strokes to suggest the feel of the grass; pick out whatever pattern you can find and emphasize it. When you are happy with the prairie, paint the cabin.

At this point, stop and analyze your painting. Does the sky carry the painting, or has too much attention been paid to the cabin? If you find that the sky seems a little timid, go back and intensify its color and value, then strengthen the clouds' shapes.

Highlighting One Element in a Complicated Scene

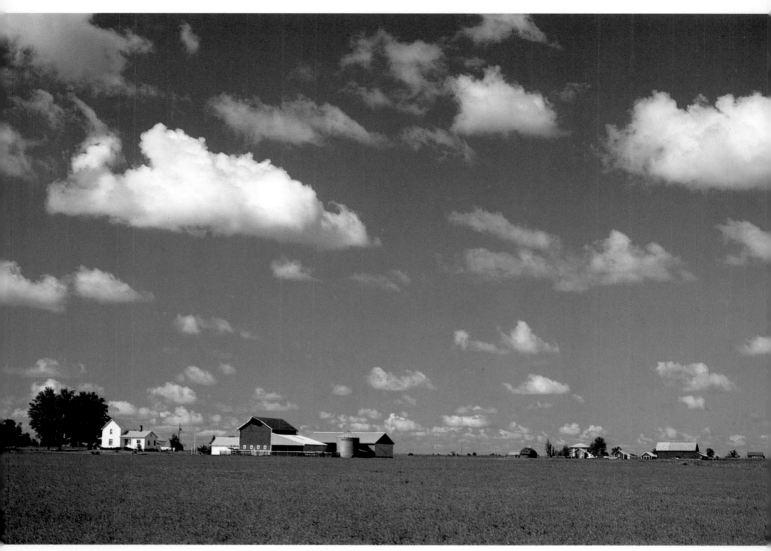

PROBLEM

Everything in this composition is small and scattered, from the farm buildings that run across the fields to the clouds that fill the sky. If you try to capture each and every detail, you'll end up with a diffuse, unfocused painting.

SOLUTION

Choose a center of interest. The low horizon line suggests that the sky be emphasized; it occupies much more space than the land. As you paint, simplify the buildings so that they don't become too important.

Farm buildings punctuate a landscape as small clouds move through the bright blue sky.

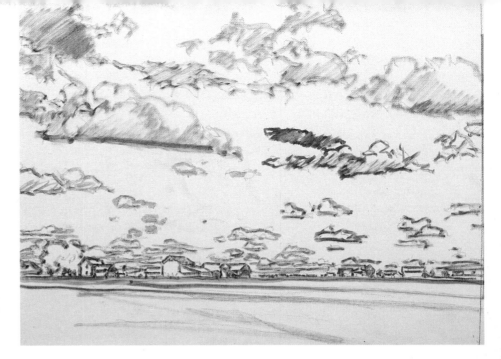

STEP ONE
With soft vine charcoal, sketch the scene, concentrating on the cloud formations. Next, dust off and fix the canvas and reinforce the drawing with thinned color. Try using raw umber. It's dark enough to make the drawing strong and it will add a little warmth to the clouds. Before you move on, brush in the dark undersides of the clouds with thinned raw umber.

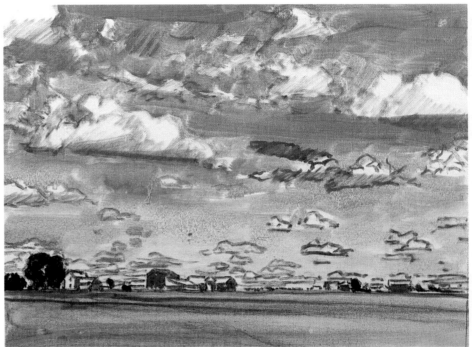

STEP TWO
Continue working with thinned color as you establish the blue of the sky and the shadowy portions of the clouds. Cobalt blue is great for the sky; make it progressively thinner and lighter as you approach the horizon. Next, quickly brush in the greens in the foreground and begin to develop the buildings.

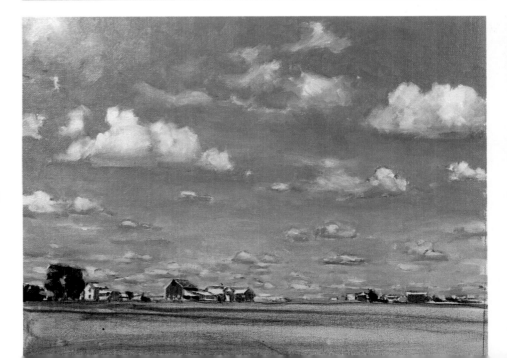

STEP THREE
Using heavier color, work back into the sky. A wet-in-wet approach makes sense here; it will allow you to soften the edges of the clouds easily. Cobalt blue forms the basis for the sky; mixed with cadmium red, it forms a deep, rich blue that is perfect for the darkest parts of the sky. Near the horizon, switch to cerulean blue and thalo green muted with a little white.

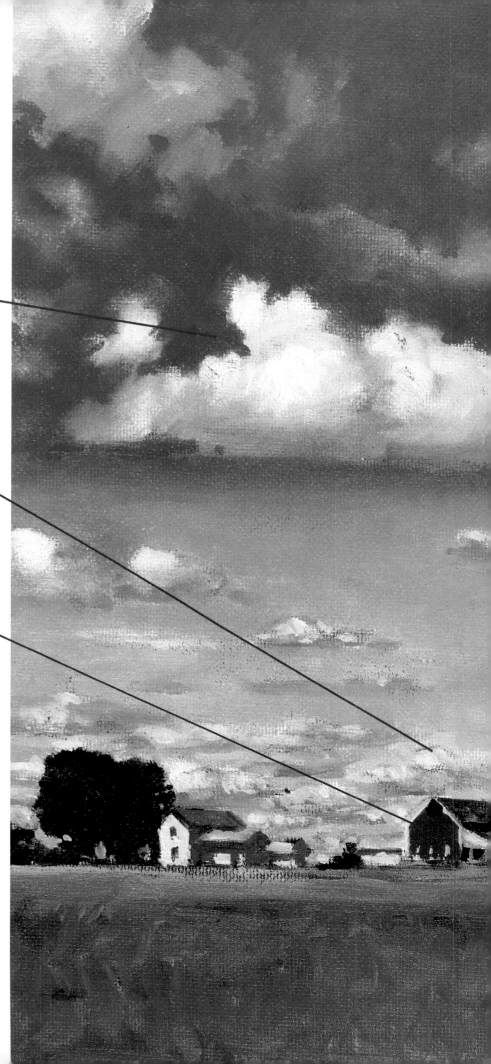

FINISHED PAINTING
Now it's time to add details to the buildings and to the trees along the horizon. Paint right over the sky. Then break up the flat green foreground, developing a pattern of darks and lights. Finally, go back to the clouds and refine their shapes and their shadows.

The deep, rich sky is made up of cobalt blue and cadmium red. The shadows that lie in the clouds are rendered with raw umber, cobalt blue, and white; their bright, light areas are done with white tinged with yellow ocher.

As clouds recede, they become pinker and contrast less sharply with the sky. Here the basic mixture of raw umber, cobalt blue, and white used to paint the other clouds is warmed with cadmium red.

The farm buildings are rendered realistically but without much detail. Their crisp, simplified shapes focus the scene and provide a clear sense of scale.

ASSIGNMENT
Find a place where you can see the sky all the way back to the horizon. Choose a time when the sky has some action to it—clouds pressing toward the ground or being swept along by the wind.

Instead of working with oils, try drawing with pastels. Pick two or three colors, plus white, and work on toned paper. Spend no more than twenty minutes on each sketch and work on a small surface.

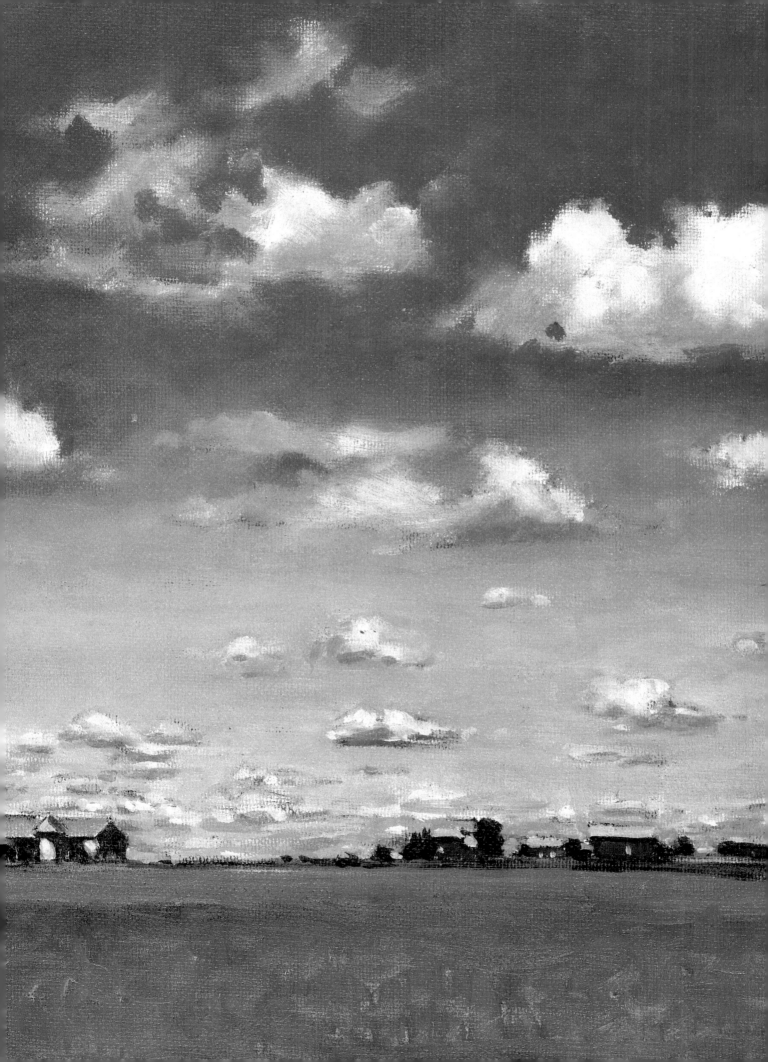

Focusing in on Detail

PROBLEM

It's difficult to create an interesting painting when nothing commands attention. Here the sky is flat and the balloons are too small to provide a focal point.

SOLUTION

Make the balloons larger than they actually are and change their placement slightly to make the composition less static. To capture all the detail possible, work on smooth Masonite.

☐ Because the balloons are so important in this composition, draw them carefully, showing as much detail as possible. You may have to invent some of it; after all, the balloons are far away and hard to see. After you've sketched the scene, dust off and fix the Masonite, then go over your drawing with thinned color.

Before you begin to use opaque color, stop and analyze the sky. In reality, it's a flat shade of blue, but you can make your painting much more compelling if you use graded color. Working around the balloons, begin to paint the sky. At the very top of the support, lay in a dark, rich blue. As you move downward, gradually make the blue slightly lighter. When you are done, take a fan brush and run it over the support to get rid of any obvious brushstrokes. The smooth, unbroken field of blue that results will help accentuate the balloons.

Now turn to the focus of the painting—the balloons. To keep their edges crisp and clean, use a small sable brush. Work with bright, clear color, to make them stand out vividly against the sky, and add as much detail as you possibly can.

When you are satisfied with the effect you've achieved, move away from your painting for a few minutes, then come back and judge it critically. Make any small adjustments in color and value that you think are necessary and sharpen up any edges that seem weak and unfocused.

On a warm summer afternoon, two hot-air balloons drift lazily in a clear blue sky.

Making a Simple Scene Interesting

PROBLEM

Once again, you are faced with a seemingly uninteresting subject. The sky is flat blue and the plane provides the only accent.

SOLUTION

Break up the sky with soft, fluid brushstrokes and a variety of blues. To emphasize the plane, make it larger than it actually is.

☐ The size of your support is sometimes dictated by subject matter. Here, where so little is happening visually, a small support makes sense. Because the jet has to be painted cleanly and sharply if it is to stand out against the sky, work on Masonite. Here the Masonite is just 8 by 12 inches.

Start with the sky. Lay cobalt blue, cerulean blue, and white on your palette. Mix your blues in small batches to add small shifts in color to the scene. Use a medium-size bristle brush with a rounded tip and work with loose, overlapping strokes as you coax the paint onto the support. What you are trying to achieve is a rich, dappled surface, one that is packed with slight differences in color and value.

When the sky is complete, turn to the jet. Paint it with a small sable brush. You won't be able to add much detail here—the plane is too distant for that. But you can make its lines clean and sharp to pull it away from the soft sky. At the very end, add the jet trails. Near the plane, make them sharp and definite. Farther away, let them blend into the sky.

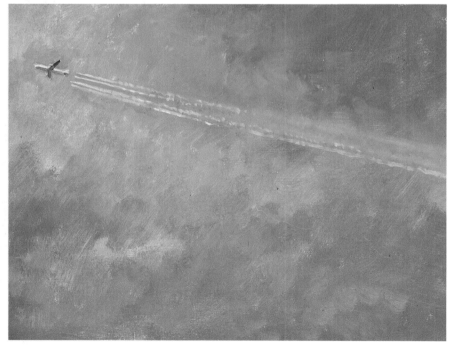

A jet shoots across the sky, leaving a stream of white in its wake.

Conveying a Sense of Great Depth

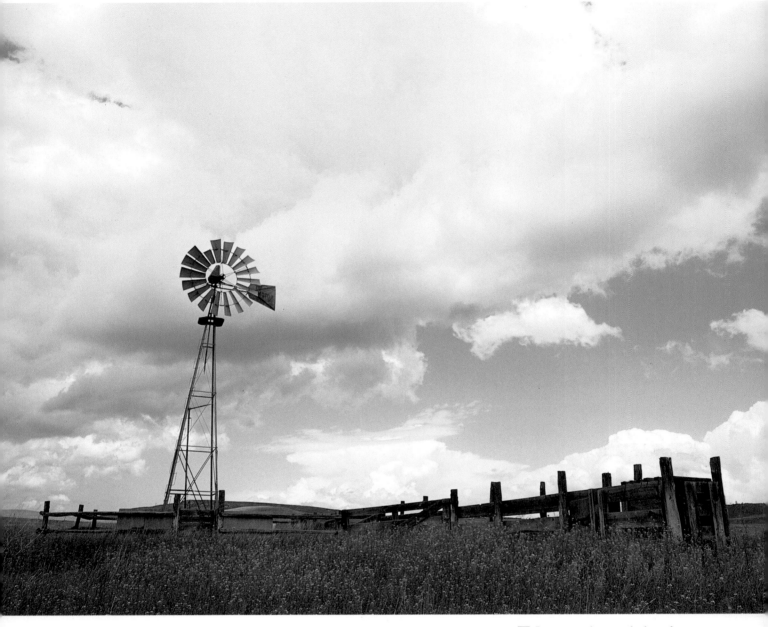

PROBLEM
It's easy to focus on the concrete elements of the picture—the windmill and the fence. But the real subject of this painting is the sky and the way the clouds roll forward to the front of the picture plane.

SOLUTION
Concentrate on the clouds. Use them to capture recession into space. Those in the forefront will be brighter and lighter than those farther back in the picture plane.

☐ In your charcoal sketch, concentrate on the clouds. Those in the frontal plane are larger and more imposing than those farther back. Sketch, too, the windmill and the fence. Keep the windmill straight and tall and in scale with the rest of the composition.

After you dust off your drawing and reinforce it with thinned color, turn to the sky. Work from dark to light, starting with the

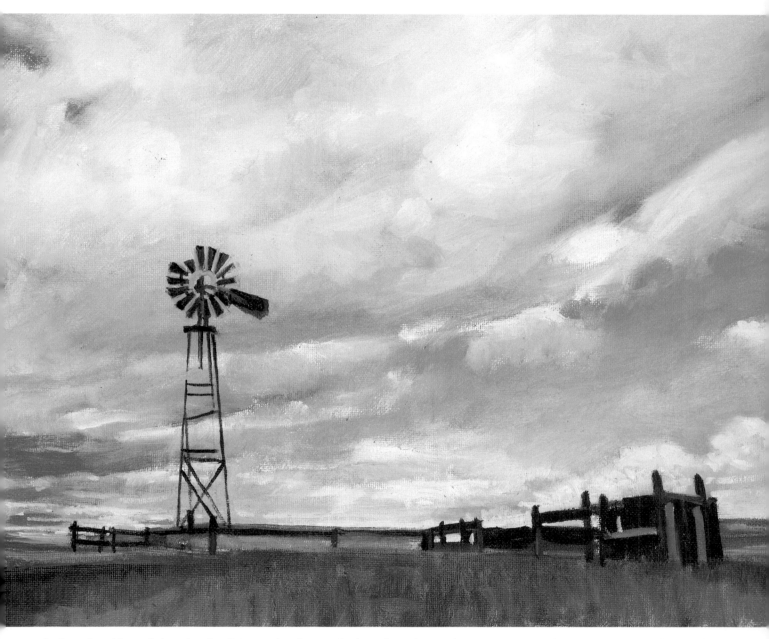

dark undersides of the clouds. For the time being, forget about the windmill. When the clouds are down, sweep in the blue of the sky.

Now begin to use opaque pigment. Working back into the sky, develop the clouds. White is their basic color, but they also contain touches of yellow ocher, blue, gray, and even brown. Use a big brush and sweeping strokes and make sure that the more distant

clouds are darker than those that lie in front.

When you are happy with the sky, turn to the foreground. Start with the grass; paint it with a vivid green, to make it spring forward, and use strong vertical strokes. Now add the windmill and the fence. For these structures, use a small sable brush; as you paint the windmill, keep your lines crisp and straight.

Once the windmill and fence

are complete, return to the sky. The undersides of the clouds must be dark enough to form a strong three-dimensional effect. If the sense of space you've developed seems muddy and unclear, go back to the clouds and define their shapes. With cool bluish-gray tones, sculpt out their structure, once again making those in the distance darker than those in the front.

Making Sense out of Complicated Cloud Formations

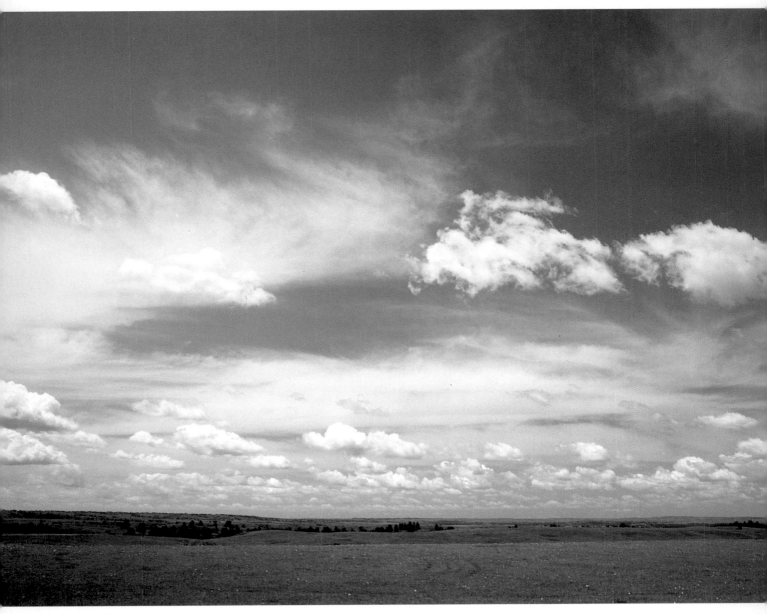

PROBLEM

Set against a lush green prairie, the sky is richly packed with complicated cloud formations, no two of them alike. Capturing all of them on one canvas isn't going to be easy.

SOLUTION

Forget about the prairie until the very end and concentrate solely on the sky. As you work, pay attention to the subtle differences that separate one cloud formation from the next.

☐ In your preliminary charcoal drawing, establish the patterns that run through the sky. Use sure charcoal strokes for the thick, dense clouds that lie in the middle of the sky; loose, gestural strokes will serve to get across the feel of the thin, airy clouds that rush through the rest of the scene.

Once your drawing is complete, you are confronted with two choices: Either reinforce the drawing with thinned color before you begin to paint, or spray your sketch with a fixative and imme-

diately begin to use broad washes of thinned color to build up the scene.

When a sky bursts with as much action as you see here, the second choice is probably the best. Right from the beginning, working wet-in-wet, you can build up the cloud masses without letting too much detail bog down your entire painting.

With a thin wash of cobalt blue tinged with ivory black, lay in the sky. Near the horizon, add a touch of cadmium red. Now wash in thinned green across the fore-

Thick, rich clouds sweep through the sky, overpowering the spring-green prairie that lies below.

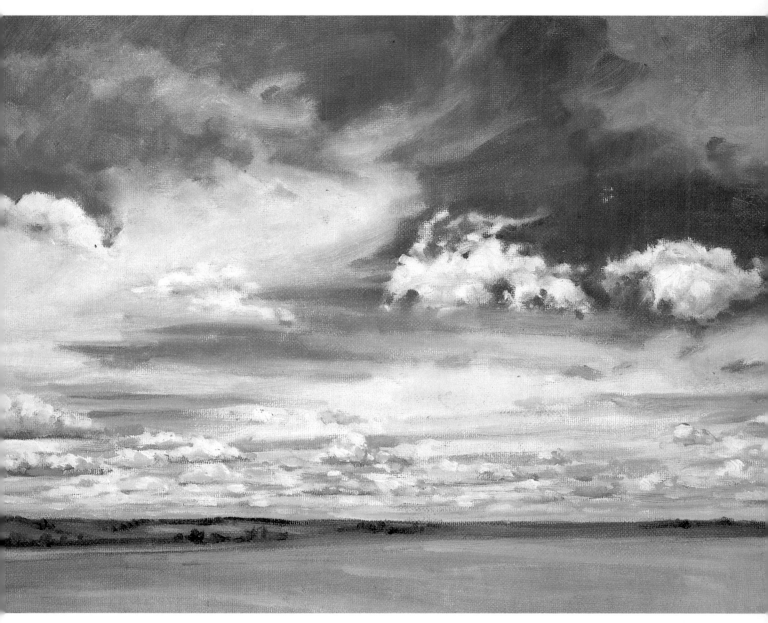

ground to establish the medium value that makes up the prairie.

That done, start working with opaque color. Continue working wet-in-wet to further develop the sky. As you paint, pay attention to the edges of the clouds: Some are sharp and well defined; others, loose and amorphous. The loose clouds seem to almost disappear where they meet the sky, so be sure to blend them well into the surrounding pools of blue. The sharper clouds call for more exact treatment to make their contours

stand out clearly against the blue.

In your final development of the sky, concentrate on the heavier clouds. Make sure that they are sharply etched against the sky. For this you'll need heavier brushstrokes and thicker paint than you've used to develop the thinner clouds. Next, articulate the clouds that lie low along the horizon. As they recede in space, they become darker and pinker. Adding touches of Mars violet to these distant clouds will push them back into the picture plane.

Finally, turn to the foreground. Enrich your basic wash of green with thicker paint, then add touches of dark brownish-green along the horizon. To animate the prairie, add the thin line of trees that runs across the lower right side of the scene.

The dark brownish-green added at the end helps separate the ground from the sky. Pulling these two areas apart adds drama to the sky: In the end, it stands out sharply against the bright spring-green of the ground.

Index

Editorial concept by Mary Suffudy
Edited by Elizabeth Leonard
Designed by Bob Fillie
Graphic production by Hector Campbell
Text set in 11-point Century Old Style